TREASURES FROM
AN ANCIENT LAND

The Art of
JORDAN

TREASURES FROM AN ANCIENT LAND

The Art of
JORDAN

Edited by PIOTR BIENKOWSKI

Foreword by HER MAJESTY QUEEN NOOR
AL-HUSSEIN OF JORDAN

ALAN SUTTON

NATIONAL MUSEUMS & GALLERIES
· ON MERSEYSIDE ·

First published in the United Kingdom in 1991 by
Alan Sutton Publishing Ltd · Phoenix Mill · Far Thrupp · Stroud
Gloucestershire
and National Museums and Galleries on Merseyside

First published in the United States of America in 1991 by
Alan Sutton Publishing Inc · Wolfeboro Falls · NH 03896-0848

British Library Cataloguing in Publication Data

Jordan: treasures from an ancient land : the art of Jordan.
1. Jordanian visual arts, history
I. Bienkowski, Piotr
709.5695

ISBN 0–86299-729-1

Library of Congress Cataloging in Publication Data applied for

Typesetting and origination by
Alan Sutton Publishing Limited.
Colour separation by Yeo Valley Graphic Reproductions, Wells.
Printed in Great Britain by
Eagle Colour Books Ltd., Glasgow.
Bound by The Bath Press Ltd., Avon.

Contents

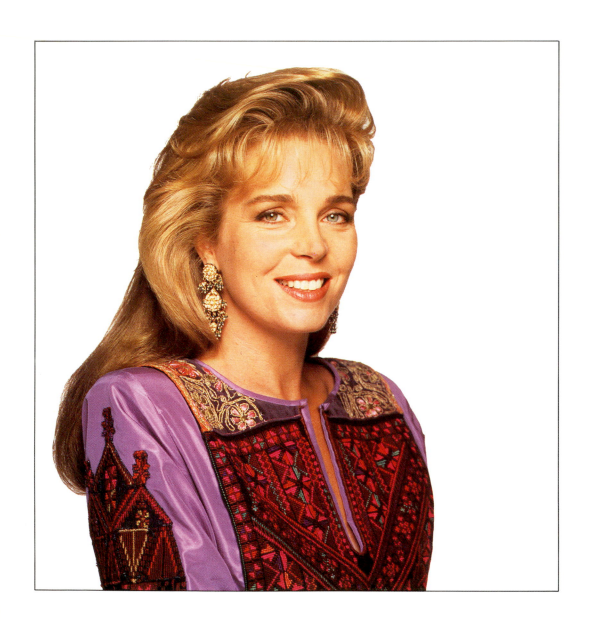

Foreword

For thousands of years, the peoples of Europe and the Middle East have interacted in human civilisation's most enduring and productive dynamic of artistic, commercial, intellectual and technological interchange – a dynamic that has mutually enriched our human cultures and our national capabilities.

Many of history's most creative and remarkable cultures – particularly during the Biblical, Classical, Medieval Islamic and Renaissance periods – interacted with one another across the Mediterranean Basin that bound them together in symbiotic growth, enlightenment and respect. They bequeathed to us an enduring legacy of arts, crafts, architecture, trading patterns, communications routes, shared values and material progress.

The lands and peoples of Jordan and the British Isles represent two of the geographical extremities of that ancient dynamic. Today, this exhibition of Jordanian antiquities and folk costumes and jewellery from the land of Jordan and Palestine provides yet another opportunity for our peoples to interact with one another, and to perpetuate the mutually constructive and enriching contacts whose roots lie in the genesis of early human history.

As the exhibition and this book both indicate, the ancient land of Jordan preserves a virtually unbroken record of the evolution of human art, culture and technology in the Middle East during the last 12,000 years. Ever since the dawn of human civilisation, the land of Jordan has been both a strategic frontier region and a pivotal crossroads amidst the great cultures of the ancient world, such as Egypt, Assyria, Mesopotamia, Greece, Rome, Byzantium and the Realm of Islam. Because they could rely on few natural resources, the people who inhabited our land always assured their well-being through a combination of intellectual and cultural capabilities, hard work, faith in their moral codes, and a commitment to open trading and political contacts with the rest of the world.

As a result of this historical pattern, Jordanian culture today is a cumulative repository of successive human traditions, practices and beliefs that must be measured in millennia. The close human ties

between the people of Jordan and Palestine lie at the heart of that tradition, and can be appreciated in the embroidery and ethnographic objects in this exhibition.

We are delighted that the exhibition and this accompanying book will provide a fresh opportunity for the culture and human traditions of Jordan and Palestine to reach, and touch, people in other parts of the world. Such cross-cultural interaction has always been central to the development and growth of the people of Jordan and Palestine, and it remains a key principle of our national development strategies today.

Preface

Liverpool has a long and distinguished tradition of archaeological work in the Near East, particularly through the former Institute of Archaeology at Liverpool University, and scholars such as Professor John Garstang who excavated at Jericho in the 1930s. The Trustees of the National Museums and Galleries on Merseyside are honoured and delighted to continue this tradition by presenting the exhibition *Jordan: Treasures from an Ancient Land* at Liverpool Museum in 1991. We are indebted to Her Majesty Queen Noor al-Hussein of Jordan for her generous patronage of this exhibition. The Trustees are also particularly grateful to His Excellency Abdul Karim Al Kabariti, Minister of Tourism; His Excellency Dr Khaled Karaki, Minister of Culture; Nasri Atalla, Secretary-General of Tourism; and Dr Ghazi Bisheh, Director of Antiquities, for their considerable help in Jordan and with the preparation of this book. Finally I should add our thanks to Piotr Bienkowski, Curator of Egyptian and Near Eastern Antiquities, for preparing the exhibition and editing this book.

Sir Leslie Young, CBE
Chairman of the Trustees
National Museums and Galleries on Merseyside

Editor's Preface

This book is published as a general introduction to the art and heritage of Jordan on the occasion of the exhibition *Jordan: Treasures from an Ancient Land*. It is my hope that the book will fill a gap in the literature on ancient Jordan. For the first time a broad overview is taken of the various art forms throughout Jordan's history, rather than the country being regarded strictly chronologically or geographically.

The format of this book follows that of the exhibition, with chapters on sculpture, pottery, applied arts, mosaics, writing, traditional costume and folk jewellery. Neither architecture nor coins have been treated separately, although architecture is included in the introductory chapter on the archaeology and history of Jordan.

Many of the objects in the exhibition were exhibited previously in Paris, Cologne, Schallaburg, Munich, Tokyo and Singapore (see the exhibition catalogues *La Voie Royale: 9000 Ans d'Art et d'Histoire au Royaume de Jordanie*, Paris, 1986, and *Der Königsweg: 9000 Jahre Kunst und Kultur in Jordanien und Palästina*, Mainz am Rhein, 1987).

I gratefully acknowledge the assistance of those who lent objects to the exhibition: Ministry of Tourism, Jordan (co-ordinating all loans from Jordanian public collections); Widad Kawar; British Museum, London; Ashmolean Museum, Oxford; Palestine Exploration Fund, London; University of Liverpool; Musée du Louvre, Paris; Bibliothèque Nationale, Paris; Musée Bible et Terre Sainte, Paris. Thanks also for support to: Visiting Arts; the British Council; the Foreign Office, London; the British Embassy, Amman; and the Anglo-Jordanian Society. I am grateful to Alan Millard, Kay Prag and my wife Basia for their invaluable help with the preparation of this book.

Piotr Bienkowski

The Authors

Piotr Bienkowski is Curator of Egyptian and Near Eastern Antiquities at the National Museums and Galleries on Merseyside, Liverpool, England, and editor of *Levant*, journal of the British School of Archaeology in Jerusalem and the British Institute at Amman for Archaeology and History.

H.J. Franken is Professor Emeritus of Palestinian Archaeology at the University of Leiden, Netherlands.

Widad Kawar has been collecting Jordanian, Palestinian and Syrian costumes for more than thirty years. The Kawar Collection presently contains 1000 costumes and accessories.

Birgit Mershen was formerly Curator of the Museum of Jordanian Heritage, Institute of Archaeology and Anthropology, Yarmuk University, Irbid, Jordan.

Alan Millard is Rankin Reader in Hebrew and Ancient Semitic Languages at the University of Liverpool, England.

Graham Philip is Assistant Director of the British Institute at Amman for Archaeology and History.

Michele Piccirillo is an archaeologist at the Studium Biblicum Franciscanum, Jerusalem.

Fawzi Zayadine is Assistant Director of Antiquities of Jordan.

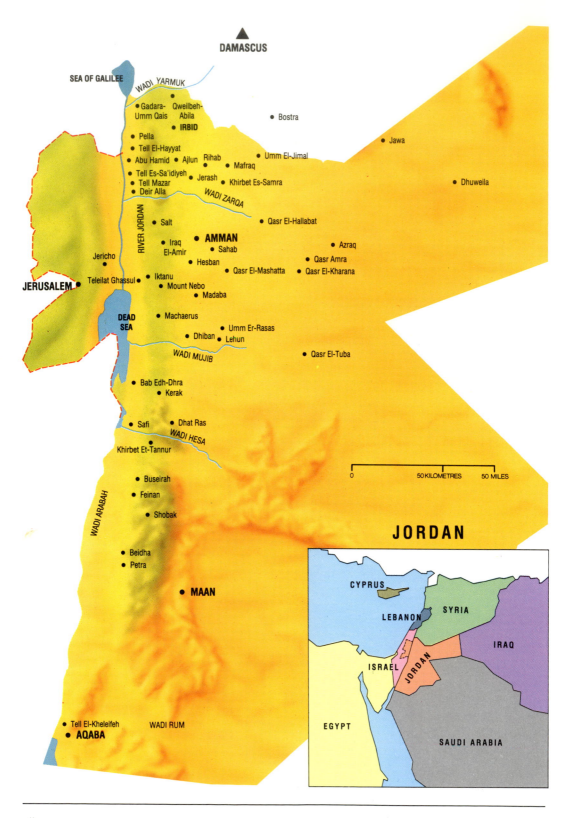

DAMASCUS

SEA OF GALILEE

WADI YARMUK

• Gadara-
 Umm Qais
• Qweilbeh-
 Abila

• Bostra

IRBID

• Pella

• Jawa

• Tell El-Hayyat

• Abu Hamid • Ajlun Rihab

• Umm El-Jimal

• Tell Es-Sa'idiyeh • Mafraq

• Tell Mazar • Jerash • Khirbet Es-Samra

• Dhuweila

• Deir Alla

WADI ZARQA

RIVER JORDAN

• Salt

• Qasr El-Hallabat

• Iraq
 El-Amir

AMMAN

• Sahab

• Azraq

• Hesban

• Qasr Amra

Jericho •

• Qasr El-Mashatta • Qasr El-Kharana

Teleilat Ghassul • • Iktanu

JERUSALEM •

• Mount Nebo

• Madaba

DEAD
SEA

• Machaerus

• Umm Er-Rasas

• Dhiban • Lehun

• Qasr El-Tuba

WADI MUJIB

• Bab Edh-Dhra

• Kerak

• Safi • Dhat Ras

WADI HESA

Khirbet Et-Tannur •

• Buseirah

WADI ARABAH

• Feinan

• Shobak

JORDAN

• Beidha

• Petra

MAAN

0 50 KILOMETRES 50 MILES

CYPRUS

SYRIA

LEBANON

ISRAEL JORDAN IRAQ

• Tell El-Kheleifeh WADI RUM

• AQABA

EGYPT

SAUDI ARABIA

CHRONOLOGICAL TABLE
SHOWING SIGNIFICANT EVENTS AND PROMINENT PERSONALITIES

	JORDAN	EGYPT	MESOPOTAMIA (MODERN IRAQ)
PALAEOLITHIC c 1 200 000 – 8500 BC	HUNTING AND GATHERING NOMADS GRADUALLY SETTLING AND CULTIVATING		
NEOLITHIC c 8500 – 4500 BC	WIDESPREAD AGRICULTURE LARGE SETTLEMENTS FIRST POTTERY 5500 BC	PREDYNASTIC PERIOD	ORIGINS OF FARMING
CHALCOLITHIC c 4500 – 3200 BC	APPEARANCE OF METAL WORKING IN JORDAN		UBAID PERIOD URUK PERIOD INVENTION OF WRITING
EARLY BRONZE AGE c 3200 – 1950 BC	'CITY STATES' SURROUNDED BY HUGE DEFENCES CHANGE TO VILLAGE AND PASTORAL LIFE c 2300 BC	ARCHAIC PERIOD UNIFICATION OF EGYPT APPEARANCE OF WRITING OLD KINGDOM PYRAMIDS FIRST INTERMEDIATE PERIOD	EARLY DYNASTIC PERIOD SUMERIANS. GROWTH OF LARGE CITIES AND TEMPLES. ROYAL TOMBS OF UR AKKADIAN PERIOD SARGON OF AKKAD UR III DYNASTY SUMERIAN RENAISSANCE
MIDDLE BRONZE AGE c 1950 – 1550 BC	RE-EMERGENCE OF URBAN LIFE IN STRONGLY DEFENDED CITIES	MIDDLE KINGDOM SECOND INTERMEDIATE PERIOD	OLD BABYLONIAN PERIOD HAMMURABI
LATE BRONZE AGE c 1550 – 1200 BC	'CITY STATES' EGYPTIAN EMPIRE	NEW KINGDOM TUTHMOSIS III AKHENATEN AMARNA LETTERS TUTANKHAMUN RAMESSES II	KASSITE AND MITANNIAN PERIODS INTERNATIONAL DIPLOMACY
IRON AGE c 1200 – 539 BC	KINGDOMS OF EDOM, MOAB AND AMMON ASSYRIAN AND BABYLONIAN EMPIRES PALESTINE UNITED ISRAELITE MONARCHY UNDER SAUL, DAVID AND SOLOMON JEWS DEPORTED TO BABYLON	THIRD INTERMEDIATE PERIOD RULE BY HIGH PRIESTS OF AMUN NUBIAN RULE ASSYRIAN INVASION	ASSYRIAN EMPIRE BABYLONIAN EMPIRE
PERSIAN 539 – 332 BC	RULE BY PERSIAN GOVERNORS	LATE PERIOD PERSIAN CONQUEST	PERSIAN EMPIRE
HELLENISTIC 332 – 63 BC	CONQUEST BY ALEXANDER THE GREAT RULE BY PTOLEMIES AND SELEUCIDS	PTOLEMAIC DYNASTY CLEOPATRA	SELEUCID EMPIRE
ROMAN AND NABATAEAN 63 BC – AD 324	CONQUEST BY ROMAN GENERAL POMPEY IN 63 BC NABATAEAN KINGDOM WITH CAPITAL AT PETRA, CONQUERED BY ROME IN AD 106 JORDAN PART OF ROMAN PROVINCE OF ARABIA	ROMAN RULE	PARTHIAN DYNASTY
BYZANTINE AD 324 – 640	OFFICIAL CONVERSION TO CHRISTIANITY POPULATION EXPLOSION	COPTIC (CHRISTIAN) PERIOD	SASANID DYNASTY
ISLAMIC AD 630 –	CONQUEST BY ARABS UNDER THE PROPHET MUHAMMAD RULE BY ISLAMIC DYNASTIES IN DAMASCUS, BAGHDAD AND CAIRO (CRUSADER KINGDOM OF JERUSALEM 1099-1291)	ISLAMIC DYNASTIES UMAYYAD 661-750 ABBASID 750-969 FATIMID 969-1171 AYYUBID 1174-1263 MAMLUK 1250-1516 OTTOMAN 1516-1918	

Jordan: Crossroads of the Near East

Jordan sits at the hub of the Near East, a vital and wealthy region of the world. In ancient times it served as a major communications and trade route, in contact with the great empires of Egypt, Assyria, Persia and Rome. Transjordan (the geographical term referring to the land east of the River Jordan) was often part of empires whose capitals were far away, or was divided into separate and often antagonistic states.

The first independent state of Transjordan was created in the aftermath of the First World War. After the war the area fell under British control. In 1921 the Emir ('Prince') Abdullah was invited to become the ruler of Transjordan. He was head of the Hashemite family, the noblest in Islam, owing to its direct descent from the Prophet Muhammad. Following the Second World War, Jordan gained full independence; on 25 May 1946 Abdullah became the first king of the Hashemite Kingdom of Jordan. The present king, Hussein, came to the throne in 1952, at the age of sixteen.

Two major factors have influenced Jordan's history from earliest times. Firstly, only the north is really fertile, largely due to a relatively high rainfall (about 640 mm. a year) and to the rich irrigable soils in the Jordan Valley, and so it has always been more densely settled by farmers, villagers and town dwellers than the south and east. The River Jordan flows from Lake Tiberias (the Sea of Galilee) into the Dead Sea, at 395 m. below sea-level the lowest point on earth.

To the south and east there is a much lower rainfall and no rivers to irrigate the land (only the Azraq Oasis has an abundant water supply in pools and swamps). These areas can be fairly harsh, and in some periods there appears to have been no settled population in them.

The contrast between the 'desert' and the 'sown' is particularly pronounced in Jordan. Much of the country has only ever been populated by nomadic beduin. Beduin are popularly thought to be nomads who live in tents and wander with their herds in search of pasture. While this is occasionally true, throughout history beduin

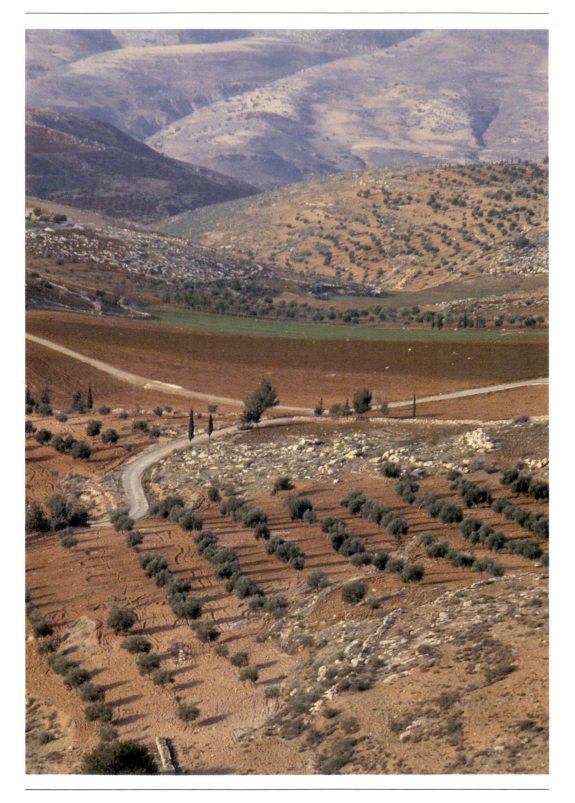

2. Beduin in the Wadi Arabah

have lived on the outskirts of settlements, and townsfolk and beduin have been mutually dependent on each other. Beduin have made a living through herding, hunting, foraging, trade and exchange, and have frequently been affected by external politics. This is particularly true of recent years, when changing conditions have forced many of them to settle permanently. As a result, the traditional beduin lifestyle is fast disappearing.

The second factor influencing Jordan's history is the country's geographical position, which puts it at the centre of communications and routes of trade for the entire Near East. In ancient times control of Jordan was seen as a strategic necessity. It stood on the caravan route from Arabia to Damascus, and it was a valuable source of copper. Each of the great empires in succession occupied the country. Even at times of independent kingdoms, the area was constantly harassed and occasionally occupied by enemy states from the north, east and west.

Prehistory

Man first appeared during the Palaeolithic ('old stone age') period (*c.* 1,200,000–17,000 BC). He was a hunter of wild animals and a gatherer of wild plants, probably following the movements of animals seeking pasture, and living near sources of water. Palaeolithic man in Jordan has left no evidence of architecture, and no

1. (OPPOSITE) Landscape near Salt, north-west of Amman

3

3. Sunrise in Wadi Rum

human skeleton from this period has yet been found. The only tools were flint and basalt handaxes, scrapers and knives (see pp. 87 ff.).

During the Epipalaeolithic (or Mesolithic, 'middle stone age') period (c. 17,000–8500 BC) the nomadic hunters began to settle. Their domestic architecture echoed the circular pattern of tents. Animals such as gazelles and dogs were domesticated and wild grains cultivated, alongside continued hunting and fishing.

The Neolithic ('new stone age') period is traditionally sub-divided into Pre-Pottery Neolithic and Pottery Neolithic. During the Pre-Pottery Neolithic (c. 8500–5500 BC) people settled down to life in huts and villages. There was a population explosion because of the effectiveness of new food sources: cereal agriculture, dom-esticated peas and lentils and the widespread practice of goat-herding. Half of the meat in the Pre-Pottery Neolithic diet came from goats, the rest from a range of wild animals. The population reached several tens of thousands. The stone tower and walls at Jericho show that defence was now a consideration.

The largest Neolithic site in Jordan is at Ain Ghazal in Amman. This consisted of a large number of buildings with plastered floors, grouped into three districts. Houses were rectangular, with several rooms. Ancestor worship was practised, as at Beidha in southern Jordan and elsewhere in Palestine and Syria. Skeletons and jawbones have been found buried under the floors of dwellings, but some of the skulls were separated and were reworked with plaster

over the cheekbones and nose and bitumen in the sockets. An extraordinary discovery was a hiding place containing many clay statues and busts (see p. 31).

The Pre-Pottery Neolithic sites in the eastern desert were very different. They were hunting camps, consisting of two or three huts, which probably reflects family hunting groups of eight to ten individuals. After the Pre-Pottery Neolithic the eastern desert was never occupied as fully again. This was probably because the climate grew warmer and drier and the desert became uninhabitable in most periods. The distinction between the 'desert' to the east and the 'sown' to the west really dates from this time.

There is evidence of small-scale trade during the Pre-Pottery Neolithic. Obsidian, a dark glass-like rock, was imported from faraway Anatolia (modern Turkey). Malachite, a bright green mineral used for ornament, and cowrie shells came from the Mediterranean Sea, and turquoise from Sinai.

The greatest achievement of the Pottery Neolithic people (*c.* 5500–4500 BC) was the invention of pottery. Early attempts to fashion pottery from plaster had been made at Pre-Pottery Neolithic Ain Ghazal and Beidha, but it was Pottery Neolithic man who systematically began to fashion vessels of clay (see pp. 62 ff.).

The Coming of Copper

With the discovery of the smelting of copper, we enter the Chalcolithic ('copper–stone') period (*c.* 4500–3200 BC). The first tools made of copper were axes, arrowheads and hooks. Flint tools also continued in use for a long time (see pp. 92 ff.).

Hunting gradually became less important than sheep- and goat-breeding and cultivation of wheat, barley, dates, olives and lentils. In the desert areas the lifestyle was probably similar to that of modern beduin.

Teleilat Ghassul was a large Chalcolithic village in the Jordan Valley. Its houses were built of sun-dried mud bricks, often on stone foundations, with roofs probably of wood, reeds and mud. The houses were planned around large courtyards. The walls of some houses were plastered and painted in bright colours with representations of processions of masked men, stars and geometric motifs, perhaps connected with religious beliefs (Plate 4).

By about 3200 BC, Jordan had developed a largely urban character. Archaeologists call the following period the Early Bronze Age (*c.* 3200–1950 BC). This is rather misleading, since metal tools were mostly of copper, not bronze, and flint was still used. Most major towns were now positioned on hills and had substantial defences.

The town of Jawa in the eastern desert was built and deserted within one generation. It had two solid concentric walls, one

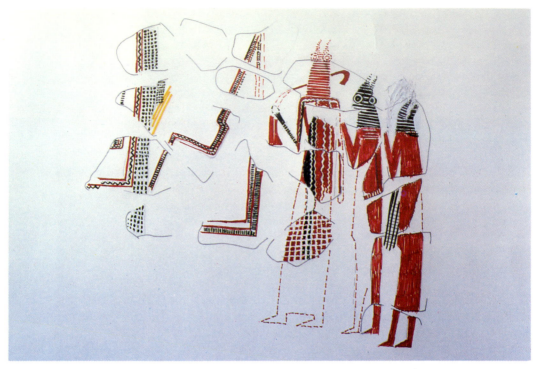

4. One of the Chalcolithic wall-paintings at Teleilat Ghassul, showing three masked figures in procession

protecting the upper town, the second encircling the lower town. Its population has been estimated at between 1500 and 2000. The inhabitants combined agriculture with hunting, gathering and stock-breeding. Jawa is still unique for its system of reservoirs which enabled water to be stored for use in the dry summer months. A dam collected the water and diverted it to basins for people and animals.

Bab edh-Dhra and Jericho were surrounded by huge stone ramparts with towers. The Early Bronze Age builders of the Jericho walls clearly understood the threat from the earthquakes which are frequent in the Jordan Valley. Each section of the wall was separated by a narrow segment which took the stress during earthquakes, and prevented the whole wall from collapsing.

At Bab edh-Dhra archaeologists discovered over two hundred thousand graves. These were shaft tombs with multiple chambers, and charnel houses of mud-brick containing human bones, pots, jewellery and weapons.

In contrast to the complex urban civilisations of Egypt and Mesopotamia, where writing developed before 3000 BC, Jordan, Palestine and Syria did not really use writing until over a thousand years later. Nevertheless, archaeological evidence shows that Jordan was in contact with Egypt and Mesopotamia.

The hundreds of dolmens scattered throughout Jordan have been dated to either the Chalcolithic period or the Early Bronze Age. A dolmen consists of two or more huge stone slabs standing side by side, capped by a third slab and sometimes closed by another. It is likely that they were burial chambers. Beneath the floors of some dolmens are small, subterranean chambers which accommodated the dead. It is possible that the dolmens are evidence of new peoples from the north, bringing with them different burial traditions.

Most of the Early Bronze Age towns were destroyed or abandoned between about 2700 and 2300 BC. A popular theory, now largely rejected, attributed the destructions to the Amorites, regarded as nomadic shepherds from Syria who infiltrated Jordan and Palestine. The Amorites are known from the Bible as inhabitants of Canaan, especially the hill country. However, many archaeologists now think that the Early Bronze Age towns were victims of changes in climate and of political factors which brought a chaotic end to a finely balanced framework of independent 'city-states'.

In the following period (known as Early Bronze IV or the Intermediate Early Bronze–Middle Bronze Age, c. 2300–1950 BC) people moved away from the large sites on hills, and settled in smaller, unfortified villages, or adopted a pastoral lifestyle.

It was once thought that the country was inhabited only by nomads, but it is now known that the population was largely sedentary. A typical Early Bronze IV village was Iktanu in the Jordan Valley. Its economy was based on farming, sheep-, goat- and cattle-herding and some hunting. The village was planned, with narrow streets separating houses with large courtyards, an industrial quarter, but no defensive walls.

The Hyksos and the Middle Bronze Age

Our understanding of what happened in Jordan during the Middle and Late Bronze Ages (c. 1950–1200 BC) has changed considerably in recent years. The first regional archaeological surveys in Jordan in the 1930s by the American scholar Nelson Glueck concluded that at this time there was a sharp decline in settled occupation, and that most of Transjordan was nomadic or semi-nomadic. More recent surveys and excavations have proved that major urban settlements existed in northern and central Jordan, but in the south there is still a settlement gap for those periods. However, we know from hieroglyphic inscriptions of the 13th century BC on temple walls in Egypt that southern Jordan was populated by nomadic beduin called Shasu.

The nature of the Middle Bronze Age settlements (c. 1950–1550 BC) is still uncertain. It used to be thought that in about 1950 BC

invaders from the north brought new pottery and other customs. Later the Hyksos, described as a military aristocracy from north Mesopotamia, invaded, and by the 18th century BC ruled a number of towns in Syria and Palestine. The Hyksos also penetrated Egypt, where they were at least partially responsible for the overthrow of its Middle Kingdom, and themselves ruled as the 15th Dynasty. They brought with them the war chariot, horses, and a new type of defensive architecture.

This view too has undergone recent change. There is more stress now on local development in Palestine, Jordan and Syria.

The name 'Hyksos' is a Greek form of the ancient Egyptian *hkaw haswt*, which means 'rulers of foreign lands'. It is likely that the Hyksos were not a specific ethnic group, but ordinary Asiatics, probably from Palestine. The term 'Hyksos' has relevance only in Egypt.

A new, distinctive type of fortification appeared at sites like Amman Citadel, Irbid, Pella and Jericho. These were towns on a hill surrounded by ramparts made of earth embankments. The slope was covered with hard plaster, which was slippery and hard for an enemy to climb. Pella was enclosed by massive walls and watch-towers.

Copper was now mixed intentionally with tin to produce bronze, a much harder material, though some bronze objects had appeared earlier (see p. 94). Craftsmen produced bronze daggers, axeheads and decorated toggle pins. Potters developed the fast potter's wheel to fashion sophisticated shapes (see p. 75).

Little is known of Middle Bronze Age religion. At Tell el-Hayyat, a farming hamlet in the Jordan Valley, a sequence of four mud-brick temples, perhaps dedicated to a female divinity, has been discovered. The whole temple was surrounded by an enclosure wall. In the second phase six large, rounded limestone stelae stood in the forecourt, with flat stones in front as if to accept offerings. In one corner of the temple was a mud-brick platform, probably an altar, and a bench around the walls. Silver and bronze figurines and copper ingots were found inside.

The dead were buried in caves or shaft tombs. Tombs were often re-used, skeletons being pushed to the back and sides to make room for the new body. Tomb 62 at Pella contained about two thousand items, including pottery, scarabs, alabasters, bronzes and gold jewellery (see Plate 151).

During the Middle Bronze Age there was growing contact with Egypt, as shown by the presence in Jordan of Egyptian faience vessels and scarabs. One series of Egyptian inscriptions mentions kings and their subjects in towns and regions in Palestine and Jordan. These are the Execration Texts, written on pottery jars or on statuettes of captive figures intended for a magical rite to thwart the operation of evil forces.

Archaeologists usually date the end of the Middle Bronze Age to about 1550 BC. At this time the Hyksos 15th Dynasty was expelled from Egypt by the rulers of the 17th and 18th Dynasties. Many of the Middle Bronze Age towns in Palestine, and probably Sahab in Jordan, were destroyed. The usual explanation is that the Egyptians pursuing the Hyksos into Palestine were responsible, although there is little evidence of much Egyptian involvement. Other factors, such as inter-town rivalry and mutual destruction, cannot be discounted.

The Egyptian Empire

The beginning of the Late Bronze Age in about 1550 BC brought no abrupt change to the material culture of Jordan or Palestine. A real political change came when the Egyptian pharaoh Tuthmosis III (1479–1425 BC) set up an empire in Canaan (that is, Palestine, Jordan and Syria). Tuthmosis carried out at least sixteen military expeditions in the area. His authority was firmly established after the successful conclusion of a seven-month siege of Megiddo in Palestine. He followed up his victory by installing rulers of his own choosing in the major towns, and also introduced a system of Egyptian governors in general control of the administration of Canaan.

The Egyptians fought against the northern kingdoms of the Mitannians and Hittites for control of Syria. The conflict with the Hittites from Anatolia reached its climax during the reign of the pharaoh Ramesses II (1279–1213 BC). The inconclusive battle at Qadesh (Tell Nebi Mend on the Orontes River in northern Syria) was followed by sixteen years of hostilities. A peace treaty was eventually signed between Egypt and the Hittites in 1259 BC.

Jordan was a key strategic area for the Egyptians. At that time there was a system of Canaanite 'city-states' in northern and central Jordan, similar to that in Palestine. Lists of areas under Egyptian control compiled by Egyptian scribes mention parts of Jordan. The prince of Pella, a rich city enclosed by a massive wall, sent letters to the Egyptian pharaoh. These were among 350 letters discovered at Amarna in Egypt, the capital of the pharaoh Amenophis IV (Akhenaten). The letters were from Asiatic rulers, written on clay tablets in the Akkadian cuneiform script (see pp. 133 ff.).

Many imports from Egypt and objects showing Egyptian influence have been discovered in Jordan, particularly at Pella and Tell es-Saʿidiyeh in the Jordan Valley. A faience vase with the name of the Egyptian queen Tawosret (c. 1200 BC) was found at Deir Alla.

The relative peace brought by the Egyptian Empire encouraged international trade, particularly with the Mediterranean and Aegean. Pottery imported from Mycenaean Greece and Cyprus is

5. Tell es-Saʿidiyeh in the
Jordan Valley

found all over Palestine and Jordan. Originally this pottery
probably contained oils and perfumes, but would also have been
used as fine tableware. Much of it was found in tombs, buried
alongside the dead.

Recent excavations by the British Museum at Tell es-Saʿidiyeh
have discovered a remarkable range of burial customs (Plates 5–8).
The most interesting was the so-called 'double pithos' burial. Here,
the deceased had been buried within a coffin composed of two
extremely large jars ('pithoi'), joined shoulder to shoulder, their
necks having been removed. In other burials bowls of pottery or
bronze had often been used to cover the face of the dead person.

The Saʿidiyeh burials in general were rich in bronze objects,
which provided valuable information regarding burial practices. In
almost every case were found textiles, preserved by the corrosion
products of the bronze, indicating that the bodies had been tightly
bound and then covered with another layer of cloth (see Plates 8,
127). The cloth has been identified as linen of Egyptian weave, and
traces of bitumen may suggest some attempt at mummification.

A temple discovered during construction work at the old airport
in Amman in 1955 gives further insight into religious beliefs. The
temple was about 15 m. square, with six small paved rooms
surrounding a central cella containing a stone altar. A stone-built

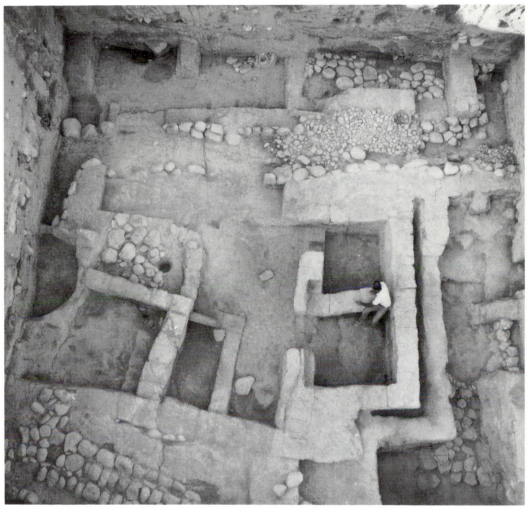

6. Aerial view of the Governor's Residency at Tell es-Sa'idiyeh, revealing the characteristic square shape and rooms grouped around a small central hall. End of the Late Bronze Age, c. 12th century BC

incinerator stood outside the building. Carbonised bones buried in the floor of the temple may indicate that children as well as animals were sacrificed here. Alternatively, the site may have been a special depository for cremated remains. Offerings included gold jewellery, bronze weapons, ivory, bone and stone objects, Egyptian scarabs and Syrian cylinder seals. Another temple at Deir Alla was built on top of an 8 m.-high artificial platform.

Sea Peoples and Israelites

The Late Bronze Age came to an end about 1200 BC, when many of the Near Eastern and Mediterranean kingdoms collapsed. The principal towns of Mycenaean Greece and Cyprus, of the Hittites in

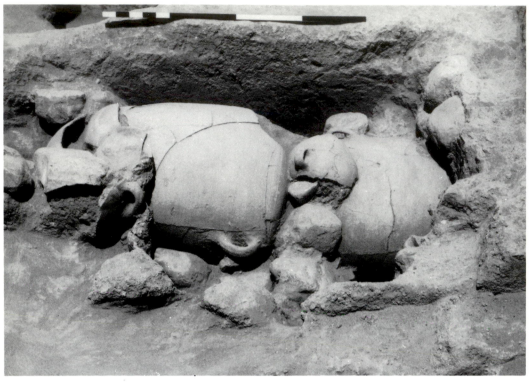

7. 'Double pithos' burial from Tell es-Sa'idiyeh. The deceased was buried inside two large jars joined shoulder to shoulder. Late Bronze Age

Anatolia and of Late Bronze Age Syria, Palestine and Jordan were destroyed. A major cause of the destructions may have been the Sea Peoples. They were marauders, probably from the Aegean and Anatolia, who were eventually defeated by the Egyptian pharaohs Merenptah and Ramesses III.

One group of Sea Peoples were the Philistines, who subsequently settled on the coast of southern Palestine (and gave Palestine its name). Their battles against the Israelites are recorded in the Old Testament.

The Israelites may have been another cause of the Late Bronze Age destructions in Palestine. The Old Testament records their exodus from Egypt under Moses and conquest of Canaan under Joshua. The Israelites destroyed many Canaanite towns, notably Jericho, Ai and Hazor, although archaeological evidence does not always agree with the biblical narrative. The conventional date for the conquest is *c.* 1230 BC.

Archaeological opinion is still divided over interpretation of the conquest story. Some scholars largely accept the Old Testament version. Others argue that the evidence suggests a more complex process, whereby different tribes came into possession of the land at different times and in different ways.

One of the issues frequently debated is the problem of Edom (the area of Jordan south of the Dead Sea). The Book of Numbers records that the Israelites coming from Egypt found Edom a fully organised state. They wrote to the king of Edom for permission to pass through his country peacefully. They were refused, and told they would be attacked if they tried to pass.

However, no Edomite settlements have yet been identified before the end of the 8th century BC. Edom as a state certainly did not exist as early as *c.* 1200 BC, when the conquest narrative is set. Defenders of the biblical version argue that the king of Edom may have been no more than a beduin sheikh, and that his 'kingdom' would have left no identifiable remains for archaeologists to find.

After the Israelite conquest, a united kingdom of Israel arose about 1000 BC with Saul and David as its first kings. After the death of David's son and successor Solomon, the kingdom divided into two, Israel in the north and Judah in the south.

The Iron Age Kingdoms of Ammon, Moab and Edom

Following the end of the Late Bronze Age in Jordan, three new kingdoms arose: Edom in the south, Moab in central Jordan, and Ammon in the northern mountain areas (Plate 9). To the north was the Aramaean kingdom with its capital in Damascus.

For the first time in Jordan's history larger kingdoms developed, rather than individual 'city-states'. One explanation for the rise of these local kingdoms may be the growing importance of the trade route from Arabia. This ran through Amman and Damascus up to northern Syria. Among the goods traded were gold, spices and precious metals. Assyrian interest in the copper mines of Feinan, the largest source of copper in the area, was probably another factor in the rise of Edom.

The wealth of these kingdoms made them targets for raids and even conquest by the Israelites, Aramaeans and Assyrians. The kingdom of Assyria, with its traditional capital at Ashur, was located in northern Mesopotamia. From the 9th century BC on, its kings campaigned to the west against the Aramaeans. Eventually they reached the Mediterranean Sea and even briefly invaded Egypt.

The Assyrian king Tiglathpileser III (744–727 BC) created a huge empire split into provinces ruled by Assyrian governors. He captured Damascus in 732 BC and Samaria, the capital of the northern kingdom of Israel, fell to Assyria in 721 BC (Plate 10). Ammon, Moab and Edom retained their independence by buying the Assyrians off with tribute, and enjoyed a period of relative prosperity.

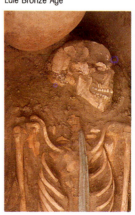

8. This skeleton of a man from Tell es-Sa'idiyeh shows distortion of the bones due to the tightness of the wrapping of the body. The bronze javelin head on his chest preserved the imprint of two cloths, indicating that it had been placed on the cloth-wrapped body and then covered with a burial shroud. Late Bronze Age

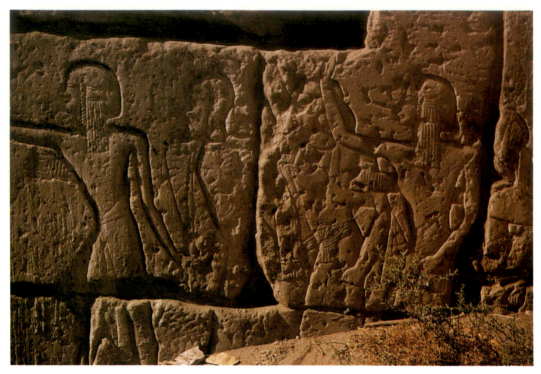

9. Two Egyptian princes leading two Moabite prisoners to the pharaoh, after the plunder of Butartu in Moab. 13th century BC. Luxor Temple, Egypt: Court of Ramesses II, East Wall (exterior)

The capital of Edom was Bozrah, the modern site of Buseirah. This was a substantial administrative centre fortified by a town wall. The city was divided into Upper and Lower Towns by an enclosure wall. The Upper Town consisted of an 'Acropolis' with public buildings built on a high artificial platform. The earlier, probably 7th-century BC, building on the 'Acropolis' had an imposing entrance off a plastered courtyard, with steps flanked by plinths forming the bases of two columns, the whole complex suggestive of a temple. The later 'Winged Building', so-called because of the outward curving of its edges, resembles Assyrian 'courtyard' buildings, although it may date as late as the Persian period. In the Lower Town were ordinary domestic buildings surrounding the 'Acropolis'. Rabbath Ammon and Dhiban, the capitals of Ammon and Moab, were also surrounded by thick stone walls. Watch-towers protected the approaches to all three kingdoms.

We know little of the religions of these kingdoms. One text of the 8th century BC from Deir Alla tells us something of the Ammonite religion. There was a pantheon headed by a goddess. A prophet transmitted the will of the gods to the people. The text refers to the prophet Balaam, whose prophecies accompanied fertility rituals performed by priests (see p. 144).

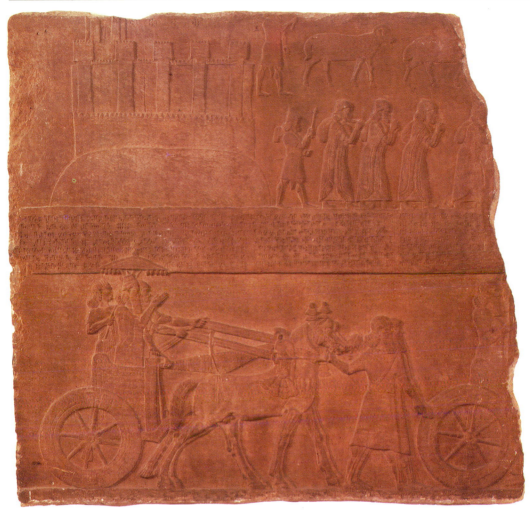

10. The capture of the town of Astartu (Ashteroth Qaranim in northern Jordan) by the Assyrian king Tiglathpileser III (744–727 BC), depicted on a relief from Nimrud in Iraq. British Museum

The Assyrian Empire ended with the fall of Nineveh in 612 BC to an alliance of Medes from Persia and the Chaldaean kings of Babylonia. In its place arose the Babylonian Empire. Nebuchadrezzar II of Babylon destroyed Jerusalem in 587 BC and deported thousands of inhabitants of Judah to Babylonia. The Jewish prophets cursed Ammon, Moab and Edom for rejoicing in the destruction of Jerusalem. The Book of Esdras even accuses the Edomites of burning the temple in Jerusalem.

The Persian Empire

In 539 BC Babylon fell without resistance to the Persian ruler Cyrus. The Persian Empire became the largest yet known in the

Near East. The successors of Cyrus conquered Egypt, northern India, Asia Minor (modern Turkey), and frequently came into conflict with the Greek states of Sparta and Athens.

Jordan and Palestine came under the control of a Persian satrap with subordinate governors. Cyrus freed the Jews from captivity in Babylonia and gave them permission to rebuild the temple in Jerusalem.

In Ammon the Persians appointed Tobiah as governor. In the biblical Book of Nehemiah, written in the 5th century BC, 'Tobiah the servant, the Ammonite' is mentioned as one of the 'governors beyond the river', i.e. west of the Euphrates. The Bible records that Tobiah used his power to hinder the rebuilding of Solomon's temple in Jerusalem.

The Edomites probably settled west of the Wadi Arabah in southern Palestine at this time, in the area later known as Idumaea. The Ammonites and Moabites frequently fought among themselves. The site of Tell Mazar in the territory of Ammon, though first constructed in the 8th century BC, was often destroyed and rebuilt until the 4th century BC. The houses of the 5th century BC at Tell Mazar, with rooms around a central courtyard, may have been used for 'private industry', with finds of domestic utensils and industrial artefacts. During the late Persian occupation of the site in the 4th century BC, dozens of deep pits and silos were built for grain storage, perhaps as security against famine or to support an army.

Economic decline, revolts, murders and harem conspiracies weakened the Persian throne. The capital Persepolis (in modern Iran) fell to Alexander the Great in April 330 BC.

The Hellenistic Period

With the conquest of Alexander, Jordan became part of the Greek world. Following Alexander's death, his generals struggled over control of the Near East for more than two decades. Eventually, Jordan came under the rule of the Ptolemies from Egypt (*c.* 301–198 BC) and then the Seleucids from Syria (*c.* 198–63 BC). The Seleucid kingdom came to an end when the Roman general Pompey conquered Syria in 63 BC.

The Greeks founded new Hellenistic cities in Jordan, such as Umm Qais, and renamed others, such as Amman (Philadelphia) and Jerash (Antioch). They established Greek as the official language, although Aramaic remained as a spoken language (see p. 145).

The finest Hellenistic site in Jordan is Iraq el-Amir, west of Amman. This was the estate of the influential Tobiad family, one of whom had been a Persian governor. The Qasr el-Abd ('the Castle of the Slave') at Iraq el-Amir is constructed of very large blocks of stone,

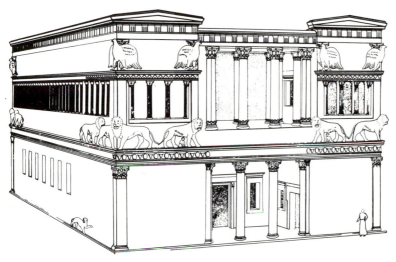

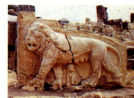

11. Reconstruction of the Qasr el-Abd at Iraq el-Amir, 2nd century BC, and one of its lion reliefs

some of which carry fine sculpted figures of lions and eagles (Plate 11). The building is rectangular, with traces of corner towers, and has two storeys, both subdivided into rooms and corridors. The Qasr is surrounded by an artificial moat. The structure was perhaps a temple or a palace, built in about 187–175 BC.

The Nabataeans and Petra

During the Hellenistic period a new Arabic-speaking people known as the Nabataeans were settling near Petra in southern Jordan.

The Nabataeans were originally nomadic herdsmen and merchants from Arabia, who came to control the major trade routes between Arabia and Damascus (see pp. 51 ff.). They traded with China, India, the Far East, Egypt, Syria, Greece and Rome. The materials they handled included animals, spices, incense, iron, copper, fabrics, sugar, medicines, perfumes, gold and ivory. They even sold bitumen from the Dead Sea to the Egyptians for use in mummification.

The Nabataeans were also great water engineers, and irrigated their land with ingenious systems of dams and canals. Nabataea reached the peak of its prosperity under King Aretas IV (9 BC–AD 40). Aretas built far-flung settlements along the caravan routes to develop the prosperous incense trade.

The finest Nabataean architecture is found at Petra, Khirbet et-Tannur, Wadi Rum and Lehun in Jordan, and at Medain Saleh in Saudi Arabia. Other Nabataean cities were built in the Negev desert in Palestine, for instance at Oboda and Mampsis.

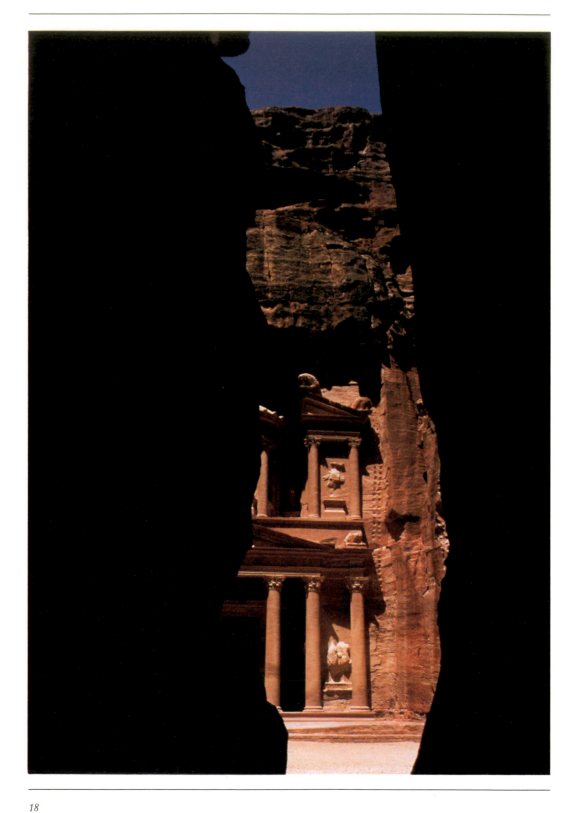

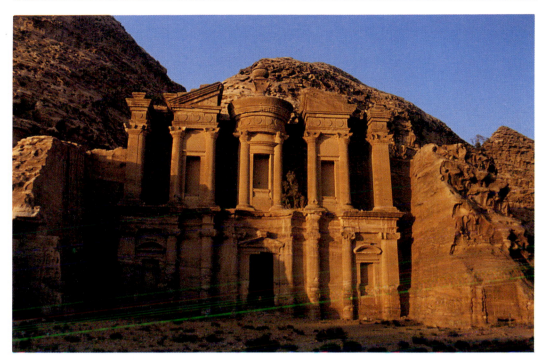

13. Petra: the Deir (Monastery), probably 1st century AD. The Deir appears to be a *triclinium*, where funeral feasts or *symposia* in honour of a god took place, as the edge of a bench is still visible in the single chamber

The capital of the Nabataeans was Petra, immortalised by Dean J.W. Burgon's poem as the 'rose-red city half as old as Time' (see Plates 12–15). However, Petra was first settled long before the Nabataeans, in the prehistoric periods. There is evidence of Palaeolithic occupation, and during the Pre-Pottery Neolithic period there was a village at nearby Beidha. An Early Bronze Age settlement at es-Sadeh within Petra consisted of twenty-five houses with rooms supported by pillars. During the Iron Age the Edomites lived on mountain tops inside Petra, at Umm el-Biyara, Baja and es-Sadeh. At Umm el-Biyara, the dry-stone houses had long corridor rooms with small square rooms leading off. The occupation was evidently domestic, judging from the quantity of spindle whorls, the remains of weaving.

Nabataean Petra was fortified by a city wall, although the city was almost naturally defended by the surrounding sandstone mountains. The classical writer Strabo writes that Petra had magnificent houses and flower gardens.

12. Petra: El Khasneh (the Treasury) from the end of the Siq. Originally perhaps a temple, this was the earliest of the classical rock-cut façades to be built at Petra, probably in the 1st century BC. Inside is one central chamber with small rooms in the back wall and on either side of the portico

Petra is famous for its rock-cut façades, with crowstep ornamentation and angular capitals. The rock-cut monuments consisted of tombs, *triclinia* (where ritual funerary feasts were held) and ordinary houses. There were a theatre, baths, and temples dedicated to the Nabataean gods Dushara and Allat. The main street was lined with shops, houses and a market-place.

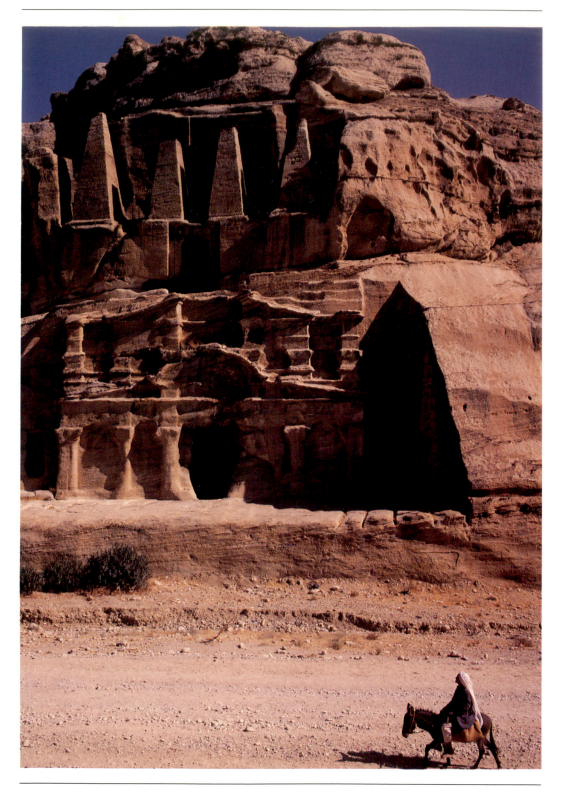

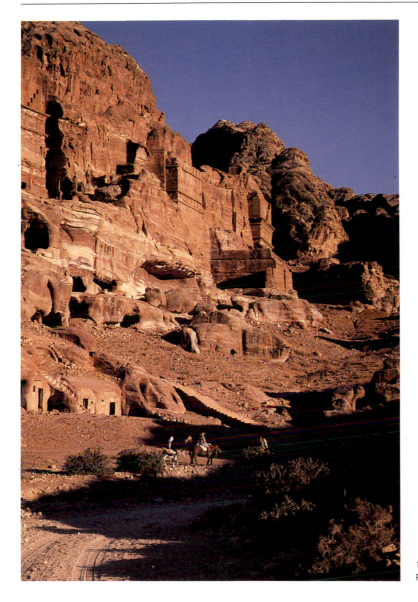

15. Rock-cut façades inside Petra

The Romans conquered Petra in AD 106, but it appears to have flourished under their rule. In the Christian period some of the Nabataean tombs were converted into churches or houses. Later the Crusaders built two castles there. Following the Crusades all knowledge of Petra was lost to the western world. It was rediscovered in 1812 by the Swiss explorer Jean Louis Burckhardt, who bluffed his way inside disguised as a Muslim pilgrim.

The temple at Khirbet et-Tannur is generally regarded as the best example and probably the archetype of Nabataean cultic

14. Petra: the Obelisk tomb, dated by an inscription probably to the reign of Malichus II (AD 40/44–70). Inside is a single chamber, with five graves set in the walls. Below it is the Bab el-Siq *triclinium*, used as a funerary banqueting-hall to commemorate the dead

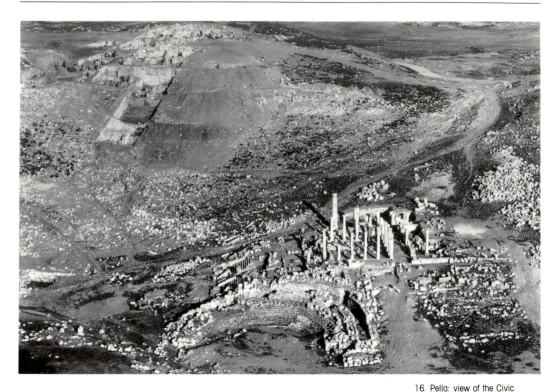

16. Pella: view of the Civic Complex and the East Cut on the ancient mound. The small theatre (*odeion*), with seating for four hundred, dates to the end of the 1st century AD. The Byzantine church, with a monumental staircase, originally dates to about AD 400

architecture. It was built on a high, isolated hill overlooking the Wadi Hesa in the 1st centuries BC and AD. In the elevated, square sanctuary area stood a central altar, a square podium about 2 m. high, containing in a niche the statues of the deities, probably Atargatis and Dushara. There was an outer forecourt, with surrounding rooms and provision for religious banquets and possibly a sacred pool. The whole temple was richly adorned with carving and sculpture (see p. 56).

Roman Province

The Roman general Pompey conquered Syria and Palestine in 64/3 BC. In Jordan the Greek cities in the north, such as Philadelphia (Amman), Pella (Fahil), Gadara (Umm Qais) and Gerasa (Jerash), created a loose federation called the Decapolis (Plate 16). In southern Jordan, the Nabataeans remained independent until AD 106 when they were annexed by the emperor Trajan. All of Jordan then became part of the Roman province of Arabia, except for the Arabic-speaking Thamudic and Safaitic tribes in the eastern desert (see p. 145).

The Romans built new roads, forts, camps and watch-towers. Amman, Jerash and Umm Qais were laid out with colonnaded

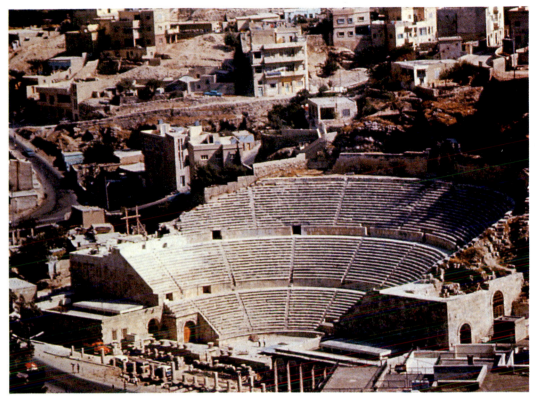

17. The Roman theatre in Amman, which accommodated an audience of six thousand

streets and provided with theatres (Plates 17–19). Latin became an official language, although Greek remained the main spoken language among the educated. Roman religion was introduced, with temples at Jerash and Amman (Plates 18, 20).

Jerash was a typical Roman provincial city, and is probably the best preserved in the Near East (Plates 18–20). It is situated north of Amman in a well-watered area of hills and forests. It had been inhabited since the Bronze Age. According to an ancient tradition the city was founded by Alexander the Great, but present archaeological evidence suggests that it dates only from the 2nd century BC.

The city of Jerash was probably originally planned and designed by Roman architects, but was added to over a period of several centuries. Among its monuments were theatres, a bath, a gymnasium, colonnaded streets, and temples to Zeus and Artemis. Its golden age was in the 2nd and 3rd centuries AD, especially following the visit of the emperor Hadrian in AD 130.

Christians built a cathedral and churches in Jerash during the Byzantine era. Every year in the cathedral they celebrated a repetition of the miracle of Cana, when Jesus turned water into wine. In spite of several earthquakes, Jerash remained an important

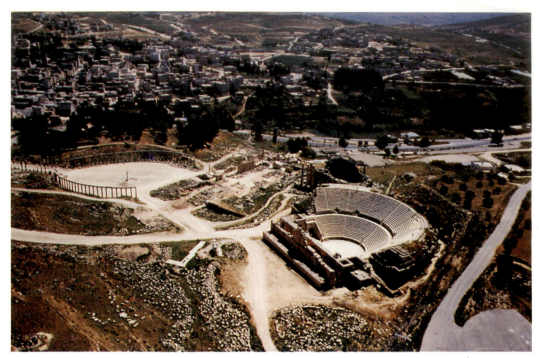

18. Jerash: the South Theatre, Temple of Zeus, Oval Piazza and Colonnaded Street

centre during the early Islamic period. The population was both Muslim and Christian, and churches continued to function. Jerash was finally abandoned at the end of the 8th century AD, although a small farming community re-occupied the ruined site of the Temple of Zeus in the Middle Ages.

The Byzantine Period

The Byzantine period dates from the year AD 324, when the emperor Constantine I founded Constantinople (modern Istanbul in Turkey) as the eastern counterpart to Rome.

Constantine was a convert to Christianity, but the first Christian community in Jordan arrived much earlier. In AD 66 the city of Pella had received fugitives from Jerusalem during the Jewish revolt against Rome. Christianity in Jordan developed slowly, accompanied by a rise in prosperity and a population explosion. All of the major cities of the Roman period continued to flourish during the Byzantine period.

Eventually, Jordan was covered with churches, especially under the emperor Justinian (AD 527–65). In the struggle between Christianity and paganism many temples were destroyed or converted into churches. Most new churches were of basilica type, with semi-circular apses to the east. Towns often had several

19. The South Theatre at Jerash, with a seating capacity of three thousand

churches, usually small and privately owned, which served only the residents of one quarter.

Many of the churches had ornate mosaic floors, with pictures of animals, people and towns. The most impressive Byzantine mosaic in Jordan is the famous map of the Holy Land, in Madaba (see p. 117).

Jordan suffered severe depopulation in the 6th and 7th centuries AD, perhaps linked to the plague of AD 542. Another cause may have been the invasion in AD 614 by the Sassanians, who had ruled Persia and Iraq since the early 3rd century AD. The Sassanians occupied Jordan, Palestine and Syria for fifteen years, but in AD 629 the Byzantine emperor Heraclius managed to recover the area.

In AD 630 came the first attack by Muslim tribes from Arabia led by the Prophet Muhammad. In AD 636 the Muslims defeated the Byzantine armies at a great battle on the Yarmuk River, which runs into the Jordan River south of the Sea of Galilee.

20. Jerash: the Temple of Artemis, patron goddess of the city. The temple was surrounded by courtyards, monumental gates and stairways, the whole dating to the mid-2nd century AD

The Islamic Periods and the Crusades

After Jordan fell to Islam, there was a brief period of Arab rule before the establishment of the Umayyad dynasty in Damascus in AD 661. During the Umayyad period (AD 661–750) Jordan continued to prosper, as it was close to the capital and was on the pilgrimage route to Mecca. It was at this time that the area east of the Jordan river acquired its present name, el-Urdun.

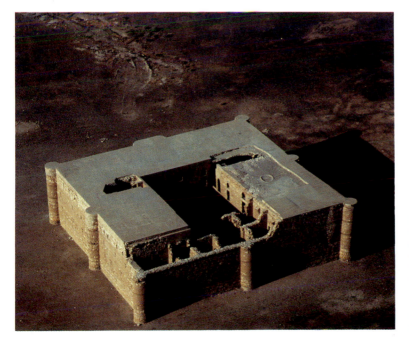

21. Qasr el-Kharana. The only entrance is on the south side. Inside are two storeys, with a courtyard in the centre, and stables and rooms constructed with arches and vaults. All the rooms were originally plastered and often carved with decorative patterns

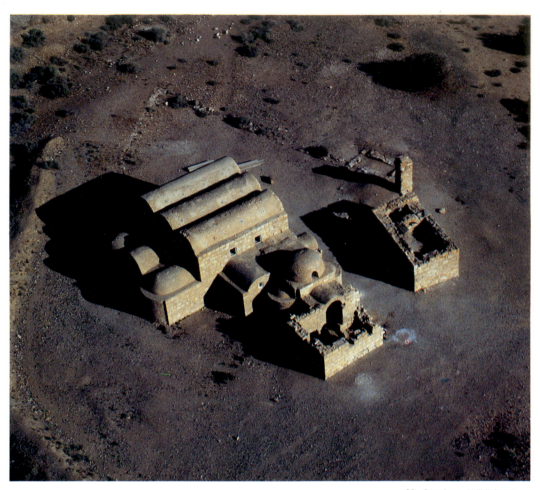

22. Qasr Amra, built between AD 705 and 715. All that remains now is an audience-hall roofed with three vaults, and a bath-house with *calidarium* or hot-room and underfloor hypocaust heating. All the walls inside were covered with fine frescoes of hunting scenes, musicians, dancers, bathers, and the enemies of Islam

Arabic gradually replaced Greek as the main language, and Islam replaced Christianity as the major religion. Nevertheless, the Muslim conquest did not cause widespread destruction or persecution, and Christianity was still practised. Churches continued to be built and repaired until the late 8th century.

The major Byzantine sites in Jordan – Amman, Jerash, Umm el-Jimal, Umm Qais and Pella – were occupied into the Umayyad period. The Umayyad caliphs built a number of castles in the desert, at Mashatta, Kharana, Qastal, Tuba, Amra and elsewhere (Plates 21–3). These were once thought to be simply hunting lodges, but it is now known that they were political, administrative and agricultural centres to control and use the desert.

The archaeology of Jordan during the following Abbasid period (AD 750–969) is currently being reassessed. An earthquake in AD 747, once thought to have caused major upheaval at the end of the

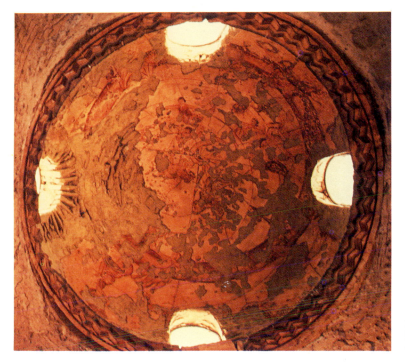

23. Qasr Amra: the fresco in
the dome of the *calidarium*,
representing the night sky

Umayyad period, now seems less significant since settlement
continued into the Abbasid period at most affected sites, such as
Pella and Umm Qais. When the Abbasids transferred the capital to
Baghdad the desert castles were abandoned, and the major Abbasid
buildings were now located in northern Syria, on the route from
Baghdad to the Mediterranean. However, recent surveys and
excavations have shown that the population of Jordan increased, at
least until the beginning of the 9th century.

In AD 969 the Fatimids of Egypt took the area and held it on and
off until 1171. The Crusaders from Europe invaded Palestine and
Jordan in 1099 with the intention of recovering the Holy Places
from Muslim occupation, and established the Kingdom of
Jerusalem. Between 1099 and 1187 they built several castles in
southern Jordan, at Kerak, Shobak and Petra (Plates 24, 25). In the
north the Arabs built castles at Ajlun, overlooking the Jordan
Valley, and Salt, on the road to Jerusalem (Plate 26).

Saladin, the Kurdish founder of the Ayyubid dynasty, defeated
the Crusaders at the Battle of Hattin in 1187. From that time Jordan
was again in Arab hands. The Crusaders remained in Palestine until
1291, when they were finally expelled by the Mamluk ruler
Baybars. The Mamluks were slave soldiers, originally from
Central Asia and the Caucasus, who seized power and ruled Egypt
and Syria from their capital in Cairo.

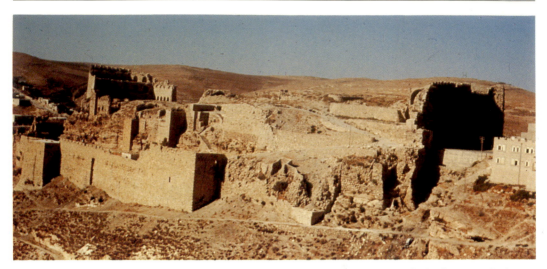

24. The Crusader castle at
Kerak, built in 1142, was
separated from the town by a
deep dry-moat. Prisoners were
hurled from the battlements
with a wooden box around
their heads so as not to be
knocked unconscious before
they reached the bottom

The defeat of the Crusaders and the unification of Egypt and Syria under the Ayyubids and Mamluks led to a short period of prosperity. Jordan was now in a key position between Egypt and Syria. Castles were rebuilt and caravanserais, like the fort at Aqaba, were constructed to help pilgrims and encourage trade and communications. Sugar was widely produced and processed at water-driven mills in the Jordan Valley and near the Dead Sea.

Mongol invasions, weak government and a series of plagues led to renewed decline. In 1516 the Mamluks were defeated by the Ottoman Turks. Jordan became part of the Ottoman Empire, with its capital at Istanbul, and remained so until 1918.

Jordan was of interest to the Ottoman Turks mainly because the pilgrim route to Mecca passed through it. The Ottomans built a series of square forts along the line of the route to protect pilgrims from the desert tribes and provide sources of food and water. But the Ottoman administration was weak and could not control the beduin tribes. Families and tribes moved frequently from one village to another. Agriculture declined, and many of Jordan's villages and towns were abandoned.

Settlements began to increase again only in the late 19th century. People from Syria and Palestine migrated into Jordan to escape over-taxation and blood feuds. Muslim Circassians and Chechens fled persecution in Russia and settled in Jordan, Syria, Iraq and Turkey.

During the First World War Ottoman Turkey fought on the side of Germany. On 1 October 1918 an Arab army entered Damascus and ended Ottoman rule. With the accession of the Hashemite family Jordan for the first time in its history became an independent and united country under its own king and government.

25. Vaulted room inside Kerak Castle, typical of Crusader building

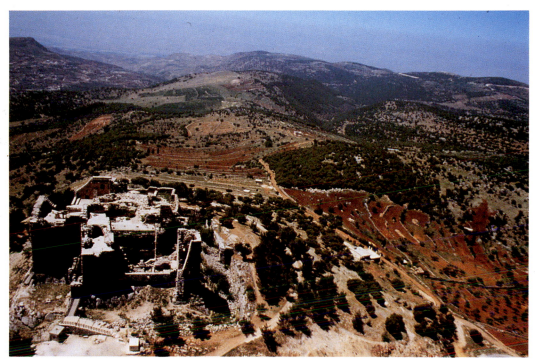

26. Ajlun castle (Qala'at al-Rabadh), built by the Arabs in 1184/5 as a defence against the Crusaders, and subsequently altered and enlarged. In the 13th century it became an administrative and storage centre responsible to Damascus

Further reading

J.R. Bartlett, *Edom and the Edomites*. Sheffield Academic Press/ Palestine Exploration Fund 1989.

I. Browning, *Jerash*. Chatto and Windus, London 1982.

I. Browning, *Petra*, 3rd edition. Chatto and Windus, London 1989.

R.H. Dornemann, *The Archaeology of the Transjordan in the Bronze and Iron Ages*. Milwaukee Public Museum 1983.

A.N. Garrard and H.G. Gebel, eds., *The Prehistory of Jordan*. British Archaeological Reports International Series 396, 1988.

P. Gubser, *Jordan: Crossroads of Middle Eastern Events*. Croom Helm, London 1983.

D. Homès-Fredericq and J.B. Hennessy, eds., *Archaeology of Jordan* I & II. Peeters, Leuven 1986 & 1989.

K.M. Kenyon, *Archaeology in the Holy Land*, 4th edition. Benn Norton 1979.

G. Lankester Harding, *The Antiquities of Jordan*. Lutterworth Press, London 1959/1967.

D.J. Wiseman, ed., *Peoples of Old Testament Times*. Oxford University Press 1973.

Sculpture in Ancient Jordan

The Neolithic to Bronze Age Periods

Jordan is situated on an important ancient communications route, the 'King's Highway', and was an intermediary between the great civilisations of the Middle East. However, this small country was not content to be a mere passageway for caravan routes. The craftsman of the Transjordanian plateau, who maintained contacts with his colleagues in Mesopotamia and Syria, and especially with his immediate neighbours in Canaan (Palestine), has demonstrated his independence and creative spirit since Neolithic times.

The site of Ain Ghazal has been revealed as a major centre of production of art from the Pre-Pottery Neolithic period, larger and more significant than its contemporaries, Jericho on the West Bank of the Jordan, and Beidha to the north of Petra. The town-planning evident at Ain Ghazal is no doubt proof of a well-structured social organisation, similar to that which created the defences at Jericho.

The delicacy of the Ain Ghazal artist is expressed in a dazzling way by the plaster statues, found in three caches (Plate 27): they represent several dozen people, modelled in plaster on a skeleton of reeds, from 40 to 80 cm. in height, and deposited together in three *favissae*, probably because they represented objects of a deconsecrated cult. This practice of burying objects formerly of cultic significance is well known in the Graeco-Roman and earlier historic periods. It indicates that the statues were the objects of veneration in private or public sanctuaries.

The statue known as 'Uriah' (Plate 28) was found in 1983 with several others in a cache. It is made of plaster modelled on a base of reeds or rushes which originally took up three-quarters of the body. The head, with its simple and expressive details, is on a long straight neck. On the top the hair may be indicated. A large nose with slashed nostrils overhangs a small mouth of which only the upper lip has been well modelled. The two pierced protruding lugs which correspond to the ears accentuate the eye openings. These are a dazzling white, encircled with bitumen and with black pupils, and seem to fix the viewer with a penetrating gaze. Having painted

27. Cache of plaster statues as discovered at Ain Ghazal. Pre-Pottery Neolithic B, *c.* 7500–5500 BC

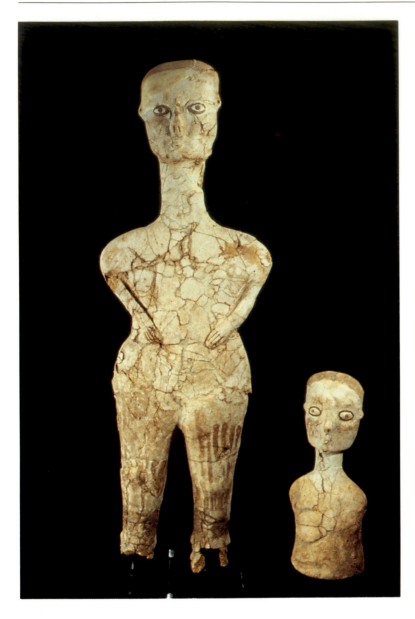

28. Pre-Pottery Neolithic B plaster statues from Ain Ghazal, known as 'Zeina' and 'Uriah'. *c.* 7500–5500 BC. Height: 84 cm. and 32.4 cm. Amman Archaeological Museum

the cheeks matt orange, the artist decorated the flattened top of the head in black, which contrasts with the white chalk base of the rest of the face. The arms are crossed on a bust with wide shoulders, suggesting an attitude of prayer.

'Zeina' (Plate 28), also in plaster on a reed frame, stands on two squat legs. Apparently the framework extended to the legs and helped to keep the statue standing. A white slip was applied to most of the face and the neck, while an orange colour applied by finger in

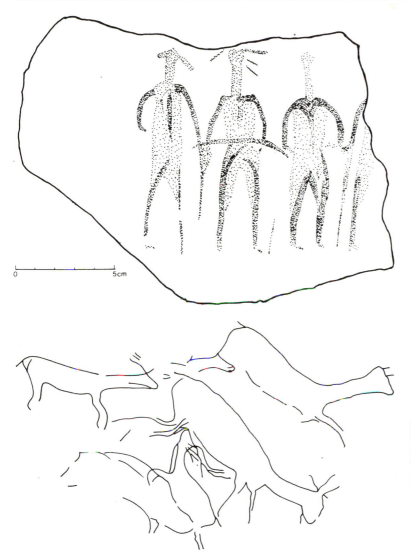

0 5cm

29. Basalt rock carvings from Dhuweila, a seasonal campsite in the eastern desert, dating to Pre-Pottery Neolithic B. One stone has outlines of several horned animals, while the other shows human figures standing in a line – the hunted and the hunters? *c.* 7500–5500 BC. Ashmolean Museum, Oxford

vertical lines is preserved on the left leg. Black paint was applied to the legs above the ankles, front and back. It perhaps suggests gaiters or goatskin trousers. In contrast to 'Uriah', the arms and hands are well modelled but are rather small in proportion to the body. Although the large hips and the fine curves suggest a female, no sexual details have been added. This neutrality may be intentional if the statue symbolises a divine 'ancestor'.

The artist succeeded in animating his creations with a discrete and silent breath of life with schematised but exact modelling of facial features, and above all the protruding eyes, which seem to fix directly upon the spectator. We know from the later Nabataean

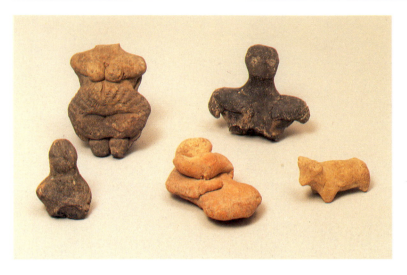

30. Human and animal
terracotta figurines from Ain
Ghazal. Pre-Pottery Neolithic B,
c. 7500–5500 BC. Amman
Archaeological Museum

idols how symbolic the eye was in the Orient. In the case of the Ain
Ghazal statues it is a sign of life and at the same time a protection
against evil. To accentuate the realism of his work, the artist has
coloured Uriah's cheeks orange. For Zeina he probably wanted to
suggest the veins on the legs by red lines and gaiters with a black
colour above the ankles.

Numerous human and animal figurines, modelled in clay or a
mixture of plaster and ash, have been recovered from Ain Ghazal,
and are probably of cultic significance (Plates 30, 31).
Unfortunately they are badly preserved, as they were hardly baked.
However, some show significant features: one small figurine (Plate
30, top left) is expressive since it represents an Astarte with
exaggerated female features, the pelvis and the rump being
disproportionate with regard to the rest of the body, and the breasts
exaggerated. It would appear to be a fecundity idol of a type
widespread in the Orient from Syria to Iran.

31. Animal terracotta figurines
from Ain Ghazal. Pre-Pottery
Neolithic B, *c*. 7500–5500 BC.
Amman Archaeological
Museum

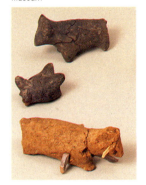

The figurine in Plate 30 (centre) is very distinctive. It is modelled
in fine red clay, well fired, and represents a seated person, holding
his face in his left arm while the right rests on his lap. Because of his
attitude he has been called 'Rodin's *Thinker*'. However, it is likely
that this is an attitude of distress and affliction. Compare for
example the attitude of Isis in mourning (Plate 59) who supports
her head on her right hand, while the left rests on her knees.

The animal figurines, modelled in poorly-fired clay, are difficult
to identify. The aim of the artist is probably not to represent a
particular animal, but simply animal types in general, as the wild
goat and gazelle which are well attested at Ain Ghazal are not
represented. The shape of the animals suggests sheep, which do not
appear to have been domesticated in the 8th and 7th millennia BC.

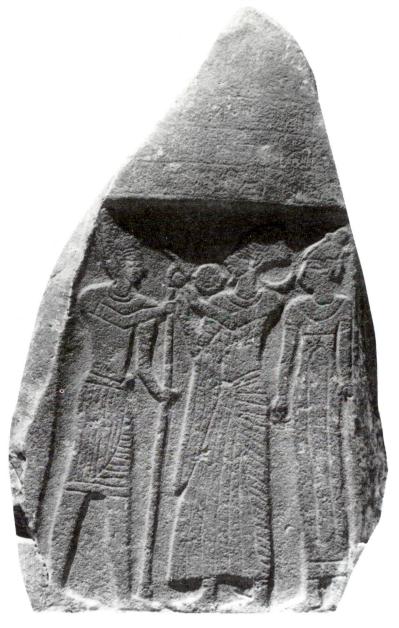

32. Anthropomorphic figurine in limestone from Abu Hamid. Chalcolithic, c. 3800–3700 BC. Height: 9.3 cm. Department of Antiquities, Yarmuk University

33. Stela from Balu'a, north of Kerak. Three figures carved in relief in local imitation of the Egyptian style may show a god giving a local king the sceptre of his rule, while a goddess watches. 13th–12th centuries BC. Amman Archaeological Museum

The dog, by contrast, was, but no figurines have been recovered which resemble this animal. This collection of animals is thus probably related to hunting practices, as is suggested by one figurine (Plate 31, second from bottom). This represents an indeterminate quadruped, probably a species of sheep, pierced through with three splinters of flint, one in the head and two in the forequarters. This is likely to represent the practice of ritual killing:

34. Moabite stela in basalt from Rujm el-Abd, at the foot of Jebel Shihân. This represents a warrior god, similar to representations of the god Baal from Ras Shamra-Ugarit in northern Syria. He holds a spear, and behind him appears an animal standing on the ground, head turned towards the god. 13th–12th centuries BC. Height: 103 cm. Louvre, AO 5055

by piercing the figure of an animal with arrows the hunter magically anticipates his catch. Similar rites are known from prehistoric periods in Europe, especially in the caves of Lascaux and Altamira where animals were painted with pikes in their bodies.

35. Anthropoid sarcophagus lid from Sahab Tomb A. The three loop handles — the two lateral ones representing the ears — were used to attach the lid. The beard, similar to that on representations of Osiris, the Egyptian god of the underworld, is also looped and could have served the same purpose. The features of the face are well-modelled. The eyes are closed, in the form of two globular protruberances, and suggest the sleep of death. Probably 10th century BC. Height: 44 cm. Amman Archaeological Museum

The hunter-gatherers of the Neolithic were succeeded in the 5th and 4th millennia BC by the agriculturalists and pastoralists of the Chalcolithic period. One common type of Chalcolithic figurine presents a very schematic human form when compared to the figurines from Pre-Pottery Neolithic Ain Ghazal (Plate 32). No trace of a face is visible and the arms and legs have been reduced to triangular stumps. This type of violin-shaped figure is well-known at Chalcolithic Teleilat Ghassul.

Little that can be called sculpture has been recovered from the Bronze Age. From the very end of the Late Bronze Age come two basalt stelae from Moab, both showing considerable Egyptian influence. One was found at Baluʿa, north of Kerak (Plate 33); it is possible that depicted here are Egyptian gods, perhaps Amun-Re and Hathor. The warrior god on the Shiḥân stela (Plate 34) has an Egyptian-style short loincloth, while his heavy hair style is extended by a braid which formed part of the headdress of Canaanite or Hittite gods in the Late Bronze Age. It is possible that both stelae originally came from the same place. They probably formed part of a sanctuary or were trophies of a Moabite king.

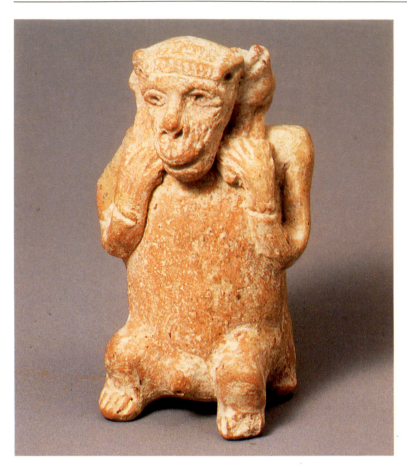

36. Terracotta figurine of a monkey carrying a lamb(?) on its shoulders, hands holding the legs. The eyes, below heavy eyebrows, were probably originally inlaid. The monkey was sacred to Thoth, the Egyptian god of wisdom and writing. Iron Age I, probably 11th–10th centuries BC. Height: 12 cm. Amman Archaeological Museum

Egyptian influence can also be seen in the anthropoid sarcophagus lid from Sahab (Plate 35). Several sarcophagi of similar type have been found in Egypt and Palestine, where they are generally attributed to the 'Sea Peoples', specifically the Philistines. The tombs from Tell el-Farʿah South, Lachish and Beth Shan in Palestine have yielded similar sarcophagi together with numerous Egyptian objects, suggesting an Egyptian influence on the owners. On the Transjordanian plateau sarcophagi of the same type have been discovered at Sahab, Amman and Dhiban and were probably produced under the influence of Egyptian craftsmen.

Ammonite Sculpture

The small kingdom of Ammon, which extended from the Zarqa River, the ancient Jabboq, to the region of Hesban in the plain of Madaba, enjoyed a reasonable amount of independence. Continuity of occupation had been attested on the Amman Citadel, the site

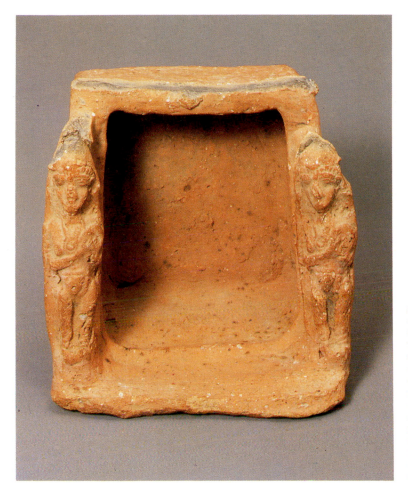

37. Terracotta model of a shrine, the entrance guarded by two naked women playing tambourines. The arms are crossed below the breasts. Between the breasts hang circular pendants. They probably represent hierodules of the cult of the goddess Astarte. The shrine, bought in Kerak, can be dated by parallels from other sites to Iron Age I, 11th–10th centuries BC. Height: 15 cm. Amman Archaeological Museum

of the ancient Rabbath Beni 'Ammon, since at least the 4th millennium BC. The glacis fortifications of the Middle Bronze Age and the rampart of the Iron Age prove that the capital had for a long time possessed a solid political organisation. Egyptian sources are unfortunately silent on the country of Ammon, the first references to an Ammonite king being in the Book of Judges 3:13 and 11:12–33 (c. 11th century BC). However, the early biblical traditions relating to Ammon and Moab are sometimes confused and perhaps lack a historical basis.

About 1030 BC King Nahash persecuted the people of Gad and Reuben who had infiltrated his country, and repulsed them. They were saved by the intervention of Saul. This same king was friendly with King David of Israel. He was succeeded by his sons Hanun and Shobi (2 Samuel 10:1–4, 17:27). No trace has yet appeared of these first Ammonite kings in inscriptions, and none of

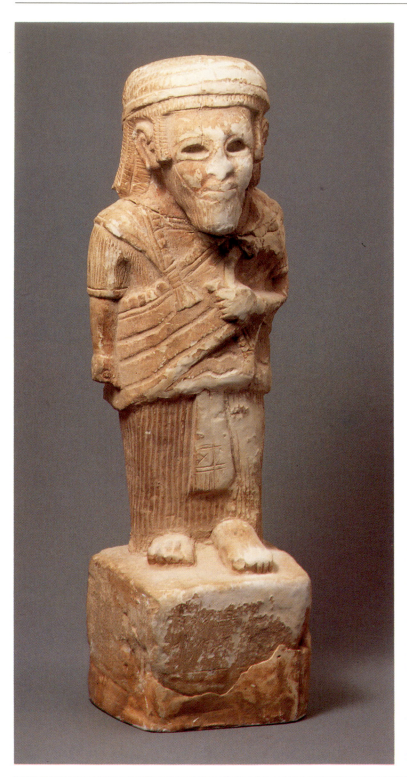

38. Statue of Yerah ´Azar. Limestone with trace of red slip, from Amman Citadel. The two-line inscription reads: 'Statue(?) of Yerah ´Azar, son of Zakir, son of Sanipu'. His pose, right arm by the side with fist clenched, left arm across the stomach holding a lotus flower, is a royal attribute. It is known from New Kingdom Egypt, Aramaean Syria, and was adopted by the Assyrian king Ashurbanipal (668–631 BC). The eyes were originally inlaid. Last quarter of 8th century BC. Height: 48 cm. Amman Archaeological Museum

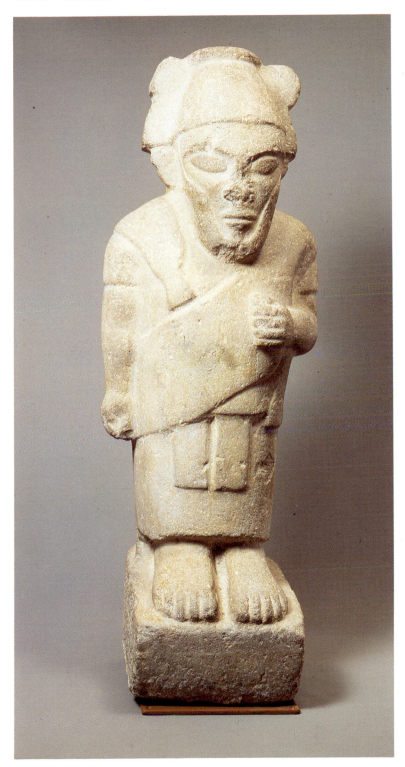

39. Standing figure. Hard grey stone, from Amman Citadel. The pose and attire are similar to those of Yerah ʿAzar (Plate 38), though more rigid. Mid-8th century BC. Height: 83 cm. Amman Archaeological Museum

40. Head with *atef* crown. Yellowish limestone with traces of ochre paint, from Amman Citadel. The right pupil is clearly marked, but the left one has worn away. Height: 25 cm. Amman Archaeological Museum

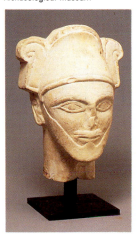

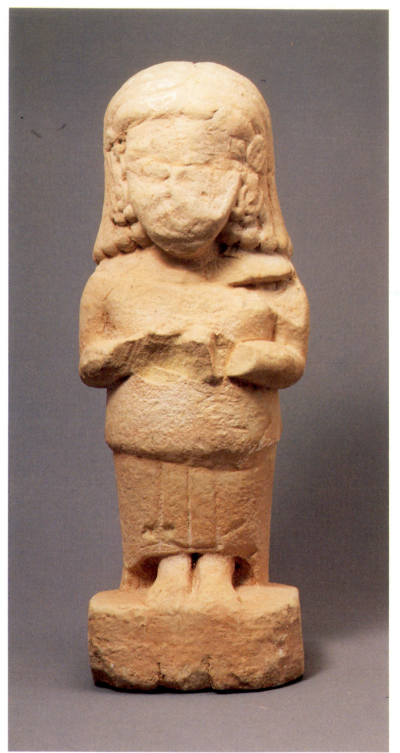

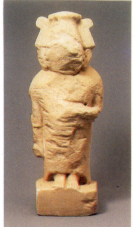

41. Statue. Yellowish limestone, from Khirbet el-Hajjar. The carving is rather crude: the head has no neck and the ears are disproportionately large. Details of the face and attire have worn away. It is possible that this statue, carved by a local sculptor, may be a poor and later imitation of the statue of Yerah ʿAzar (Plate 38). 8th century BC. Height: 51 cm. Amman Archaeological Museum

42. Female statue. Yellowish limestone, from Khirbet el-Hajjar. The long tunic leaves the bare feet uncovered. The ends of a belt can be seen below the smock. Unfortunately all the details of the face have worn away; only the right eye is preserved. The thick hairstyle falls into the nape of the neck in regular plaits. On the ears are ornate earrings formed of a double ring with three tassels. The arms folded on the stomach perhaps held an offering. Female statues are rare in Ammonite sculpture. This one together with Plate 41 may have formed a royal couple. Height: 47 cm. Amman Archaeological Museum

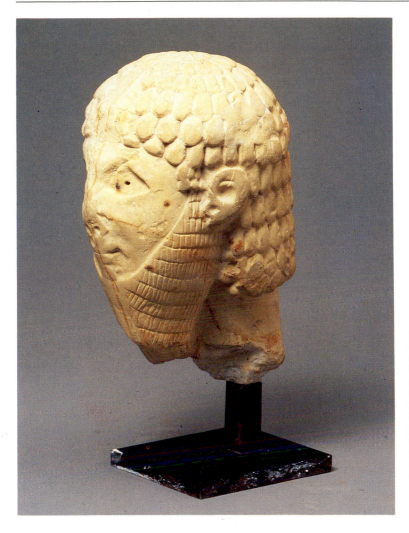

43. Male head. Limestone, from Amman Citadel. The thick hair is arranged in lozenge-shaped curls, covering the nape of the neck. The beard, recalling that of the Egyptian god Osiris, has been carved in wide, parallel bands at the top, but much narrower at the pointed tip. The almond-shaped eyes originally had inlaid pupils, while the thin-lipped mouth suggests a slight smile. Height: 20 cm. Amman Archaeological Museum

the numerous seals which have been found in the region dates before the 8th century BC (see pp. 141ff.).

We are on surer historical ground with the Assyrian kings who exercised hegemony over Syria-Palestine from the reign of Shalmaneser III (858–824 BC) on. King Ba'asha, son of Ruhubi of Beth Amana, joined a coalition which fought Shalmaneser III at Qarqar near Hamath in 853 BC. However, historians are uncertain whether this refers to an Ammonite king, Beth Amana possibly being a small kingdom in northern Syria or Lebanon. In 733 BC Tiglathpileser III invaded northern Palestine, Philistia and Transjordan in response to an appeal from King Ahaz of Judah, whose country was facing a coalition of Edom, Samaria and Damascus. The Ammonite king Sanipu submitted to the Assyrian

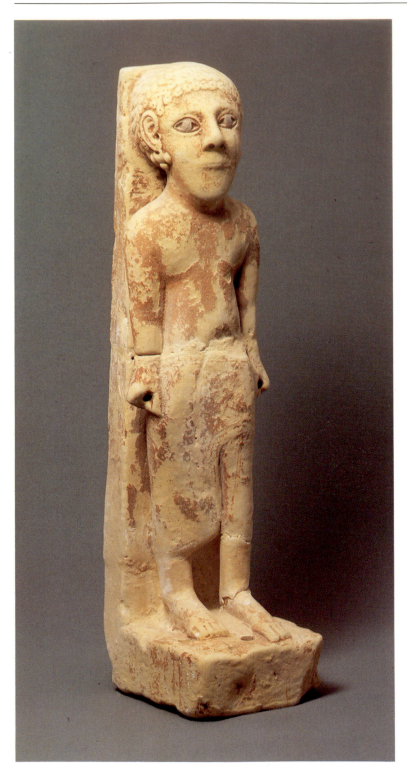

44. Male statue. Yellowish limestone with red, flaking paint, from Irjan. The figure wears a fringed loincloth which reveals the left leg. Both arms are held at the sides, and the hands probably originally held weapons. The stiff attitude and the tight mouth suggest the determination of a soldier. The hair and nose suggest that the man is of African origin. The large ears have crescent earrings with tassels. The eyes were originally inlaid. Height: 44 cm. Amman Archaeological Museum

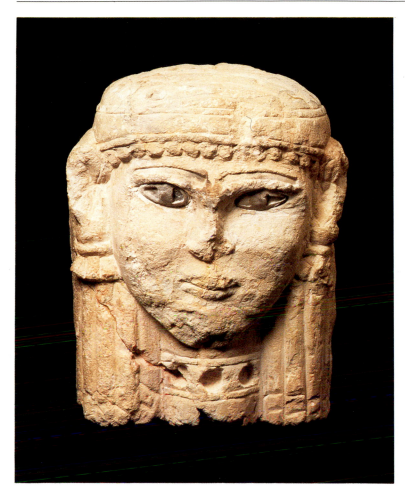

45. Double-faced female head. Soft limestone, from Amman Citadel. Some of the ivory inlay in the eyes still remains. On the reverse are engraved the Ammonite letters *b* and *s*, while on the eye of the face on the reverse is a sign resembling the Egyptian word *nfr*, encircled by two uraei. The three holes on the collar were probably originally intended for inlaid garment decoration or necklaces, possibly in ivory. 7th century BC. Height: 30 cm. Amman Archaeological Museum

46. Horserider with pointed helmet. Reddish clay with black and white paint, from the Meqabelein tomb. The rider has been modelled separately from his horse. The subtlety of the facial features suggests that his head was made in a mould. The beard and moustache have been painted black. The black and white bands on his body perhaps indicate that he is wearing armour. In his right hand he holds a riding crop which rests coiled on the horse's flank. It is possible that the rider, common in Cyprus in the same period, represents a god or a soldier. 7th century BC. Height: 12 cm. Amman Archaeological Museum

king. The same king is named on the statue of Yerah ʿAzar, son of Zakir, son of Sanipu (Plate 38). Next reigned Pudu-Ilu (*c.* 701–668 BC) under the Assyrian kings Sennacherib, Esarhaddon and Ashurbanipal. After him reigned Amminadab (*c.* 667 BC) under Ashurbanipal, then Hissal-El and Amminadab II, whose names are inscribed on the bottle from Tell Sirân (see p. 141). The last Ammonite king, Baʿalyasha (the Baalis of the Book of Jeremiah 40:41), was defeated by Nebuchadrezzar and his capital destroyed, after plotting the assassination of Gedaliah, the Babylonian governor of Judah.

Ammonite sculpture betrays the influence of the neighbouring civilisations of Egypt, Assyria and the Aramaeans. However, if the elements and poses of this sculpture are not new, their arrangement shows the individuality and creative spirit of the Ammonite craftsman.

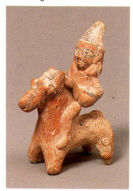

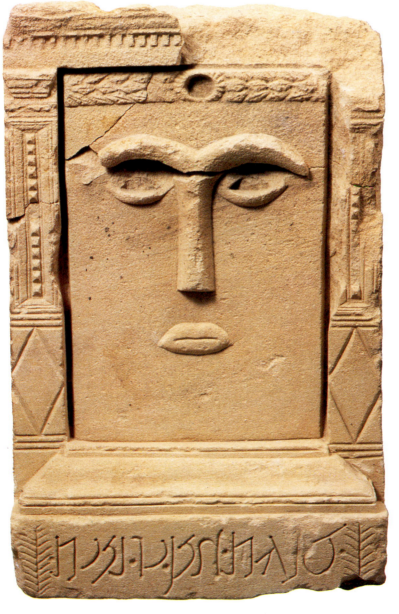

47. Anthropomorphic idol. Yellowish sandstone, from the Temple of the Winged Lions, Petra. The stylised but expressive face is carved in raised relief. The thick lips contrast with the nose which has been reduced to a straight bar. The eyes, originally inlaid, are accentuated by arched eyebrows. The inscription on the base reads 'Goddess of Hayyan son of Nybaťʼ. Although it possesses a mouth, the stela cannot tell us its name, and remains anonymous. The cavity at the centre of the crown of laurels probably contained the attribute of the goddess, which may have been a crown of Isis as on Plate 49. The Temple of the Winged Lions would thus have been dedicated to the Egyptian goddess Isis, assimilated to the goddess of Petra, al-ʼUzza-Aphrodite. A figurine of Isis in mourning, similar to Plate 59, and a statuette of Osiris have been found within the temple. Height: 32 cm. Amman Archaeological Museum

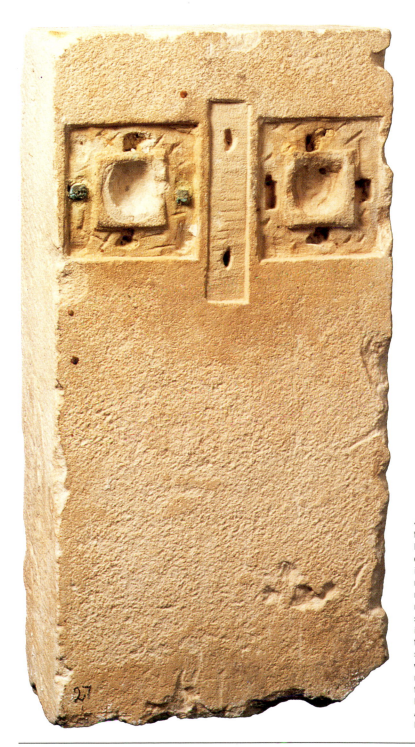

48. Eye idol. Limestone, from the Temple of the Winged Lions, Petra. This stela is embellished with two squares in relief, separated by a rectangular band, representing the eyes and nose. The remains of bronze studs on the relief probably indicate that these parts of the face were modelled in stucco or perhaps decorated with precious metal. There is no mouth. This stela belongs to the 'Tacit Visage' type. Height: 37 cm. Amman Archaeological Museum

49. Idol of al-'Uzza-Isis. Sandstone, from Petra. The star-shaped eyes were originally inlaid. Stelae with star-shaped eyes were engraved on rocks in Wadi Rum and dedicated to al-'Uzza and al-Kutba. The originality of this stela is the laurel frieze enclosing a stylised crown of Isis, consisting of a solar disc between two horns and two ears of corn. Compare this with the crown of Isis in mourning, Plate 59. Height: 50 cm. Petra Archaeological Museum

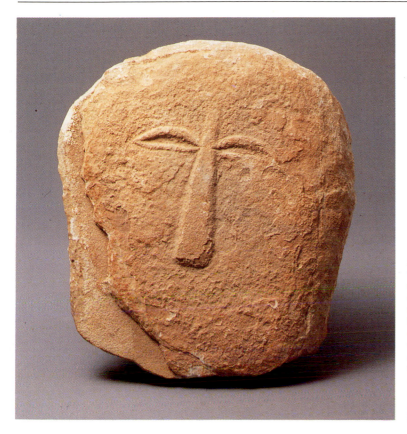

50. Stela carved with a human head. Brownish sandstone, from Khirbet Rizqeh. The face is stylised, with the nose in raised relief, the eyes like hollowed-out olive stones. This stela has many parallels in Arabia and is of the 'Tacit Visage' type. It was a commemorative stela, called *nefesh* in Nabataean. 1st century BC–1st century AD. Height: 26.5 cm. Amman Archaeological Museum

In order to analyse and understand better this considerable production, archaeologists have attempted to classify the sculptures in different categories. Rudolph Dornemann distinguishes four types: 1) an Egyptianising group; 2) Transjordanian; 3) Syrian; 4) Hathoric heads (e.g. Plate 45).

In a detailed study, A. Abou Assaf classed the Ammonite sculptures in the round in five groups which date: I–II from 800 to 730 BC; III–IV from 730 to 690 BC; V from 690 to 580 BC. This classification, which is based on the inscription on the statue of Yerah ʿAzar (Plate 38) and those on the Hathoric heads (Plate 45), is not easy to justify for all the sculptures now known.

The present writer prefers to distinguish four trends in the body of Ammonite sculpture, without prejudging the dates:

1. An Aramaising trend, represented by Plates 38–42. The dress often recalls that of Aramaean dignitaries: a long tunic with short sleeves, crossed by a wide sash whose ends go under the arms; a fringed shawl, ending in a tassel, wrapped around the shoulders and torso. Several of the figures wear the *atef* crown,

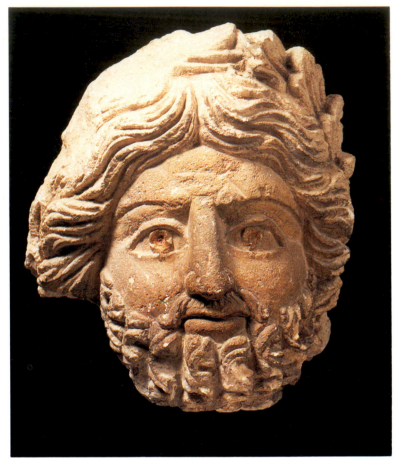

51. Head of a god. Limestone, with traces of paint, from Khirbet Tannur. This fine head represents Qaus, god of the Tannur sanctuary. The thick hair, crown of laurels, spiral beard which recalls Parthian technique, and the thick lips give the impression of force and determination conveyed by a storm god identified with Zeus-Hadad. The pupils were originally inlaid with a precious material. Height: 32 cm. Amman Archaeological Museum

52. The god Qaus of Khirbet et-Tannur. Cincinnati Art Museum

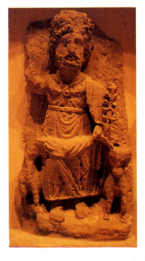

of Egyptian origin. It is uncertain whether this Ammonite crown is worn by a god or a king. Since Yerah ʿAzar (Plate 38) does not wear a crown, many scholars have denied that he is a king, although his grandfather, Sanipu, and one of his successors, Pudu-Ilu, are known from Assyrian inscriptions. However, it is possible that the *atef* crown was worn by a deified king only after his death, and Yerah ʿAzar is represented while still alive. The unmarked pupils on the standing figure (Plate 39), as on the earlier anthropoid sarcophagus (Plate 35), perhaps suggest the sleep of death of a deified king wearing the *atef* crown.

2. An Egyptianising trend, illustrated by Plates 43 and 44. Strong Egyptian influence can be seen in the Osirian beard and hairstyle (wig?) of the male head (Plate 43), and the pose and loincloth of the male statue (Plate 44).

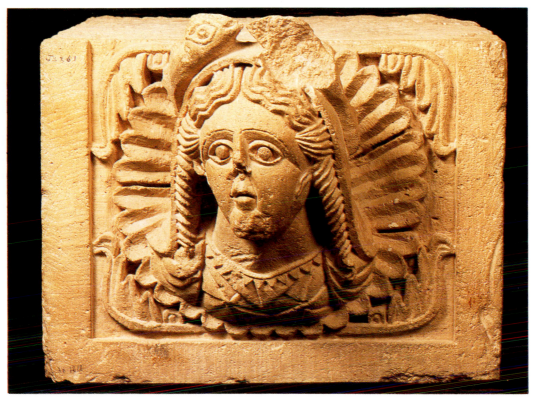

53. Fish goddess. Limestone, with traces of red paint, from Khirbet et-Tannur. On top of the veil are two fish, the attributes of the Syrian goddess Derketo, whose temple in Askalon was famous in the 1st century BC according to Diodorus Siculus. The serrated collar and the pleats represented by triangular incisions are of oriental type. 1st century BC–1st century AD. Height: 27 cm. Amman Archaeological Museum

3. An Assyrianising trend represented by a bust recently discovered on the Citadel at Amman (see *Annual of the Department of Antiquities of Jordan* 33, 1989, Plate LI).

4. A Syro-Phoenician trend represented by the double-faced female heads (Plate 45). Four of these heads were discovered in 1968 built into a Hellenistic drain on the Citadel in Amman. They all have mortice holes top and bottom, and seem to have served as impressive ornaments in some important structure, perhaps as column capitals or more likely window balusters. They recall the ivories from Nimrud in Mesopotamia known as 'The Woman at the Window'. In particular, they parallel very closely some of the Syrian-style ivories from Nimrud, though carved in a different medium.

The Nabataean and Roman Periods

Recent research places the country of origin of the Nabataeans to the north-east of Arabia, in the region of al-Hasa, to the south-east of Kuwait. This is based on information in the Assyrian annals and

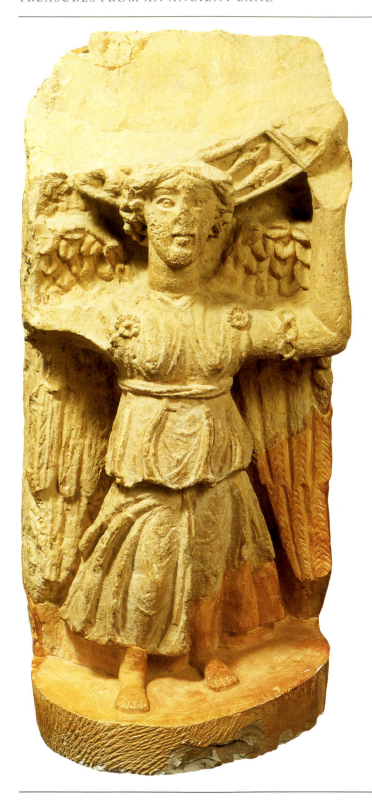

54. Victory holding the Zodiac. Limestone, from Khirbet et-Tannur. The medallion of Tyche (Fortune), encircled by the twelve signs of the Zodiac, is now in the Cincinnati Art Museum (see Plate 55). Victory's long *peplos*, the cord, the fold above the knees, the armlet and the rose-shaped fibulae are all characteristic of the series of Victories from the Hauran in Syria. Originally, Victory stood on a globe inside a niche. 1st century BC–1st century AD. Height: 73 cm. Amman Archaeological Museum

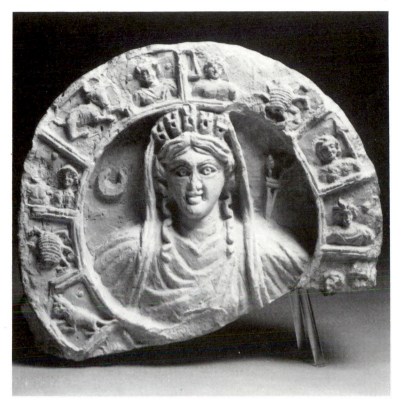

55. Tyche (Fortune) at the centre of the Zodiac (see Plate 54). Pisces and the lower part of Aquarius on the right and a fragment of Virgo on the left are missing. The other signs from the right are: Capricorn, Sagittarius, Scorpio, Libra, Aries (represented by Athena), Taurus, Gemini, Cancer and Leo. The signs do not follow the normal order of the Zodiac but are divided into two groups of six, corresponding to the spring calendar (Aries to Virgo) and an autumnal one (Libra to Pisces). This calendar was adopted by the Nabataeans probably because it followed the rhythm of the agricultural feasts in autumn and spring. Cincinnati Art Museum

the Roman geographers. The Nabataeans infiltrated the south of Transjordan following the caravan routes from the Arabian-Persian Gulf to the Red Sea and the Mediterranean. This is probably to be dated around the 6th century BC, following the campaign in 552 BC of the Neo-Babylonian king Nabonidus who devastated Edom and deported its inhabitants.

At the time of the expedition in 312 BC of Antigonus the One-Eyed, a general of Alexander the Great, the Nabataeans were still semi-nomads and were living in Reqem-Petra, their commercial centre. To safeguard their goods, they had deposited them on top of an impregnable rock (*petra* in Greek). This is most probably the mountain of Umm el-Biyara, the site of an Edomite village in the 8th and 7th centuries BC. Athenaios, the general of Antigonus, took away 500 talents of silver as well as a large quantity of myrrh and incense. However, he was pursued by the Nabataean soldiers and his troops annihilated.

56. Unfinished fish goddess. Limestone, from Khirbet et-Tannur. Cincinnati Art Museum

Having established their security, the caravaneers of Petra spread in the 3rd century BC into the Negev to the west and the Hauran to the north. In the following centuries they took over the trade in spices from the Minaeans. Thus they transported to Petra and ports

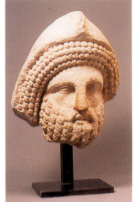

57. Male head. Limestone, from Petra(?). Parthian influence is seen in the Phrygian cap, the four rows of tight curls, and the thick, curly beard arranged in spirals, recalling the sculptures from Hatra. This man, with his serious and meditative expression, may be a Nabataean priest. Height: 34 cm. Amman Archaeological Museum

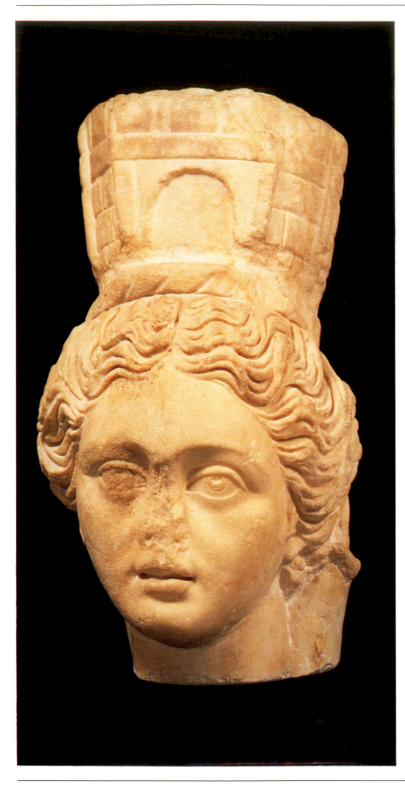

58. Head of Tyche (Fortune). The Tyche of Amman-Philadelphia wears a crown in the shape of a hexagonal citadel, symbol of the power and prosperity of the city. The type, Tyche as protector of the city, was created by the sculptor Eutichides about 300 BC at Antioch. This sculpture is an imitation of a Hellenistic original, and can be dated to the 2nd century AD. Height: 58 cm. Amman Archaeological Museum

such as el-Arish and Gaza incense from Arabia Felix, myrrh from the Somali coast and spices from India. They founded a trading empire which stretched from Hegra-Medain Saleh in the south to Bostra in the north, and from the Wadi Sirhan in the east to the Negev and Sinai in the west. Furthermore, they had trading posts on the islands of Kos and Delos, and at Puteoli where they built a temple to their god Dushara, and doubtless in Rome where a Nabataean inscription has been found on the Palatine. In Egypt, Nabataean temples prospered at Tell esh-Shuqafiya, Daphne, in the eastern Delta and at Qasrawet in northern Sinai. No doubt they also had a trading post at Alexandria.

As a result of these international contacts, Nabataean art draws from diverse elements to create an original synthesis. It is difficult, therefore, to speak of a properly Nabataean style. However, as J. Starcky has pointed out, if the elements are foreign, their composition is original and can be described as Nabataean. We can therefore distinguish four styles, which we call schools, even if they do not really merit such a title:

1. The first school can perhaps be described as Arabian. It is characterised by rectangular stelae, each embellished with a

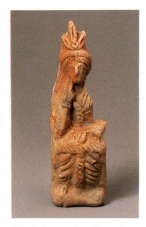

59. Isis in mourning. Terracotta, with traces of ochre paint, from the potter's kiln of Zurrabeh, Petra. This type of Isis, mourning the death of Osiris, inspired the representations of Demeter lamenting the disappearance of Persephone. Isis was probably assimilated to al-'Uzza-Aphrodite, to whom the Temple of the Winged Lions at Petra was perhaps dedicated. Height: 17 cm. Petra Archaeological Museum

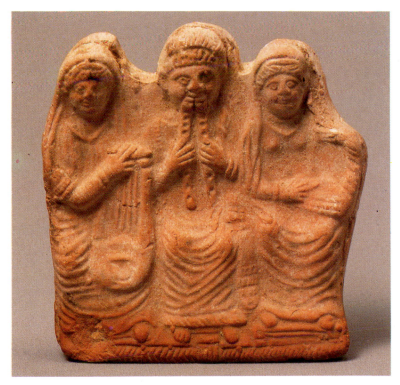

60. Group of musicians. Terracotta, from Petra. A man and two women are seated on a bench, their feet on cushions(?). One woman plays a stringed instrument, the other a lyre. The man plays a double flute. The group probably represents a sacred concert, as attested by the Roman geographer Strabo. Height: 8.7 cm. Amman Archaeological Museum

stylised anthropomorphic figure. Such a stela can be 'talking' (Plate 47) or of 'tacit' type (Plates 48–50). Both types are common in southern Arabia and at Tayma in the north.

2. The second school can be called Graeco-Syrian. It draws its elements from ancient Ammonite or Aramaean traditions, with Hellenistic influences superimposed. Its principal characteristics are the symmetry of facial features, projecting palmettes, prominent eyes and a thick hairstyle with curls or plaits which sometimes fall on the temples, called 'love locks' by the beduin (compare for example the statue of Yerah ʿAzar, Plate 38, and that of the Tannur god, Plates 51, 52). The reliefs from the sanctuary of Tannur in the Wadi Hesa (the ancient Zered, between Edom and Moab), like the Ammonite sculptures, constitute a distinctive category because they represent a local art (Plates 51–6). The unfinished head of a fish-goddess (Plate 56) found in the sanctuary of Tannur proves that the artists worked on site.

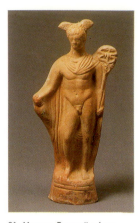

61. Mercury. Terracotta, from Sarih, near Irbid. In his right hand is a purse, symbol of his role as protector of commerce, in his left a staff. The two small wings on his head recall his job as messenger of the gods. 2nd–3rd century AD. Height: 24 cm. Amman Archaeological Museum

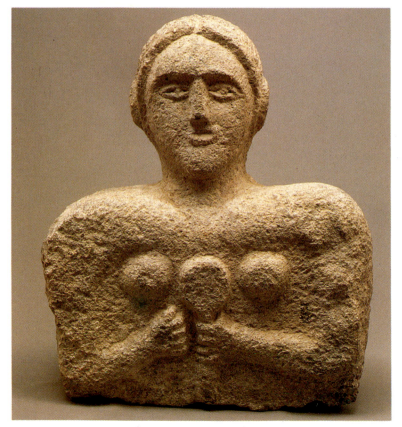

62. Bust of a woman. Basalt, from Gadara-Umm Qais(?). The artist has carefully omitted all human features from this schematic portrait. The left hand holds a mirror. Height: 47.5 cm. Irbid Archaeological Museum

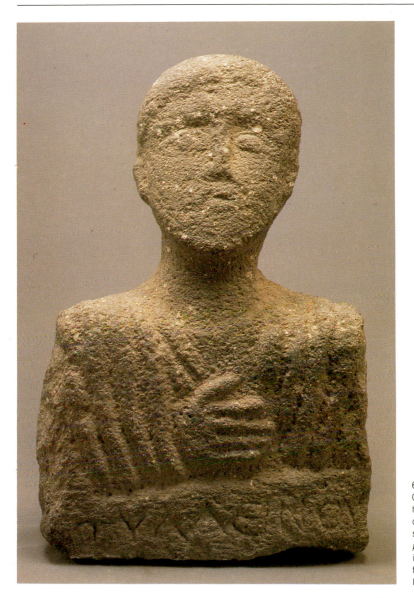

63. Bust of a man. Basalt, from Gadara-Umm Qais. His right hand emerges from the folds of his cloak to rest on his stomach, in the gesture of a *pater familias*. His name is inscribed in Greek letters on the base. Height: 50 cm. Irbid Archaeological Museum

3. Several sculptures from Petra and Tannur show an undeniable Parthian–Hellenistic influence which manifests itself in absolute frontality, globular eyes which fix on the spectator (fish-goddess, Plate 53, and Victory, Plates 54, 55), and above all the Phrygian bonnet, the hairstyle of round curls or spirals and a curled beard (Plate 57). As Nelson Glueck noted: 'The points of difference between Nabataean and Parthian sculptures are noticeable, but the similarities are too close to be accidental.'

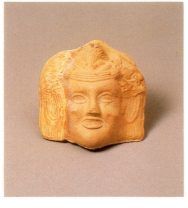
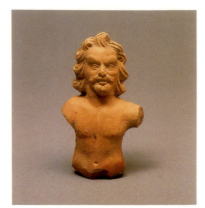
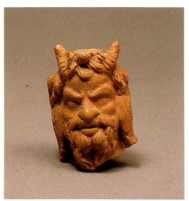
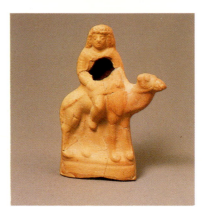

64. Terracottas from Jerash. Clockwise from top left: a mask, a bust of a man, a camel-rider, and Pan. 1st–2nd centuries AD. Amman Archaeological Museum

4. The fourth school is Graeco–Roman and belongs to the Roman Province of Arabia. The annexation of the Nabataean kingdom by Trajan in AD 106 had the advantage of reuniting the traditions of the caravan centres with those of the Hellenistic cities of the Decapolis. A new flowering of sculpture, painting and minor arts appeared in Petra, Philadelphia-Amman, Jerash and Gadara-Umm Qais (e.g. Plate 58). If the influence of the great imperial metropoles such as Antioch, Damascus or Alexandria is evident, the local artists nevertheless retained their personality and originality. They decorated the temples and public buildings with religious or imperial sculptures and the tombs with mythological frescoes, as in the necropolis of Qweilbeh–Abila. In response to popular demand, mass production of religious figurines developed in Petra. A pottery kiln of the Roman period was discovered there in 1979, from which many figurines were recovered (Plate 59). At Jerash, where many pottery kilns have been discovered, the production has links with Hellenistic traditions and is important for the study of religious iconography (Plate 61).

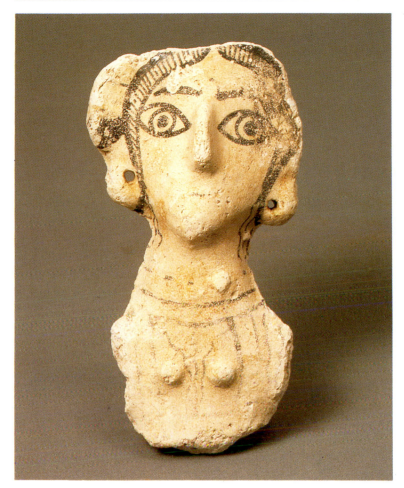

65. Figurine. Clay with black paint, from Muhayy. Stylised bust of a woman. Other examples indicate that this was part of a small mirror, and that the whole belonged to the trousseau of a young bride. Byzantine, 6th century AD. Height: 12 cm. Kerak Archaeological Museum

66. 'Madonna and Child' ceramic figurine from Pella. This figurine illustrates how Christian iconography perpetuated the ancient Syrian and Egyptian representations of Astarte and of Isis with Horus. Byzantine, 6th century AD

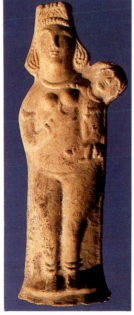

In the north of Jordan, and particularly at Gadara–Umm Qais, there is a tradition of sculpture in basalt, characterised by very schematic features (Plates 62, 63). Numerous examples are known in the Hauran in southern Syria. This sculpture is in general funerary. The stylisation and schematism which characterise it are not a result of the isolation of the region, since Gadara and the Hauran were open to Hellenistic influence from the 3rd century BC on. These busts with very schematic human features are reminiscent of the stelae of Arabian style already mentioned (Plates 47–50; compare the stela from Khirbet Rizqeh, Plate 50, and the busts from Gadara, Plates 62, 63). The stylisation is intentional in both types and can be explained by the repugnance of a Semitic Arab population to represent human features.

In 1933 in Jerash, an important deposit of pottery was discovered in an ancient tomb. This deposit comprised a collection of

figurines, masks, decorative vases and moulded lamps dating to the 1st and 2nd centuries AD (Plate 64). The group represents an important contribution to our knowledge not only of religious life in this Decapolis city during the Roman period, but also of daily life, since among the figurines were found theatre actors, old men and even the sick. Recently the Jerash Archaeological Project has discovered pottery deposits of the Roman and Byzantine periods near the South Gate as well as numerous pottery kilns which were in use until the Byzantine and Islamic periods. Jerash was without doubt an international centre for ceramic production, comparable to Arezzo in Italy. Many of the traditions of the Roman period carried on into Byzantine Christian times (Plates 65, 66).

Further reading

A. Abou-Assaf, 'Untersuchungen zur Ammonitischen Rund-bildkunst'. *Ugarit-Forschungen* 12 (1980), 7–102.

J.R. Bartlett, *Edom and the Edomites*. Sheffield Academic Press/ Palestine Exploration Fund 1989.

P. Bienkowski, 'Umm el-Biyara, Tawilan and Buseirah in Retrospect'. *Levant* 22 (1990), 91–109.

G. Bolelli, 'La ronde-bosse de caractère indigène en Syrie du Sud'. In *Hauran I, 2*, ed. J.-M. Dentzer, Paris 1986.

R. H. Dornemann, *The Archaeology of the Transjordan in the Bronze and Iron Ages*. Milwaukee Public Museum 1983.

N. Glueck, 'The Zodiac of Khirbet et-Tannur'. *Bulletin of the American Schools of Oriental Research* 126 (1952), 5–10.

N. Glueck, *Deities and Dolphins: The Story of the Nabataeans*. New York 1965.

P. Hammond, 'Excavations at Petra 1975–1977'. *Annual of the Department of Antiquities of Jordan* 22 (1977/8), 81–101.

D. Homès-Fredericq, ed., *Inoubliable Petra*. Exhibition catalogue, Musées Royaux d'Art et d'Histoire, Brussels 1980.

J.H. Iliffe, 'Imperial Art in Transjordan'. *Quarterly of the Department of Antiquities of Palestine* XI (1944), 1–26.

D. Kirkbride, 'Ancient Arabian Ancestor Idols'. *Archaeology* 22 (1969), 116–21, 188–95.

La Voie Royale. Exhibition catalogue, Musée du Luxembourg, Paris 1986.

A. Livingstone, 'Taima, Recent Soundings and New Inscribed Material'. *Atlal* 7 (1983), 105 and Plate 93b.

J.-T. Milik, 'Origine des Nabatéens'. In *Studies in the History and Archaeology of Jordan I*, ed. A. Hadidi, 261–5. Amman 1982.

E.D. Oren, 'Excavations at Qasrawet in North-western Sinai'. *Israel Exploration Journal* 32 (1982), 203–11.

C. Rathjens, *Sabaica* 2, 219–24. Ludwig Appel, Hamburg 1955.

J. Starcky, 'Le temple nabatéen de Khirbet Tannur, à propos d'un livre récent'. *Revue Biblique* 75 (1968), 206–35.

E.S. Strong, *Roman Sculpture from Augustus to Constantine*. New York 1969.

G.W. Van Beek, *Hajar bin Humeid*. Baltimore 1969.

G.R.H. Wright, 'Découvertes récentes au Sanctuaire du Qasr à Petra II: Quelques aspects de l'architecture et de la sculpture.' *Syria* 45 (1968), 25–40.

F. Zayadine, 'Al-'Uzza-Aphrodite'. In *Lexikon Iconographicum Mythologiae Classicae II*, 167–9. Zurich/Munich 1984.

F. Zayadine, ed., *Jerash Archaeological Project I*. Amman 1986.

A History of Pottery-making

The Invention of Pottery-making

In order to understand the technical developments in the history of potting in the Levant it is necessary to sketch the process of the invention of making pots in Neolithic times. Many elements of the developments in the history of potting go back to that period. In those days people began to understand the processes of pot-making and they tried out a wide range of possibilities.

The craft of pot-making was invented in the Levant in the 6th millennium BC. A popular view about the invention of pot-making is that somebody in Neolithic times noticed that a lump of clay which had fallen in a fire had become hard as stone after cooling off. People then tried to make bowl-shaped forms from clay which they heated and so pot-making was invented.

It is, however, very unlikely that this is how the craft of pot-making was invented. The first people to make pottery must already have had rather extensive technological knowledge about raw materials and pyrotechniques. There was almost certainly already some kind of 'learned' organisation in Neolithic society, most likely composed of priests or priestesses, which preserved and cultivated all knowledge about and experience of the natural environment which had been assembled over the ages.

It is not surprising that flint-knapping and flint tool-making were invented early in Palaeolithic times and pot-making so much later. Ancient man learned to discern flint stone and how to make certain tools from such stones. It is now customary in studies about prehistoric tools to describe flint assemblages taking into account the manufacturing techniques. Through such studies archaeologists have learned much about different qualities of flint, and how certain tools were produced by exercising pressure or by striking the stone.

In contrast to this procedure, pottery from ancient cultures is not described by archaeologists by means of an analysis of its production process and this reflects the difference in nature of the two raw materials, flint and clay. The property needed to make

tools from a flint nodule is an elementary property: a shock wave propagates through a flint in a plane (as it does in glass), which is the requirement for making stone tools like knives and so on. This could have been discovered by chance. By contrast, only one of the many properties of clays involved in pot-making is manifest in the natural state.

Clay will more or less preserve its shape after drying out, unlike all other types of earth and sands. As soon as this shape, for instance the impression of a foot in a clay soil, becomes wet again, it can be pressed into another shape.

Before people discovered how to make pottery they had to discover other properties of clays, and after pot-making was invented people continued to learn about using clays. At least ten thousand years earlier people began to grow crops and learned to differentiate between soil types such as clay and sand. They experienced that dry clay was hard and dry sand was not. They knew that the surface of clay while drying would start flaking off. When they started to use clays for building walls for their dwellings they found that one could prevent clay from flaking by mixing the wet clay with dried animal manure or with chopped dry vegetable matter (i.e. temper). Finally they also knew that normally clay beds contained fine or course gritty material which could not be dissolved in water: clay could be washed out of a piece of land by rain, leaving behind stones or sand.

People in the Neolithic period were actively trying to improve harvests and to domesticate animals, and learning more about soils must also have been one of their interests. At least one of their experiments to improve materials has become known, which is burning lime. This was one link in the series of discoveries leading to pot-making. Lime burning requires temperatures over 825°C. People used it to make plaster for their house floors and walls and they experimented with making vessels from lime.

When can we say that a clay vessel is fired? When it does not dissolve when put in water. We know that in general a minimum temperature of 600°C is needed for clay particles to begin to fuse together, thus forming a body which keeps its shape when moistened. Neolithic people had the knowledge of preserving or isolating heat by using kilns and when firing clay they must have found that a dull red glow in the fire was needed to reach the required temperature.

However, making a shape for a vessel needs skill. Clay must be wet when used for making a form. There are many different types of clay and the amount of water to be added to a dry clay varies with the type. When the right balance between the amount of water and clay is found, clay must first be given a certain shape from which one can start making a vessel. Usually this is a ball or a bun shape which is made after temper has been added and the clay has

been kneaded in such a way that all air bubbles are driven out. For a simple shape like a small bowl a ball of clay is required. When the ball is opened by pressing a thumb into the ball one finds that clay under such pressure will escape in every direction, which is not what one needs in this case. Counterpressure is thus needed. Next one finds that when a crude bowl shape is made and the clay dries out, the shape begins to shrink and to develop cracks. If less water needed to be added there would be less shrinkage and so a non-plastic filler or temper is used, material which does not shrink after drying and which reduces the required amount of water and clay. All possible fillers have their own advantages and disadvantages, depending on what shape one wants to make, how the pot is fired and for what purpose it will be used.

There must therefore have been a good deal of experimenting in making shapes that would not disintegrate either during drying or firing, before Neolithic man was able to produce pottery. Pottery was not invented when one or two pots came out of the fire undamaged; pottery was invented when people were capable of controlling the production of pots, knowing how to do it and even more importantly, what not to do. This knowledge was based on experience with 'good' and 'bad' raw materials, as well as on some understanding of the elementary processes. Thus, for instance, clay is never drier than the air surrounding it and it must soon have become clear that during the wet season pots would not become sufficiently dry in preparation for firing. Unless special measures are taken, pots cannot be fired in damp weather.

It seems surprising that Neolithic pottery would show already all the elements of the craft of potting which determined its production for millennia to come. But if we realise that without the practical knowledge and experience built up during Pottery Neolithic times pottery production would be impossible, this is no longer a mystery.

The experiments with various clays led to the selection of the right clay beds. It can be demonstrated that Neolithic potters experimented with various fillers. Thus they found that the use of pounded pottery sherds or grog in clays produced a very good mixture for shaping vessels. This mixture is known in our times as 'chamotte' and is widely used in art classes because it readily enables two parts made separately, such as a cup and its handle, to stick together and remain joined after drying and firing.

One of the non-plastics Neolithic potters experimented with was lime sand. They must have discovered the disadvantages of using coarse lime sand, which would destroy pots fired over c. 825°C, when lime turns into quicklime. It absorbs up water after cooling, which makes the slaked lime expand in volume, thus causing damage to the pot wall. Very small lime particles will not cause damage to the pot, and so potters discovered that they had to

control the grain size of the non-plastic materials which they mixed with their clays. Lime sand was used extensively in later times, but it strongly restricted the possibilities of improving the products.

It is very likely that potters had already experimented with mixing two clays to improve the workability of the raw material, but this has not yet been proved. The earliest known instance is in the Iron Age. They experimented with mixing different fillers, having first started by adding dry manure to their clay. Thus there were experiments with using lime sand and quartz sand and with mixtures of the two. They found that it was always important to control the grain size of the non-plastics and they started using sieves to ensure an even and fine grain size.

An important observation they made was that fired clays could produce different colours. They selected red-firing and cream-firing clays, made slurries and covered the surface of their pots with one or two slips using a brush. This produced a strong coloured decoration on the surface. The colour of both slips could be strengthened. Very fine lime powder could be added to a slurry of a light-firing slip to make it lighter and iron powder made from red haematite nodules, found in the river beds, was used to improve the red colours. Some of these nodules would practically dissolve in water. Such slips have a deeper red colour than the Neolithic pottery itself shows.

Yet another discovery was that of burnishing. Slips contain very fine clay particles, and tend to shrink more than the clay with filler from which the pot is made. Thus slip tended to flake off during drying. If it was rubbed with the smooth surface of a shell or bone tool ('rib') as soon as the pot had dried to the leather-hard state, it would not flake and the clay particles were aligned with the surface and thus reflected the light evenly, which produced a shine.

Looked at horizontally, the shape of pots is usually round. The simplest form made from a clay ball is a hemispherical bowl. This is done by holding a clay ball in the left hand and pressing the clay between thumb and fingers of the other hand while rotating the ball (Plate 67). Neolithic potters did not use a potter's wheel but they did use devices to rotate the clay while forming pots apart from rotating a pot in the hand. Thus they made pots on little woven-reed mats which left their impression in the bases. They also used, for instance, shallow limestone bowls into which they pressed a clay sheet to become the base for a larger shape. They added a clay roll to make the shape higher, by rotating the stone bowl with one hand and kneading the roll onto the existing lower part of the vessel with the other hand. This was the invention of the mould which was often used by later potters. It was also the first step in the process of the invention of the potter's wheel. When the form was completed and dry, they used a flint knife to make the wall thinner by scraping away surplus clay.

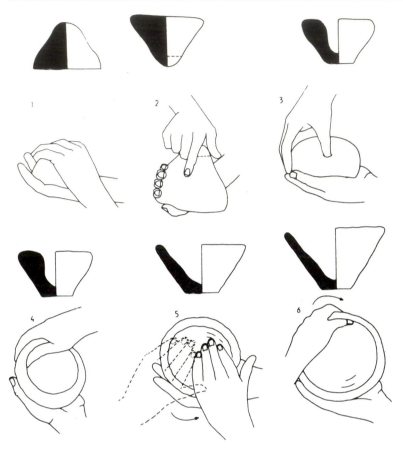

67. A method of making small bowls by hand

Scraping away surplus clay from a roughly finished form became normal practice in potting from Neolithic times to the present day (Plate 68). Potters call it 'turning'. While building a pot shape by first making a base and then adding coils to make the vessel higher or larger, more weight is added on to the lower and still wet part close to the base of the vessel. Thus there is the danger that the shape will collapse under its own weight. So the potter makes the lower part thicker than the intended finished shape should be. Once the lower part has become leather hard the surplus clay can be removed with the rib.

Finally these potters used some kind of kilns in which to fire their pots. A study of sherds from that period shows that some were fired under atmospheric pressure which does not build up in open fires. A kiln has an inlet for the flames of the fire and oxygen and it has an outlet for the fumes. If the outlet is too small to allow for a free flow of heat through the kiln, atmospheric pressure builds up and this affects the pots in the kiln in several ways.

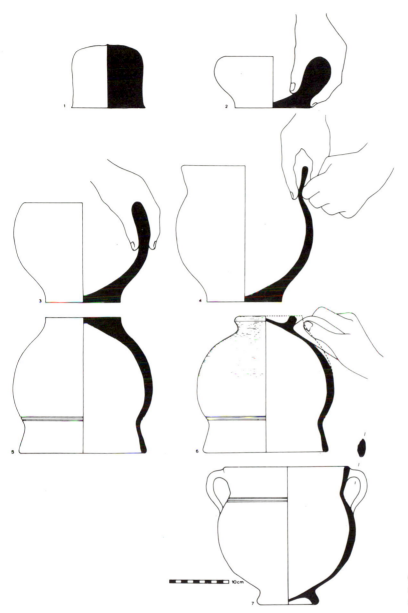

68. The lower part of a bowl is made thin by scraping away surplus clay

It is the oxygen entering the kiln which creates the colour of the pottery. Practically all clays used in the Levant in antiquity contain iron. During firing iron will oxidise when in contact with oxygen and become red. But before iron can take up oxygen, the carbon of the fuels and also carbon present in the clay will take the oxygen. And this means that, depending on the way the kiln is made and used, pottery will come out red (oxidised), or with pale colours

('neutral'), or grey to black ('reduced'). Again depending on how the pottery is stacked in the kiln some pots may show a whole range of different colours between red and black, thus indicating the flow of oxygen.

Very often a colour description of ancient pottery mentions colours that are caused by a neutral or slightly reducing kiln atmosphere. Potters in the Levant have occasionally tried to use the possibility to manipulate the surface colours of their pots. On the other hand it can be shown that they often did not really understand how to deal with the colouring of pottery. Much of the Neolithic pottery shows neutral colours. On the whole, however, the earliest pottery is very well fired and the red slips used to decorate the surface often came out with good reddish-brown colours. From the above explanation it is clear that a white-firing slip does not contain iron or only very little.

This description of the invention of pot-making in Neolithic times not only shows how pots were first made, but it also characterises the craft of potting in the succeeding periods until the beginning of the second millennium BC when new methods were introduced.

Before turning to the Chalcolithic period a few general remarks may be of help in understanding better the potting techniques discussed.

Most of the clays used in the Levant are calcareous clays, clays mixed with certain amounts of lime, or marly clays. These are easy, beginners' clays when a light hand-wheel, rather than a potter's wheel, is used. Such clays are differently named after their properties: lean, short or dry clays do not have much coherence and become sloppy when too much water is mixed with them. They are called open clays because they give few problems when the finished shape is put aside to dry. Water can easily escape through the many pores. Adding non-plastic fillers naturally makes them more porous.

These easy-to-handle potter's clays had several disadvantages. It was virtually impossible to do more with them than make fairly ordinary and rather unattractive-looking crockery for daily use. Attempts at decoration were not very successful, at least when compared with the pottery produced in Cyprus or on the Greek mainland. This coarse material, which was not 'demanding', did not force the potters to master the complicated or really sophisticated techniques needed to make either artistic or qualitatively really good pottery. This turned the potters into servile followers of the methods employed by their ancestors. Yet another drawback of these calcareous clays was that they were salty. Salts would settle on the surface of drying pots and become an insoluble surface coat when sulphuric gases fused with the salts during firing. This coat, called scum, would obscure painted decorations on the pottery.

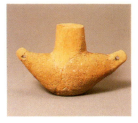

69. 'Butter churn', from Teleilat Ghassul. The shape imitates leather containers, and was probably used for milk products or water transport. Chalcolithic, c. 4500–3200 BC. Length: 21 cm. Amman Archaeological Museum

70. Cornet cup, from Teleilat Ghassul. This was probably simply a drinking vessel. Chalcolithic, c. 4500–3200 BC. Height: 19 cm. Amman Archaeological Museum

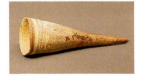

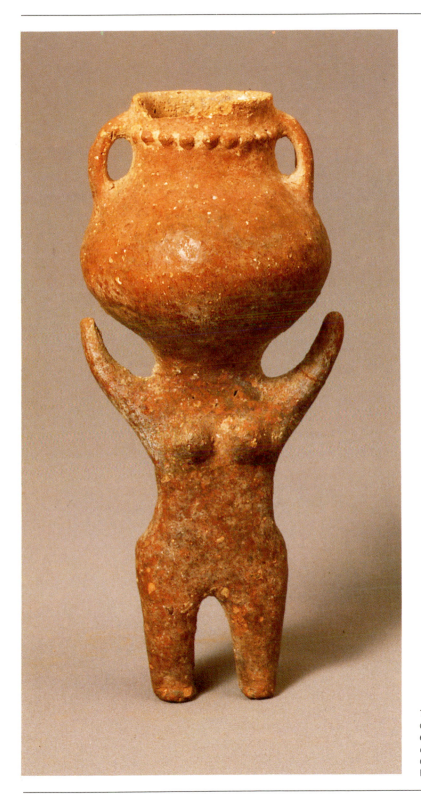

71. Female figurine with amphora on head, from Bab edh-Dhra. Early Bronze Age IA, *c.* 3200–2900 BC. Height: 14.5 cm. Amman Archaeological Museum

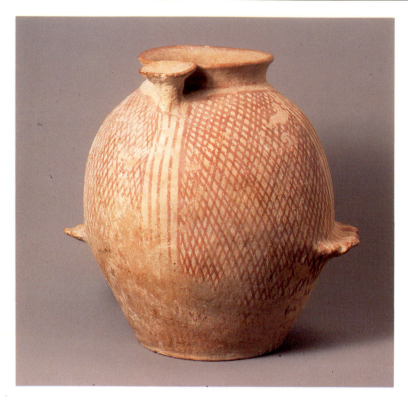

72. Painted jar, with spout and ledge handles, from Ghor es-Safi. Early Bronze Age IB, *c.* 3200–2900 BC. Height: 25.5 cm. Amman Archaeological Museum

One important aspect of the history of the invention of pot-making is that without a mental process of creating and guarding a traditional craft, there would not be any means for archaeologists to determine either the period or the culture to which an excavated group of pots once belonged. The tradition consists of a body of practical knowledge, transmitted by the potters from generation to generation, which directs all activities, from where and how to dig the clays to the firing of the kilns. It is often ill understood that pottery produced in a certain culture at a certain time shows a cohesion, no matter how different the pot shapes may be, because the production of all these various shapes took place within a tradition containing well-defined sets of procedures which were the same for all vessels. The sketch of the invention of pot-making clearly shows that without a faithful transmission of basic knowledge potting would not be possible. And this is not only true for the potter's craft but for many others.

73. Painted bowl, from Jericho. The decoration imitates basket-work. Early Bronze Age IB, *c.* 3200–2900 BC. Height: 11.5 cm. Amman Archaeological Museum

The Chalcolithic Period

Turning to the Chalcolithic period, we see that potters invented new shapes using traditional methods. One of the most

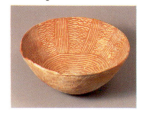

conspicuous new shapes was the large storage jar. It was built up 'by hand' from large clay coils while the pot was somehow slowly turned round or while the potter walked around the vessel under construction. Each time a fresh coil was fixed on to the growing wall the potter had to let it dry before the next one could be added. He tied a rope around each newly-made coil to keep it in shape, and he also fixed at regular intervals clay bands around the wall, to which he added relief by series of finger impressions and the like. These jars were made very hard by firing almost to melting-point. Explaining this is problematic, since the material is always strongly reduced and heated to the stage of wet sintering, which normally would require a temperature of *c.* 1100°C, and it was virtually impossible to generate such high temperatures in that period. However, the effect could have been achieved if these jars were fired in thick layers of charcoal while the fire was kept going for a long time. It is reckoned that a prolonged duration of 'soaking' at a fixed temperature would have had the same effect as raising the temperature by 5°C to 10°C per hour. Moreover, strong reduction or lack of oxygen in the heat contained in the ashes would accelerate the effects of fluxes in the clay. In this way the Chalcolithic potters nearly succeeded in making stoneware (traditional stoneware is fired close to 1300°C).

Pots were not entirely covered with slips; some were painted, incised or received appliqué decoration.

By the end of the Neolithic period so-called 'ledge handles' were applied to pots that needed handles (see Plate 72). But potters had not really mastered the art of making a good, strong grip for holding a jug or mug. Handles had ugly shapes and tended to come off in the fire. So a handle was invented made of a round flat slab of clay, folded double through the middle, then split open at the fold and fixed on to the wall. Thus a large area of contact between pot and handle was obtained which gave a strong bond. Small handles were made in the same way but with a pointed stalk of bamboo the potter pierced a hole through them.

Something should be said about the bases and the rims of Chalcolithic pots. Round bases were made in the hand or in small stone or pottery cups. Much skill was needed to secure a regular shape for the entire pot. Large pots were made on flat bases which were made from a flat cake of clay. When building up the shape with clay coils there was a fair chance that the shape would become lop-sided. As the rim was the last part to be finished it could be, and often was, well out of the centre or vertical axis of the pot. Apart from that the rim needed special care because it would develop vertical cracks from drying and shrinking. If the rim was not parallel with the base potters could not make it horizontal by cutting away surplus clay because it contained too many coarse non-plastic materials. The rim had to be folded. By folding the

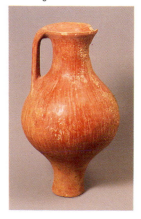

74. Strainer jug of piriform shape, from Jericho. Early Bronze Age II, *c.* 2700 BC. Height: 35 cm. Amman Archaeological Museum

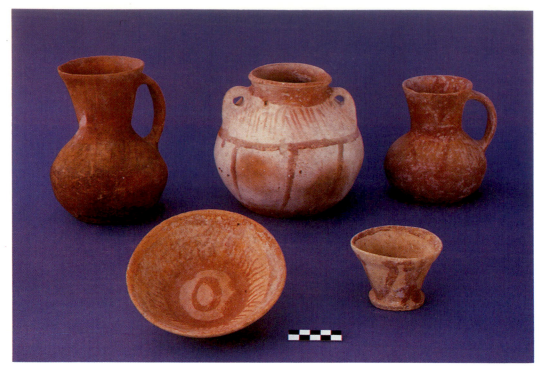

75. Group of Early Bronze Age IV pottery from burials, Seil al-Hammah. *c.* 2300 BC

upper part of the rim down along the outside or inside one could correct its plane, and potters soon discovered that a folded rim would increase the strength of the drying lower part of the body.

The Early Bronze Age

There was a slow development of pot forms during the Early Bronze Age. Within the range of known constructing methods the potters experimented by adapting shapes to current needs or demands, and one gets the impression that not only were there workshops of professional potters but also that much somewhat 'primitive' or home–made pottery was produced. All small items were still made in the hand, but the piriform juglets show that people had better control over the resulting shape (Plate 74). There was more variety and the finish or surface treatment had become finer. The lower part of pots could be made inside a small hole in hard, dry soil lined with ashes. Then a coil was added to model the upper part. In small communities the women may have made their own household crockery in that way and fired it in open pits.

A red paint was used on some pots for decoration, made of clay slurry mixed with red ochre (Plates 72, 73). Red slip was used on small items, which were often thoroughly burnished and had a

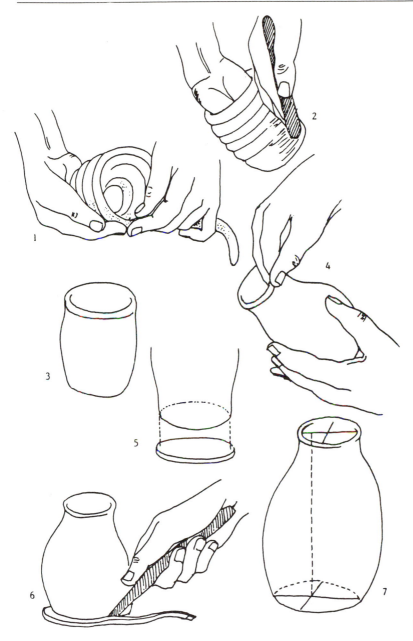

76. A method of jar manufacture by hand during Early Bronze Age IV

high sheen (Plate 74). Burnishing was also applied in trellis patterns. A group of storage jars was coated with lime after which the white surface was painted in geometric patterns.

Cooking pots required a special composition of the clay paste, since they had to be resistant to thermal shock. One should not put a plate of one's dinner service on a gas flame because it will crack.

Pottery does not readily conduct heat, and a small area of pottery in contact with a flame will slightly expand and thus break the vessel. The recipe for heat-shock-resistant fired ware was invented by the Neolithic potters. This recipe lasted well into the 20th century AD in the Levant. The secret has only partly been discovered. Pounded calcite as a dense filler in a low-fired clay body will render it fairly fireproof. The potters had another ingredient, probably some form of iron which was added to the mixture. Other recipes for cooking-pot ware were discovered or invented during the Iron Age but the original mixture always survived.

In the transitional period between the Early Bronze Age and the Middle Bronze Age (Early Bronze Age IV) potters made medium jars with flat bases and remarkably thin walls (Plate 75). They used coils to build these jars and one finds the finger impressions on the inside in regular rows where the coils were fitted together. The outside shows a smooth surface. The explanation is that two moulds were used, one for the lower part and one for the upper part. The moulds were open on both sides, clay coils were fitted against the inside wall of the mould, and when both were ready the

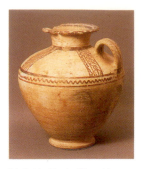

77. Painted jug in 'Chocolate-on-White Ware', from Pella. Middle Bronze Age II–Late Bronze Age I, c. 1650–1400 BC. Height: 27 cm. Irbid Archaeological Museum

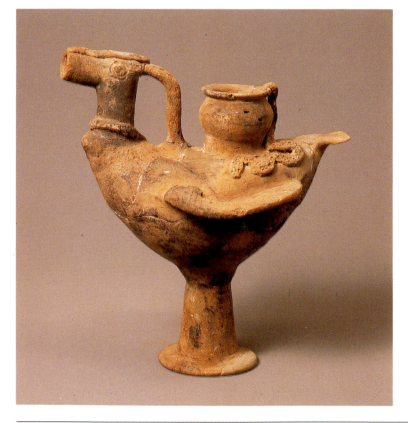

78. Zoomorphic jug in the shape of a bird, from Jericho. The jug is filled through the bowl on the bird's back, and its beak is the nozzle. Middle Bronze Age II, c. 1800–1550 BC. Height: 22 cm. Amman Archaeological Museum

two moulds were fitted together and the two halves of the pot wall joined. Then the contraption was put on a flat clay slab which was to form the base. After the clay had dried and shrunk, the moulds were taken off and the potter added a flaring neck and rim and some ledge handles. In this method the base is not very well attached to the body and sometimes comes straight off when the pot is lifted from a tomb. Otherwise the techniques do not differ from those of the previous period (Plate 76), but incised decoration was more common than the use of slips or paints.

Both the shapes and the colours of the ware are indicative of this period. Often the pottery has a pale surface colour, although the same type of clay was used as previously. The potters probably mixed lime dust with their clays.

79. Biconical jug, from Qweilbeh. The painted decoration shows an ibex in front of a tree. Late Bronze Age, c. 1550–1200 BC. Height: 14 cm. Amman Archaeological Museum

The Middle Bronze Age

It was only in the Middle Bronze Age, roughly in the 19th century BC, that quick turning became common practice in Jordan. The craft was certainly introduced from northern Syria.

Quick turning, or throwing, was a new way of making pottery, which required a different type of clay and different tools. When throwing pots on a wheel, potters use plastic clays, which means clays that are more cohesive. This is best illustrated by reference to a practical test to see how plastic a clay is. A thin roll is made from wet clay, sometimes called a rat's tail. By moving both ends towards each other a ring is made. Lean clays will soon begin to show cracks in the process but plastic clays will allow for a ring to be closed without this happening. Using such a clay the potter can make a pot by first throwing a cylinder and then widening it by

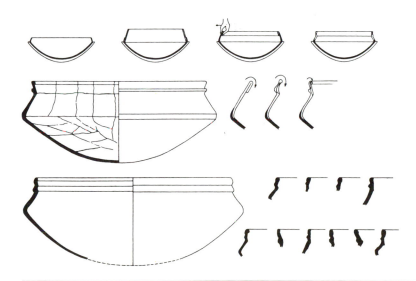

80. The production of cooking pots during the Late Bronze Age

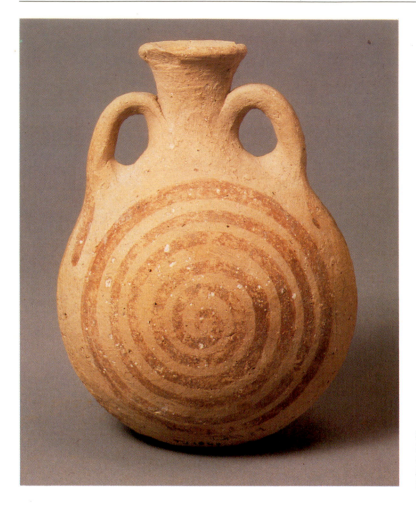

81. 'Pilgrim flask', from Madaba. Iron Age I, c. 11th century BC. Height: 14.5 cm. Amman Archaeological Museum

82. Painted juglet, from Sahab. This is an imitation of the so-called Cypro-Phoenician vessels. Iron Age II, c. 7th century BC. Height: 8.5 cm. Amman Archaeological Museum

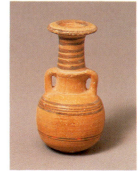

applying pressure inside from the base upwards. This results in the wall having a smoothly flowing curve. While the pot is rotating quickly the potter makes use of the centrifugal force for widening the shape. Throwing allows for the production of comparatively thin-walled pottery. A problem is that it is not easy to attach appendices like handles or spouts to such a form because the clay is not sticky but rather like rubber. Some clay slurry is often used as a binder between two separately made parts. Pots made from such clays shrink heavily when drying and have to be protected from draughts since uneven drying will result in cracks. Firing has also to be done very carefully. On the other hand, throwing speeds up the production and it is not economical to use this method if there is not a large market for its products. Thus the economy of the production requires a quick turnover and once the market is there small potteries will be pushed out of business. At the same time

forms will become more standardised and there is less chance that such pottery will be decorated, which would take extra time. We see in the Middle Bronze Age that more delicate shapes are often coated with a slip and burnished but there is very little painted decoration. By the end of the period, however, painted decoration appears (Plate 77). It is the first time that animals and plants are depicted and technically it was done in the only way which could produce good results when using salty clays: the potters coated the pots with a thick, white-firing slip on which the motifs were painted with black and red iron paint, thus creating a good contrast between the colours.

One pot was not thrown on the wheel. The cooking pot kept its Early Bronze Age character, since the very coarse calcite temper which had to be used acted as sandpaper on the hands of the potter when it was turning round quickly.

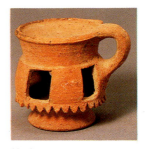

83. Censer, from Tell el-Kheleifeh. The denticulations at the base are a characteristic of Edomite pottery. Iron Age II, 8th–6th centuries BC. Height: 10.3 cm. Amman Archaeological Museum

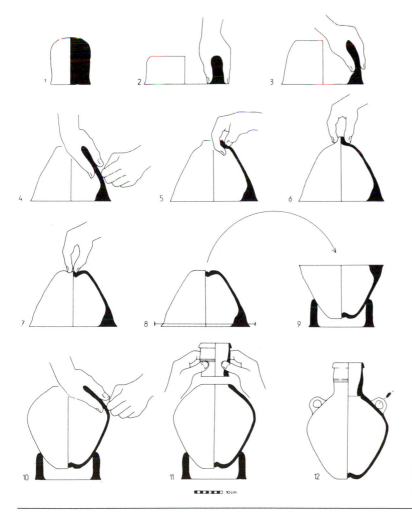

84. A method of first constructing the lower part of a jar and then the upper part

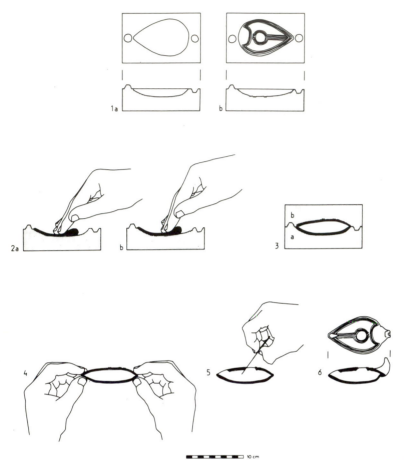

85. Manufacturing lamps using a mould

The Late Bronze and Iron Ages

Middle Bronze Age developments were reversed during the Late Bronze Age. Thrown pottery began to disappear and the old methods came back. In many ways the craft of potting declined, as if potters no longer understood some aspects of the craft. Thick-walled pottery appears again, which in itself was not a bad thing if the decline of the economy was one of the reasons why potters stopped making thin-walled, rather vulnerable shapes. But coarse lime sand as temper appeared again which often caused the pot wall to bloat, thus damaging any form of decoration. In the late 13th century BC pots were made in a biconical shape because potters left the lower half very thick until they had finished the conical upper part (Plate 79). Then they scraped away surplus clay from the lower part on the outside, giving it an inverted conical shape. They did not bother about the fact that often bases were much thicker than

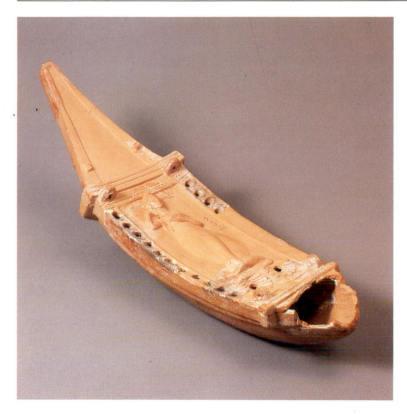

86. Boat-shaped lamp, from Jerash. The holes along the sides are for wicks. The relief shows Aphrodite, her left hand holding an apple. Roman, 2nd century AD. Length: 44 cm. Amman Archaeological Museum

the walls and as a result cracks developed during drying or firing. Thirty to fifty per cent of the pottery had bases with cracks running right through and potters used tar or lime to mend the cracks.

Some potters decided to cut most of the base away after the shape had been finished. They filled the hole in the base with clay which was extremely heavily tempered with dry dung and which would not shrink much. Handles had to be made from the same mixture so that they would not shrink off the body. The potters must have been alarmed by these phenomena. Someone began to solve the problem by first making the upper part of the vessels and then turning them upside down to make the lower part. This could be done with coils in such a way that until the base was closed the wall and base thickness could be controlled. The potter who discovered this solution really understood why bases cracked.

The cooking pot, however, was not hit by the general malaise. Cooking-pot makers used a mould, rather like a wide but shallow open bowl, in which they applied a very thin sheet of clay, smoothing it out right up to the rim. Then they used a clay coil to make an inverted neck and a flaring rim (Plate 80).

During the early Iron Age the craft of potting slowly recovered.

87. Lamp with lion-head handle, from Jerash. Roman, late 1st century–2nd century AD. Length: 22 cm. Amman Archaeological Museum

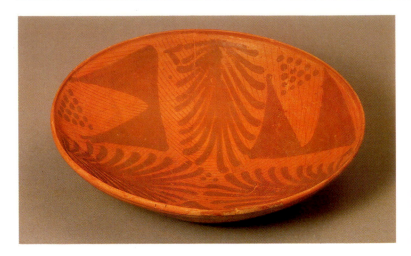

88. Painted bowl, from Petra.
Nabataean, second half of
1st century AD. Diameter: 19.1
cm. Amman Archaeological
Museum

Short and rather salty clays were used on a large scale, slow turning was practised, and potters carefully scraped the lower parts of their bowls and jars to make sure that there was more or less equal thickness in base and pot wall. Only rarely did potters bother to decorate their pots, having lost the knowledge of making slips and paints. Only the makers of so-called pilgrim flasks kept up the tradition of painting the flasks (Plate 81). Jordanian potters developed their own local shapes. It was not until Iron Age II that thrown pottery was introduced again on a large scale, probably under the influence of the Assyrians (Plates 82, 83). Cooking pots could now also be made on a fast wheel since it had been discovered that a good replacement for pounded calcite was very finely powdered quartz sand in large quantities.

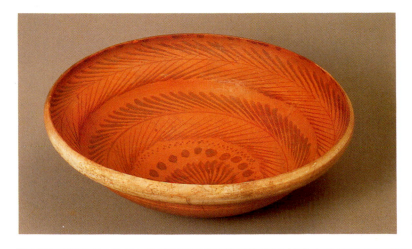

89. Painted bowl, from Petra.
Nabataean, 1st century AD.
Diameter: 15 cm. Amman
Archaeological Museum

The Roman Period

Rather little is known about developments in potting techniques during Persian and Hellenistic times, but shapes indicate that throwing became general practice, although it was probably not very well developed. The most efficient use of a thrower's wheel was developed in Roman times. During the 1st century BC potteries were organised and run like factories. Thus one potter would operate a thrower's wheel making only the lower part of jars upside down, starting from the middle and throwing clay upwards and inwards to the axis until the shape was closed. Another one would make the upper half of jars until the neck, and a third one would make necks with rims and handles. A fourth man would do nothing but lute these bits together (Plate 84). As an example of the efficiency, handles were made from a large prepared clay sheet, about 1 cm. thick, lying on a flat surface. This sheet was cut lengthways in strips 4 cm. wide and the strips were cut into 10 to 12

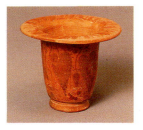

90. Painted goblet with horizontal rim, from Petra. Nabataean, 1st century AD. Height: 7.6 cm. Amman Archaeological Museum

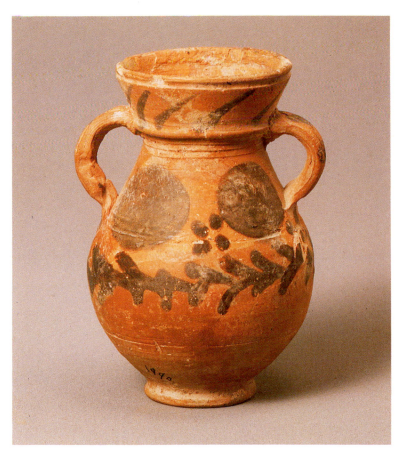

91. Painted amphora, from Petra. Nabataean, 2nd century AD. Height: 10.2 cm. Amman Archaeological Museum

cm. lengths. The strips were folded double through the length and brought to the worker who fixed handles on to jars. Smaller handles were often made by throwing a tube, then cutting the tube in narrow slices and cutting each slice in two halves.

Lamps were normally made in two halves in moulds, the upper half having decoration in relief (Plates 85–7). The potters started to reduce the thickness of the wall of the cooking pot by making a groove in a spiral in the body. This had the double effect of letting the heat penetrate more readily through the wall and enlarging the surface contact with the heat.

There is no question that any sort of art pottery was produced. Apart from the geological region near Petra there were no clay sources that could be used for such purposes, although the potters certainly did search for good clays. There was very little local decorated pottery but potters could make very thin-walled bowls and jugs.

The Petra potters used the same techniques but their clays allowed them to make very thin and delicate shapes with very smooth surfaces fit for decoration. Fine painted ware is undoubtedly one of the most attractive and original achievements of Nabataean art (Plates 88–92). The motifs were usually restricted

92. Painted cooking pot, from Petra. Nabataean, 2nd century AD. Height: 8 cm. Amman Archaeological Museum

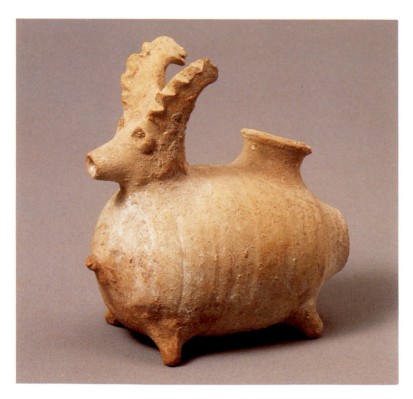

93. Zoomorphic vase in the shape of an ibex, from Muhayy. It was probably used as a water jug. Byzantine, 5th century AD. Height: 11.5 cm. Kerak Archaeological Museum

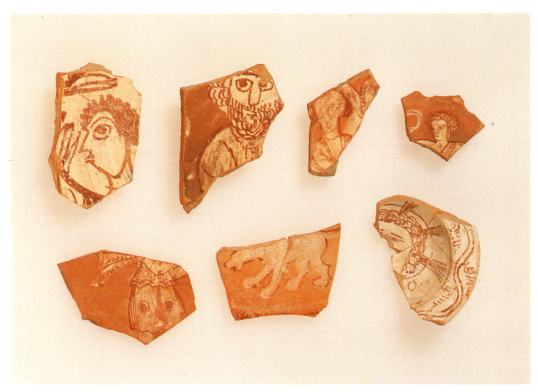

94. Fragments of 'Jerash Bowls', from the Temple of Zeus. This pottery, painted in deep red with floral and animal motifs and occasionally human figures, was produced in Jerash in the Byzantine period. 6th–7th centuries AD? Jerash, Department of Antiquities

to geometrical or vegetal forms, more or less stylised. Since scum-forming was normal with these clays, the potters must have fired their decorated wares inside fireproof boxes or large vats which would prevent the pottery from being in contact with the flames of the fire.

The Byzantine-Islamic Periods

With some slow developments during the ages the Byzantine potters continued in the same tradition and so did the Umayyads. A cooking pot was invented with a lid which would always fit. Potters threw the entire pot upside down, then turned it right side up and starting from the somewhat thickened rim they threw the pot until it was nearly closed with a small knob at the top with a tiny hole to let steam escape. They then made an incision along the rim without entirely freeing the lid from the body. After firing the customer had to tap the lid to break it from the pot. Potters used both red-firing and white-firing clays but the distinction may not lie in differences of the clays but simply in whether sweet water or salt water was used to prepare them, salt water producing very light-firing colours.

95. Jar decorated with wavy lines, from Pella. Byzantine-Umayyad, 6th–8th centuries AD. Height: 19.5 cm. Amman Archaeological Museum

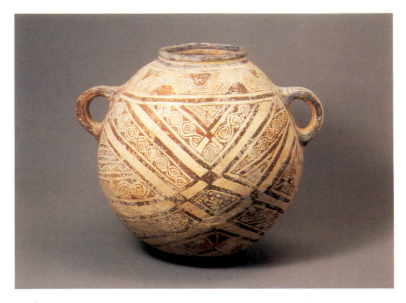

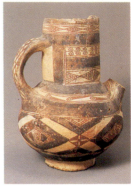

96. Painted hand-made jug, from Hesban. Mamluk, 13th–16th centuries AD. Height: 24.5 cm. Amman Archaeological Museum

97. Painted jar. Mamluk, 13th–16th centuries AD. Height: 31 cm. Amman Archaeological Museum

There is now more painted decoration (Plate 94) and we see that the same failures, already described, occurred. Moreover, while higher firing temperatures were used than in pre-Roman times, another cause of failure had turned up. Iron, used for paints, when in contact with lime and chlorites in the clays, becomes volatile at 925°C and so decoration tended to disappear from the surface. There was one telling attempt to overcome the problems. Potters painted jars with a white-firing paint (not containing iron) and then fired them with strong reduction to get a black surface with white decoration. But often the black did not succeed very well and white on pale grey does not impress one as attractive (Plate 95).

In the early Islamic period the pottery was still thrown but with the decline of the towns the demand diminished. The numerous new villages which arose on all good agricultural land with a new population saw a totally new technique of potting. This was far more economic for the peasants to use, home-made to their specific needs on the farms and technically almost Neolithic (Plates 96, 97). The production of this pottery continued until the present day. It was totally hand-made pottery and very likely made by the farmers' wives after the harvest. Local clays were mixed with grog, made from sherds of broken pots, including wheel-made pots, that were lying about. The bases were made in a shallow mould, in which cloth was spread first, then a rather wet lump of clay was put in the mould and covered with cloth. Next the potter pressed the clay between the two rags into the required shape, and for larger shapes coils were added. This pottery is very attractive because it was entirely and rather carefully coated with a white-firing slip and

98. Bowl with black and turquoise paint under transparent glaze. Mamluk, 13th–14th centuries AD. Diameter: 25 cm. Amman Archaeological Museum

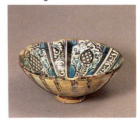

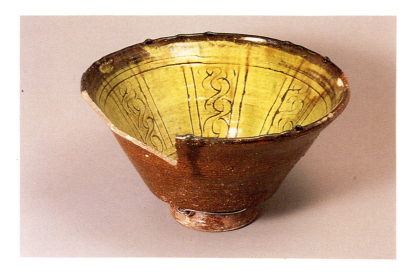

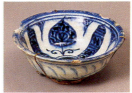

99. Bowl with blue paint under transparent glaze. Mamluk, 13th–14th centuries AD. Diameter: 14.3 cm. Amman Archaeological Museum

100. Dish, slipped and incised under yellow glaze, from Hesban. Mamluk, 13th–16th centuries AD. Diameter: 26.5 cm. Amman Archaeological Museum

then painted with ochres in many different geometric designs, even below the bases. In this period the hand-made cooking pot reappears and it is tempered with pounded calcite. Throwing survived in the production of pottery for the sugar industry.

One other significant new technique has to be mentioned. Byzantine potters used transparent lead glaze inside some cooking pots. This made it easier to clean them. (Normally one would 'clean' a cooking pot by putting it upside down on hot ashes from the bread oven.) Early in the Islamic period glazed bowls began to appear (Plates 98–101). There was almost certainly a glazed pottery industry in Jordan because during the following ages the production was not influenced by new developments in glazed wares which took place in Syria. The pottery was thrown, the vast majority being bowls. A white-firing slip was then applied on the inside and most of the outside. A transparent glaze was applied, mostly made from lead; and oxides from iron, copper and, in the beginning, manganese were used as colourants. By making grooves in the inside surface of the bowls through the white slip the potters made geometric designs and slip trailing was also applied, a technique still widely used on simple glazed flower pots today.

Pottery cast in moulds with raised relief decoration, both glazed and non-glazed, was probably imported into the country, as was the blue- and black-decorated white frit ware.

101. Dish, with underglaze slip, from Hesban. Mamluk, 13th–16th centuries AD. Diameter: 30.3 cm. Amman Archaeological Museum

Further reading

D. Homès-Fredericq and H. J. Franken, *Pottery and Potters, Past and Present: 7000 Years of Ceramic Art in Jordan*. Attempto Verlag, Tübingen 1986.

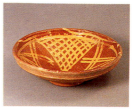

Art and Technology

The repertoire of exotic materials available to ancient craftsmen varied over time. On the one hand, new materials became available through growing technical skills and greater long-range trade. On the other, some traditional materials were replaced by newer, more efficient ones, like the replacement of stone tools by metal. However, certain media remained in use, long after they had been superseded by other materials for everyday purposes.

The earliest efforts were based on chipped stone, followed by animal bone and shell during the Epipalaeolithic period. A little later an increasing range of coloured stones appeared, reflecting the greater degree of interaction and exchange between human groups. The Chalcolithic period saw the first appearance of copper, which became more important as the Bronze Age developed. The production of precious metals, ivory carving, glass and faience developed through the Middle and Late Bronze Ages, largely under the stimulus of demand for luxury and status items from the elites of the various urban centres. Naturally, the pattern of demand shifted at times, to reflect changes in the kind of material fashionable in the wider world. In some cases we see a demand for imported items which may at times have led to the production of local copies. Not surprisingly it is during the periods of economic decline, such as the closing centuries of the Early Bronze Age, that luxury items are least common.

Perishable materials such as wood, leather, cloth and reeds are rarely preserved. There is some tomb evidence, such as part of a bowl from Bab edh-Dhra and fragments of furniture from Jericho, which gives an impression of the kind of wooden objects in production. In addition to vessels and furniture, wood was used for hafting tools, in building work, and as part of composite items such as ploughs and chariots. For most other organic materials no such evidence survives. As a result, we are dealing with a rather selective sample of ancient manufactures, and the possible influence of crafts whose remains are now lost to us on those which survive should not be forgotten. In fact, a large part of our material represents luxury items, not everyday products.

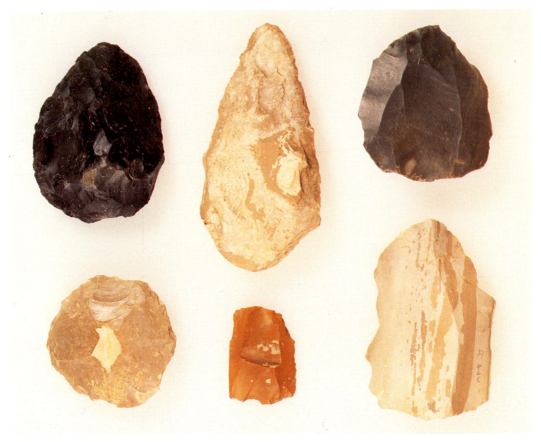

102. Flint tools from Azraq. Palaeolithic, c. 200,000 BC. Amman Archaeological Museum

Stone

In the early prehistoric periods durable stone tools and manufacturing waste form the largest single part of the surviving record. Tools fall into two main classes, chipped and ground.

Only certain types of stone are suitable for producing chipped stone tools, mainly flints, cherts and obsidian; the latter is a kind of volcanic glass, which when found in Jordan usually comes from sources in eastern Turkey. These rocks fracture in a particular way when struck, the breaks being sharp-edged.

The earliest tools of the Acheulean industry (Lower Palaeolithic, around 200,000 BC) were made by removing flakes from a core to leave a tool of the desired shape, such as the distinctive pear-shaped handaxes (Plate 102). These were probably multi-purpose items, designed for holding directly in the hand.

In the Late Acheulean, dated around 150,000 BC, flint knappers began to make tools not from a core, but from flakes struck from it. Flake tools had a much wider range of shapes and specialised

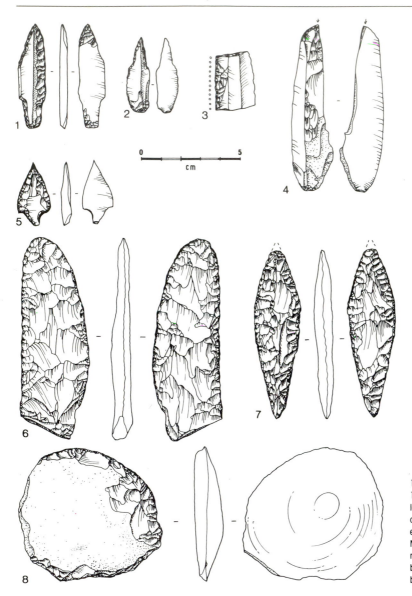

103. Flint tools from Dhuweila.
1–4 (Pre-Pottery Neolithic B,
late 7th millennium BC):
arrowhead, borer, sickle
element, burin. 5–8 (Late
Neolithic, late 6th–early 5th
millennium BC): arrowhead,
bifacial knife, leaf-shaped
bifacial tool, flake scraper

functions. In later periods small tools called microliths were developed, designed to be mounted in groups on a wooden haft (to form sickle blades, for example). Stone axes and other woodworking tools appeared, while the pressure-flaking technique, whereby flakes were removed from a shaped core by pressure, not direct impact, allowed the production of magnificent knives and spearheads (Plate 103). With modifications, the production of flake tools continued into the Bronze Age, while there is evidence from Deir Alla for re-use during the Iron Age of earlier stone tools found in fields near the site.

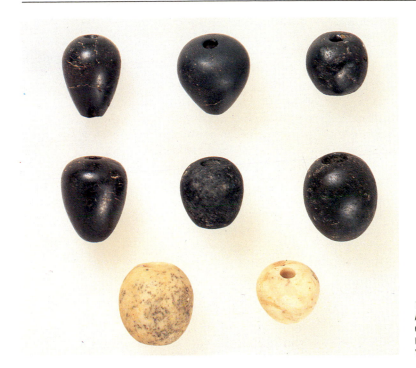

104. Stone mace-heads from
Abu Hamid, Jordan Valley.
Chalcolithic, c. 4000–3800 BC.
Department of Antiquities,
Yarmuk University

Chipped stone tools did not suddenly disappear with the advent of metals. Although some items such as flint axes and daggers were replaced quite quickly, stone remained perfectly adequate for other purposes, such as scrapers and sickle-blades, which were super-seded gradually. Flints continued in use as strike-a-lights, throw-away blades and in threshing sledges into recent times.

Ground stone tools are generally made of different types of rock from chipped tools, those whose properties make them unsuitable for flaking, such as limestone, sandstone and basalt. Ground stone tools are known from Epipalaeolithic sites in the Azraq Basin, although they are more common in the succeeding periods. Mortars, stone bowls, pounders and grinding implements, where durability was more important than a sharp edge, were made from ground, rather than chipped stone. The development of such tools was probably linked to the processing of a wider range of food plants, and in particular to the greater utilisation of wild cereals.

Stone maceheads, dating to the Chalcolithic and Early Bronze Age, were hafted by means of a vertical perforation made by a drill (Plate 104). A variety of materials was used, generally hard, dense stone such as haematite, basalt, alabaster or limestone, and the stone has a smooth, polished surface. In ancient Egyptian art the pharaoh is often shown with a raised macehead in his right hand, in preparation for smiting down his enemies. This suggests that these

items had a certain symbolic importance, which might explain the degree of time and effort spent in preparation. Jordanian maceheads represent a local version of a tradition extending from ancient Mesopotamia to Egypt. Although they would have made effective weapons, they were probably soon replaced in that role by copper daggers and axes. They become increasingly rare after Early Bronze I, although the macehead may have retained a symbolic importance for some time afterwards. Stone examples are especially numerous at Abu Hamid in the Jordan Valley, and in graves at Jericho and Bab edh-Dhra. Copper examples are known from a Chalcolithic hoard found at Nahal Mishmar on the west side of the Dead Sea.

In the Chalcolithic period flaring basalt bowls occur widely throughout Palestine and Jordan (Plate 105). Some bear linear or geometric incised decoration, and while some have tripod bases, others stand on pedestal bases, which can be partly cut away. Considering the time and effort required to manufacture these items, and their frequent occurrence as grave objects, they should probably be seen as prestige items, having some social or symbolic importance. They are probably related to objects of similar shapes made in a dark, burnished pottery known as Esdraelon Ware, which is found in northern Palestine and Jordan, while similar shapes occur in more conventional ceramics at Bab edh-Dhra.

Tripod basalt vessels are known from tombs dating between the Middle Bronze Age and the Iron Age (Plate 106). Many sheep and goat bones were found beside one of several basalt incense burners found in early Iron Age levels at Tell es-Sa'idiyeh, a good example of the use of stone for the manufacture of cult objects, a practice which continued into later periods. The Late Bronze Age temple discovered near the old Amman Airport (see p. 10) produced fragments of a number of stone vessels deposited as offerings. Some are of local rock, others imported from Egypt and Crete, stressing the role of polished stone objects as 'valuables'.

Several Iron Age sites in southern Jordan have produced rectangular limestone or 'alabaster' cosmetic palettes, shaped with a human head at one end, and bearing finely incised decoration (Plate 107). These seem to imitate shell palettes of a type found from Greece to Assyria, the white stone providing a substitute for the shell of the originals.

During the Roman period limestone was a popular material for decorated sarcophagi, which were placed in rock-cut tombs found throughout the country. A similar notion, albeit on a smaller scale, can be seen in the appearance of small limestone reliquaries (Plate 108). These objects, found in early Christian churches, were intended to contain sacred relics, fragments of the bones of saints, martyrs, or other special individuals. Decorated with various Christian symbols, they were generally placed in a hole in the floor

105. Basalt bowl from Abu Hamid, Jordan Valley. Chalcolithic, c. 4000–3800 BC. Diameter: 30.4 cm. Department of Antiquities, Yarmuk University

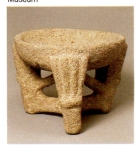

106. Basalt tripod mortar from Tell es-Sa'idiyeh. Iron Age II, 8th century BC. Height: 14.5 cm. Amman Archaeological Museum

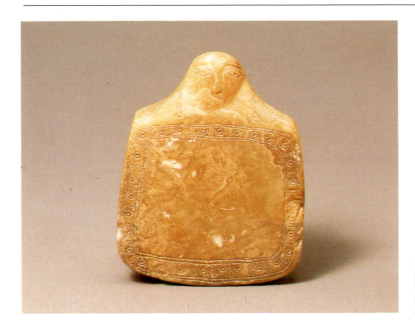

107. Alabaster cosmetic palette from Amman Citadel. Iron Age II, 7th–6th centuries BC. Height: 12.5 cm. Amman Archaeological Museum

of the church, called a reliquarium. Some were designed so that oil could be poured into them through a funnel, and would then drain out of the reliquary into a small phial or ampoule, where it would collect. This holy oil could then be used in the treatment of the sick and for other religious purposes. Besides stone, silver and other precious materials were also suitable for these objects (see Plate 125).

Carved stone remained a popular medium into the Islamic period, when various vessels and minor objects were decorated with finely executed Qur'anic texts. Other such objects include a lamp from Mafraq standing on four feet, decorated in an architectural style (Plate 109).

Alabasters

'Alabaster' vessels have a long history in Egypt, where they were made of hard calcite. Most of the vessels found in Palestine and Jordan are local products, inspired by Egyptian examples, and were made from gypsum, which occurs in the Jordan Valley and around the Dead Sea. The gypsum was first carved into an approximate shape, the hollow central area was then chiselled out, and the outside finished by polishing with abrasive materials. The stone was probably worked with chisels or gouges, unlike the harder Egyptian calcite, which required drilling. Tool marks can occasionally be seen on the insides of vessels, the outsides having been smoothed off.

108. Limestone reliquary from the Church of St John, Khirbet es-Samra. 5th–8th centuries AD. Length: 10 cm. Samra, Department of Antiquities

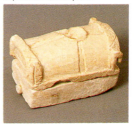

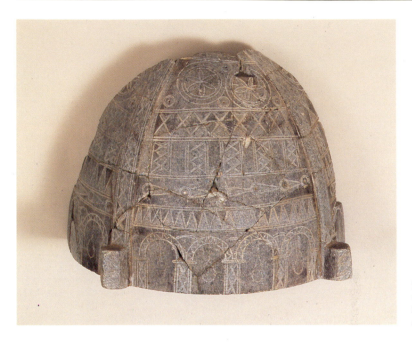

109. Part of a steatite lamp from Mafraq. Umayyad, 8th century AD. Height (existing): 20.5 cm. Amman Archaeological Museum

Although alabaster vessels are found as early as the Chalcolithic period, and Egyptian imports occurred in an Early Bronze Age cult building at Ai on the West Bank, they remained quite rare in Jordan until the later Middle Bronze Age (Plates 110, 111). Some alabasters imitate the forms of local ceramic, and possibly wooden, vessels, others are more directly inspired by Egyptian shapes. Popular forms include bag-shaped vessels and single-handled miniature-jugs. An open bowl with four rams' heads found in a Middle Bronze Age tomb at Jericho shares many features with wooden vessels from the site. Most alabaster vessels come from tombs, although a number of unfinished pieces from occupation areas at Beth Shan, on the West Bank of the Jordan, suggest the existence there of a local production centre.

In the Late Bronze Age new shapes appeared for alabaster vessels. As before there is a mix of local and Egyptian styles. Alabaster vessels remained popular through the Iron Age, and into the Persian and Hellenistic periods, although the range of shapes is more restricted: small tear-shaped vessels, known as alabastra, and small alabaster palettes for crushing aromatic substances or cosmetics. These too are Egyptian-influenced.

Copper and Bronze

Brightly coloured copper ores were prized as coloured stones as early as the Neolithic period, long before the extraction of copper

110. Alabaster four-footed dish from Jericho. Middle Bronze Age II, c. 1800–1550 BC. Diameter: 12 cm. Amman Archaeological Museum

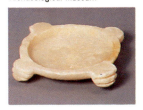

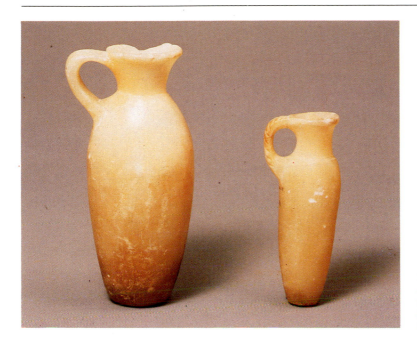

111. Alabaster juglets from
Jericho. Middle Bronze Age II,
c. 1800–1550 BC. Height: 15.5
cm. and 15 cm. Amman
Archaeological Museum

itself. They featured in the decoration of the famous plastered skulls
from Jericho, for example. A major source of copper, perhaps used
intermittently from the Chalcolithic period until Roman times, is
known at Wadi Feinan, on the east side of the Wadi Arabah, south
of the Dead Sea. In the Roman period the mines were worked by
convict labour, in effect a death sentence.

Copper-base items can be shaped in various ways. The early
objects were probably hammered into shape. The use of moulds,
often thought of as 'open' but probably closed with a simple lid,
allowed roughly-shaped objects to be cast and then finished by
hammering. By the Middle Bronze Age more sophisticated two-
piece moulds were in use. These, if made of suitable stone, such as
schist or steatite, permitted the repeat production of weapons,
jewellery and figurines in quite complex shapes. More complex
shapes could be produced by the lost-wax process. A wax model
of the required shape was produced and a clay mould formed
around it. On heating, the wax melted, and was poured off,
leaving behind an impression in the clay mould, in the shape of the
desired item. Molten metal could then be poured into the mould,
and allowed to cool. Normally, of course, the mould had to be
broken in order to get the object out, unlike stone moulds which
were re-usable.

The earliest copper objects comprised tools such as chisels, flat
(non-socketed) axes, and decorative items like rings and pins. The
capabilities of Chalcolithic metalsmiths are illustrated by the range

of copper cult-objects – elaborate 'wands', circular stands, crowns – found in a cave at Nahal Mishmar on the west side of the Dead Sea. Equally fine material may yet be found elsewhere in the region. Weapons such as daggers, crescent-shaped axes (Plate 112) and other copper objects became more frequent later in the Early Bronze Age.

The Middle Bronze Age saw the increasing use of true bronze (a tin-copper alloy), the tin being imported from sources far to the east. More sophisticated products appeared, such as elaborate dress-pins, metal belts of a kind found widely throughout Syria, Cyprus and the Nile Delta, socketed axes, and daggers with finely-ribbed blades. Some of these objects were cast from two-piece moulds. Late Bronze Age production was largely a development of that of the Middle Bronze Age, such as a curved sword from the temple near Amman Airport, and bronze mirrors of Egyptian style.

Towards the end of the Late Bronze Age and into the Iron Age metal items in 'international' styles appeared. By this time luxury items comprised an important part of bronzesmiths' repertoires. Occasional bronze armour scales are found, designed for sewing on to a leather backing. Iron Age graves from Tell es-Sa'idiyeh have produced a cauldron, and also a tripod stand, with curving legs ending in feet shaped like those of a cat. This was intended to support a large vessel. Similar items occur at sites from Iraq to Greece, and were intended to hold liquids such as wine, water, or a mixture of the two. Metal wine sets appeared towards the end of the Late Bronze Age (Plate 113). These comprised a jug for pouring, a drinking bowl and a strainer. They were most likely of Egyptian inspiration, as similar examples in both gold and silver are known from Tell Basta in the eastern Nile Delta.

Bowls, strainers, rings and bracelets have been found in Persian-period tombs at Meqabelein, Tell Mazar and Umm Udhaina (Plate 114). Some examples are decorated with chased or incised floral motifs. A bronze censer with a stand in the shape of a human figure of a type called a caryatid, unique in Jordan, but related to forms current in Syria and the east, was found at Umm Udhaina (Plate 115). During the 1st millennium BC dress pins used for fastening cloth were replaced by the fibula, a kind of spring clip, not unlike a modern safety pin. These occur widely through western Asia and Europe.

During the Hellenistic and Roman periods, bronze continued to be popular as a medium for luxury items. Elaborate, cast-bronze lamps were produced, sometimes in the shape of birds or other animals, or bearing human faces (Plates 116, 117). A considerable quantity of religious and ritual paraphernalia was manufactured, such as bells, crosses, chandeliers and incense burners. Bronze coffin-fittings in the shape of a lion's head were also popular in the

112. Copper crescentic axe from Jericho. Early Bronze Age III, c. 2700–2300 BC. Length: 24.5 cm. Amman Archaeological Museum

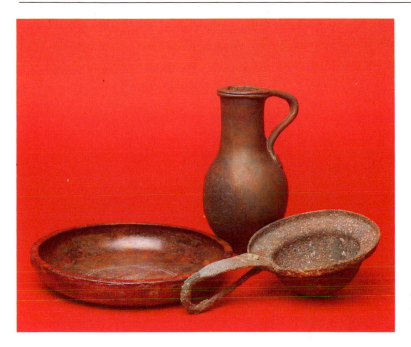

113. Bronze wine set, comprising jug, bowl and strainer, from Tell es-Sa'idiyeh. Late Bronze Age, c. 1550–1200 BC. British Museum

114. Bronze bowl from Umm Udhaina, Amman, with a relief floral pattern developing from the centre. An Aramaic inscription on the exterior reads: 'Belonging to 'Elshamar, son of 'El(ya)zan'. Persian, 6th century BC. Diameter: 22.2 cm. Amman Archaeological Museum

115. Bronze caryatid censer
from Umm Udhaina, Amman.
Persian, 6th century BC. Height:
34 cm. Amman
Archaeological Museum

116. Bronze lamp in the shape of a duck, from Kerak. Roman. Length: 20.5 cm. Amman Archaeological Museum

117. Bronze lamp with handle in the shape of a face, from the House of the Carpenter, Jerash. The face may be a representation of the god Pan. On the body of the lamp is engraved in Greek the name of the owner: Abdaanathas. Roman, 1st century AD. Length: 20 cm. Jerash, Department of Antiquities

Roman East. In fact, the popular British lion-head door-knocker is a descendant of these.

Early Islamic sites have produced material whose roots lie not only in the Graeco-Roman world but also in the civilisations to the east, the Sassanians and Palmyra, and no doubt the long-established pre-classical local traditions. The magnificent bronze brazier from el-Fedein, near Mafraq, is decorated with plaques depicting amorous scenes taking place underneath arches, probably cast by the lost-wax method (Plate 118). The four feet are each shaped like a griffin with outstretched wings, while cast figures are attached to each corner. Bronze braziers, albeit of rather different designs, played an important role in the ceremonial of royal establishments during the Iron Age, and are depicted on ancient Assyrian reliefs.

Iron

Towards the end of the 2nd millennium BC iron began to appear on a regular basis for the first time. Now smiths had a choice of materials with which to work. At the temperature at which copper melted, iron was merely 'spongy', and contained a certain amount of slag within its structure which had to be hammered out. Unlike bronze implements, iron objects could not be mass-produced, as iron-casting was impossible prior to the introduction of the blast furnace. Only then could a temperature sufficiently high to melt iron be obtained (over 1500°C). Although these were introduced in China in the late 1st millennium BC, they were not used in Europe or the Middle East until the later Middle Ages. Iron tools had to be laboriously hot-forged by hand. Although this may seem a poor replacement for multiple bronze castings, and a far slower process, it may have benefited the metal industry by forcing it to improve its organisation in order to ensure adequate supplies of tools and weapons, which were required in large quantities.

Other basic ironworking processes such as quenching the hot object in cold water to harden the metal, and carburization, the process whereby hot iron in contact with carbon (i.e. charcoal) is transformed into steel, were all aspects of a new kind of metallurgy, completely different from that of bronze-working. Iron was not automatically a better metal than bronze; only the carburized form was really superior. The adoption of iron may owe as much to matters of cost and availability, iron-bearing minerals being much more common than copper ores, as to technical factors.

Iron may first have come to prominence through the use of iron-bearing minerals as fluxes, to remove slag during copper-smelting operations. An early example of iron, a knife from Pella in the Jordan Valley, seems to date from the late Middle Bronze Age, several centuries prior to the Iron Age proper. Throughout the

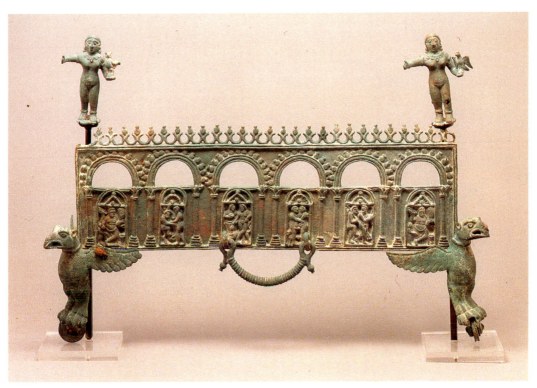

118. Bronze and iron brazier from Mafraq. Umayyad, 8th century AD. Height: 47 cm. Amman Archaeological Museum

Middle East the earliest iron objects seem to have been treated as valuable items, reflecting the metal's novelty prior to its mass production. By the 12th century BC the early stages of the Iron Age, iron jewellery occurred in tombs in the Baq'ah Valley near Amman, and at Madaba. Iron was fully established throughout the Mediterranean area by the 10th century BC, being preferred for weapons, tools and construction work. Bronze was retained for cast or sheet products, for which iron was unsuitable.

As iron was largely the material for everyday tools and equipment, which are rarely found in graves, the source of so much of the most artistic material, our range of ancient ironwork is rather less impressive than that of bronze. Furthermore, iron objects deteriorate badly in the soil. A collection of tools from a 3rd-century AD context at Jerash is therefore of great interest (Plate 119). These were found in a series of small workshops which had been destroyed suddenly, and apparently not looted. The material, which has been painstakingly restored, includes an adze, a compass, callipers, saws, a heavy chopper and a pair of folding iron legs, designed to support a table – in essence the tools of a carpenter's workshop. Such finds are relatively infrequent in Jordanian archaeology.

119. Iron tools from Jerash: a key, callipers and a compass. Roman, 3rd century AD. Jerash, Department of Antiquities

The Metal Industry

The production of metal objects requires an extensive 'support' network. Ores must be mined, then smelted with charcoal to release the metal. This operation requires quantities of timber for charcoal-burning, as well as transport, often over long distances, via several middlemen, of both raw and finished materials. Wood supplies are vital in a relatively arid region like Jordan, where once cut, local timber supplies may have taken some time to regenerate. For these organisational reasons, although village smithing no doubt existed, much metal production was probably in the hands of the main institutions, temples, palaces, or local rulers, who could then control the distribution of the products. In this way metal production formed part of the political process, a means of dominance and control. Unlike other luxury materials, metal can be recycled, hence a degree of control was probably exercised over the circulation of scrap. The sheer scale and complexity of metal production, and the way in which it integrates many different aspects of the political and economic spheres, suggests that the metal industry played an important role in the development of complex societies.

Jewellery

Jewellery has a long history in Jordan. Beads of bone and marine shell and pieces of coloured ochre are known from Epipalaeolithic sites. In all periods materials were sought for their decorative value,

colour, shape or rarity. Materials included stones such as carnelian, turquoise, haematite and coloured copper ores (Plate 120). In eastern Jordan prehistoric sites have been discovered with evidence for specialised production of beads from local stone. Over time, metals came to play an increasingly important role in jewellery production. From the Early Bronze Age gold and silver became key components in the jeweller's art, a tradition which has lasted to the present day.

Gold

There are two main types of gold. Reef gold occurs as an irregular mass, in quartz veins. It is extracted by crushing the material, and sifting the ores – gold mining. Placer gold is found in stream beds, where it has been deposited by the weathering of gold-bearing rocks, and is retrieved by panning.

The early sources of gold are not clear, although Turkey is a favourite candidate. Gold is first noted in Mesopotamia during the 5th millennium BC, and large quantities appear in the 3rd-millennium BC Royal Cemetery at Ur in southern Iraq. Some gold was found at Early Bronze Age Numeira in Jordan, and at Jericho and Khirbet Kerak on the West Bank.

In later times, Egypt was an important source of gold. Letters dating to the 14th century BC found at Tell el-Amarna in Egypt, written by neighbouring rulers (see p. 9), request (among other things) that the pharaoh send them gold from Egypt, where it was said to be 'like dust'. There are references to large amounts of gold booty carried off from Jerusalem after its submission to the Assyrian army of Sennacherib in 701 BC. Looting and tribute-taking must have resulted in the movement back and forth throughout the Near East of large numbers of gold objects over centuries of war and conquest.

The goldsmith could work with relatively few tools: a wooden block, hammer and anvil, chisels, awls, gouges, punches and polishers. Gold can be worked cold, but requires periodic annealing in order to avoid excessive brittleness. The metal is quite easy to beat out into thin sheets, making it an ideal covering for objects made of other materials, a useful deception. Beads can be made by placing a covering of sheet gold over a wooden or bitumen core. Gold vessels were worked-up from sheet, as were those of copper or bronze, and probably shared many stylistic details with their cheaper counterparts. For the addition of fine surface detail, the vessel could be filled with pitch, which provided a firm but yielding surface, and worked from the outside. Techniques employed included engraving, whereby a sharp tool removes a small amount of metal, or tracing, in which a blunt tool is used to compress, but not to remove, the material. Filigree involves the use

120. Necklace of gold, carnelian, faience, stone and ivory, from Tell es-Sa'idiyeh. Late Bronze Age, c. 1550–1200 BC. British Museum

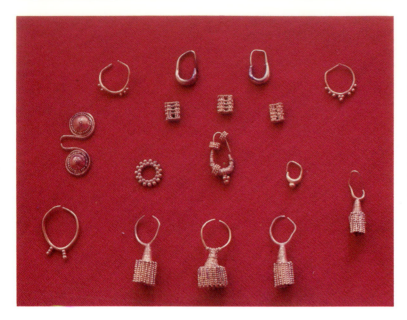

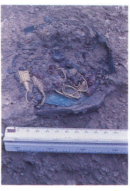

121. Hoard of gold jewellery from Tawilan, near Petra. Above, the hoard as discovered inside a badly encrusted bronze bowl. The style of the jewellery ranges from the 9th to 5th centuries BC. Petra Archaeological Museum

of fine wire to make delicate tracery, while granulation consists of the arrangement of small grains of metal, joined to the underlying material by soldering, or brazing. These and many other techniques are well represented among the gold jewellery presently known from ancient Jordan.

Metal cult-figurines are quite rare in Jordan, but a seated male figure was found in a Late Bronze Age building at Tell Safut, near Amman. Although composed of bronze, it was covered in sheet-gold, no doubt intended to impress. A range of goldwork, including toggle pins, beads and pendants, was recovered from the vicinity of the Late Bronze Age temple near Amman Airport.

Jewellery is better represented among tomb finds, and appears on settlements in occasional 'hoards', the function of which is not entirely clear. 1st-millennium BC sites such as Umm Udhaina and Tawilan provide evidence for a thriving local goldwork industry, producing material that, although rather provincial by international standards, was technically quite skilled, and shows general familiarity with styles current in the wider world (Plate 121). Some pieces from the Tawilan hoard occur in forms which appear elsewhere in silver, rather than gold.

By the classical period, metal jewellery was joined by rings and bracelets in coloured glass, with both glass and gold combined in some examples (Plate 122). There is a fine gold amulet in the shape of a scorpion from a Nabataean tomb at Petra. Cameos are now set in gold. Earrings with gold, pearl and turquoise in combination are known, and a gold fibula was found on the Citadel in Amman.

122. Gold and glass bracelet from Dhat Ras, near Kerak. Roman. Diameter: 7 cm. Amman Archaeological Museum

Silver

Mesopotamian texts of the 3rd millennium BC refer to 'the silver mountain', believed to refer to Anatolia (modern Turkey). Certainly, by the early 2nd millennium BC silver from Anatolia was shipped to Mesopotamia and Syria (and probably indirectly to Jordan) in exchange for tin and textiles. Most ancient silver was obtained from galena, a lead ore, which occurs in several locations in Anatolia. The lead was also used for weights, to form the core of statues, in soldering, and for building: as rivets, clamps for stone, lead sheet and pipes.

Silver is harder to work than gold, being less suitable for forming thin sheets. The addition of a small amount of copper increases the metal's hardness, and such a mix occurs regularly in rings and pins. Objects could also be silver plated, such as the fasteners on a bronze belt from Middle Bronze Age Jericho.

Silver was mostly used for pins, rings, jewellery settings and cult items (Plate 124), and for bowls and dishes. A silver/copper or bronze figurine was recently recovered from a Middle Bronze Age temple at Tell el-Hayyat in the Jordan Valley (see p. 8), and a silver reliquary was found in an early Christian church at Hesban (Plate 125). In Mesopotamia and Syria silver functioned as the standard of value from the late 3rd millennium BC onwards. Land, livestock and various manufactures, as well as legal fines and compensation, could all be reckoned as amounts of silver bullion, and it was used in coinage from the 1st millennium BC onwards.

A Roman cemetery excavated near Queen Alia Airport south of Amman provided useful evidence on the nature and distribution of jewellery among different burials. Copper, bronze and iron rings and anklets were common, gold and silver much rarer. Similarly, most beads were made of coloured glass rather than gemstones. The little truly precious material present was concentrated in a few graves, suggesting an unequal distribution of wealth among the occupants of this cemetery.

Bone and Ivory

Bone was a good material for tools. Hard and strong, bone can take a sharp point, and is readily available, the preferred material being the long bones of grazing animals. Preparation can involve soaking to soften, heating to make splitting easier, shaping with stone blades and polishing with abrasives. Bone was frequently used for harpoons, arrowheads, and other piercing tools such as awls, needles and pins. Some of the tools found in the Pre-Pottery Neolithic B settlement of Ain Ghazal (see p. 4) may be associated with crafts such as weaving and leather working. Bone was also used for beads.

123. Gold statuette of Aphrodite. Roman. Height: 4.2 cm. Amman Archaeological Museum

124. Silver earring from Umm Udhaina, Amman. Persian, 6th century BC. Height: 5.7 cm. Amman Archaeological Museum

In later periods, bone was used as a cheap substitute for ivory. Small decorated bone panels, probably designed as furniture fittings, have been found on several Palestinian Middle Bronze Age sites, including Jericho. Although largely replaced by metal tools, bone continued to be used into much later periods, especially for pins, needles and awls.

The two main forms of ivory in use in ancient western Asia were hippopotamus and elephant ivory. Although African elephants supplied much of the ivory used in Egypt, that from Jordan may well have come from the smaller Syrian elephant, a relative of the Indian branch of the family. Although hunted to extinction by the late 1st millennium BC, these once roamed the marshy, heavily forested river basins of Syria. There are even references to the 15th-century BC pharaoh, Tuthmosis III, killing 120 elephants during a hunt in the 'land of Nii', while on campaign in Syria.

Although there is evidence from southern Palestine for ivory-working as early as the Chalcolithic period, it does not appear in significant quantities in the Levant until the end of the Middle Bronze Age. In common with other luxury items at this time, this may have been under Egyptian influence. Ivory was used in the manufacture of inlay for wooden boxes, such as those from Pella and Tell es-Sa'idiyeh (Plates 126, 127), and to make inlay for furniture, and other small, valuable items such as cosmetic applicators and gaming pieces. The ivory plates on the Pella box show a combination of Egyptian motifs such as papyrus columns, *djed* pillars and *uraeus* serpents, but arranged in such a way as to suggest that their symbolic meaning was not fully understood by the local craftsmen.

Some impression of the range of Levantine ivory work of the Iron Age can be gleaned from the vast quantities of material excavated from the storerooms of the Assyrian kings at Nimrud in northern Iraq. This material formed part of a huge collection of tribute and booty collected from numerous Assyrian campaigns, including several against kingdoms in Palestine and Jordan. Ivory is used by biblical writers as a metaphor for luxury and conspicuous wealth. Nimrud apart, what appear to be hoards of ivory objects are known in Palestine from Megiddo, where they were found along with gold jewellery and alabasters, and from Samaria, where more than five hundred fragments were recovered. Most of this was inlay from furniture which survived less well than the ivories.

By Roman times the Syrian elephant was extinct, and ivory was supplied from North Africa. Ivory statues were added to the repertoire, together with the use of more naturalistic representations on figurative pieces. In early Christian times ivory was made into book covers and reliquaries. Islamic ivory-working continued the same tradition, although scholars have suggested that we can see some changes to the iconography (Plate 128). There was

125. Silver reliquary, from the North Church at Hesban. The cross is ornamented with the symbols Alpha and Omega. Late 6th century AD. Length: 11 cm. Amman Archaeological Museum

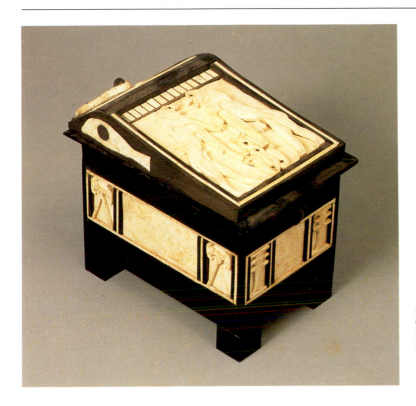

126. Box inlaid with ivory, from
Pella. Reconstruction; the box
would originally probably
have been made of ebony.
Middle Bronze Age IIC,
c. 1650–1550 BC. Height:
13.6 cm. Amman
Archaeological Museum

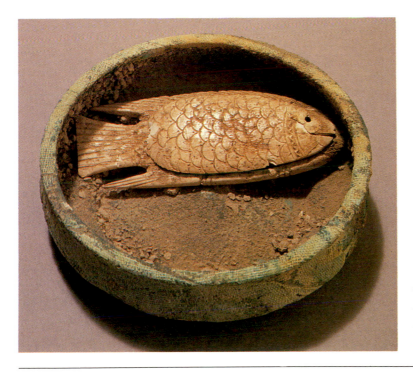

127. Ivory cosmetic box in the
shape of a fish, found inside a
bronze bowl at Tell es-Saʿidiyeh.
The exterior of the bowl is
covered with fabric. Late
Bronze Age, *c.* 1550–1200 BC.
British Museum

greater use of abstract designs based on plant or animal motifs, including eastern motifs such as palm trees, hanging lamps and camels, and a more frequent use of inscriptions, generally religious phrases, used on the ivory components of pulpits and mosque doors. By the 13th and 14th centuries AD ivory for European craftsmen was supplied from Africa, via Mamluk-controlled Egypt.

128. Ivory pyxis from Mafraq, with geometric decoration. Umayyad, 8th century AD. Height: 7 cm. Amman Archaeological Museum

Faience and Glass

The same raw materials – soda, lime and silica – are used in the production of faience and glass. Faience is a composite material, consisting of a body of quartz paste and a glazed surface layer. Faience objects, especially amulets, pendants and seals, were often formed in a mould, dried and then fired.

Faience first appeared in the Near East around the end of the 5th millennium BC, but faience vessels first appeared in Jordan around the 17th century BC. Jordanian faience is often taken as being of Egyptian inspiration, but is locally made. A number of examples come from Middle Bronze II tombs at Jericho. Formed by hand, round a core, flat and round-based bottles are the most common shapes (Plate 129). Decoration is often in blue or green glaze bearing linear or floral designs in matt black. There is now increasing evidence for the existence of a thriving faience industry in western Syria during the Middle Bronze Age, with evidence for workshops at sites such as Meskene and Ras Shamra. A drop-shaped vessel bearing a cartouche (a decorative knot containing a royal name) of the Egyptian ruler Tawosret, dated c. 1200 BC, was found on a temple site at Tell Deir Alla, suggesting that faience vessels were still being imported at that time. Production peaked during the late 2nd millennium BC, and although faience continued to be made, its role was overtaken by glass in later periods.

Glass has a non-crystalline structure, as the silicate materials are completely fused in the melt, which thus maintains some of the characteristics of a liquid, even in its cooled, solid state. Unlike faience, glass production is a 'hot' process, the object being formed while molten. Metal ores are used for colouration: copper for blue, manganese oxide mixed with ferric oxide for black, calcium antimonate for white, and so on. The multicoloured effect visible on the surface of many ancient glass objects is a patina, caused by the leaching of salts in the original mix, and is not intentional.

There are several methods of forming glass objects. Core-forming was the earliest method, involving the application of molten glass to a hollow core of mud or clay formed around a metal rod. Glass and faience pendants were cast in simple open moulds from quite early on. An important change came during the 2nd century BC, with the appearance of more sophisticated casting

129. Faience bottle from Jericho. Middle Bronze Age IIC, c. 1650–1550 BC. Height: 7.5 cm. Amman Archaeological Museum

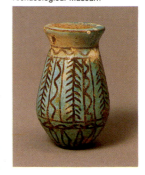

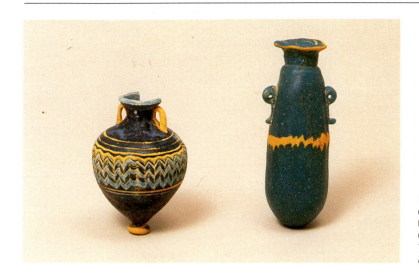

130. Glass amphoriskos and alabastron from Umm Udhaina, Amman. Persian, 6th–5th centuries BC. Height: 7.2 cm. and 9 cm. Amman Archaeological Museum

procedures. For example, vessels could now be formed between two interlocking moulds, an inner and outer, glass powder or molten glass being inserted in the space between the two moulds, and then heated. Glass-blowing probably first appeared in Syria during the late 1st century BC. It involved the use of a pipe, through which the craftsman could blow the molten glass, permitting the production of a wider range of shapes. This innovation made glass production faster, cheaper and so more widely available. Glass objects were also produced by the lost-wax method, a process originally developed for the metal industry, which was particularly suitable for complex shapes.

Glass production probably developed against a technical background derived from faience-making, most likely in Syria or northern Iraq around 1500 BC. The first glass products were polychrome, core-formed vessels (Plate 130). Although shapes changed, core-formed vessels comprised the bulk of glass production throughout the 2nd and most of the 1st millennia BC. However, by the Hellenistic period, variegated, multicoloured glass was being replaced by vessels composed of one colour only. The other main application of glass in its early stages was in the production of simple cast-glass amulets, pendants and figurines, and beads imitating precious stones. Clear glass had appeared in western Asia by 700 BC.

Until the late 1st millennium BC, glass and faience were largely luxury items. Most were produced in workshops belonging to palaces and temples, and they are mostly found in special contexts like wealthy graves or in association with major buildings.

The combination of mould-made glass, and a little later the advent of glass-blowing, had an important effect on the industry. It

131. Glass bowl from Muhayy. Roman-Byzantine, late 3rd–early 4th century AD. Diameter: 11.5 cm. Kerak Archaeological Museum

resulted in a major increase in the speed of production, leading to greater availability and lower prices. Large glass bowls and other tableware now appeared, perhaps in part replacing ceramic and metal vessels in this role. Soon after this invention the development of glass-blowing led to the appearance of a far wider range of products, including, for the first time, glass storage vessels. Alongside the appearance of blown glass there was a proliferation of various forms of cast, mould-made glass, in particular linear-cut, ribbed and faceted bowls. The classical period also saw more glass used in jewellery and as inlay. Major glass industries are known to have existed in Syria and Alexandria, and although we know very little about provincial centres, glass was being made in Hebron in Palestine by the 9th century AD.

Translucent glass vessels are most common in the Roman period. During the Byzantine period stemmed goblets and long-necked vessels appeared (Plates 131, 132). Glass vessels with trailed decoration became characteristic Syro-Palestinian products. During this period production of small glass pendants continued, usually mould-made, often in the shapes of animals or miniature glass vessels (Plate 133). Glass was also used for jewellery, with rings and bracelets in coloured glass appearing in both plain and twisted forms. Examples of similar bracelets decorated with applied, twisted strands of glass in contrasting colours, are known from the Mamluk period, when the technique was especially popular. Window glass too appeared during the Roman period, and was widely used in later churches. During the early Islamic period, small glass panes set in stucco were used as architectural ornamentation. Throughout these centuries a blue-green glass was the norm, and glass was no longer an exclusive, luxury material.

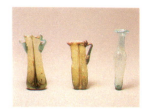

132. Roman-Byzantine glass vessels: left, from Qweilbeh, 4th–5th centuries AD, Amman Archaeological Museum; centre and right, from Muhayy, late 3rd–early 4th century AD. Kerak Archaeological Museum

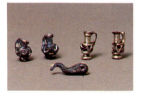

133. Glass lockets from Gadara-Umm Qais. Roman, 3rd–5th centuries AD. Amman Archaeological Museum

Further reading

R.D. Barnett, *Ancient Ivories in the Middle East*. Qedem 14, Jerusalem 1982.

D.B. Harden, *Glass of the Caesars*. British Museum Publications 1987.

R.A. Higgins, *Greek and Roman Jewellery*. Methuen, London 1980.

K.R. Maxwell-Hyslop, *Western Asiatic Jewellery: c. 3000–612 BC*. Methuen, London 1971.

P.R.S. Moorey, *Materials and Manufacture in Ancient Mesopotamia: The Evidence of Archaeology and Art. Metals and Metalwork, Glazed Materials and Glass*. British Archaeological Reports 237, Oxford 1985.

The Mosaics of Jordan

A hundred years after the discovery of the first mosaic at Madaba in December 1880, a year in which ninety Christian beduin families began to build themselves houses amongst the ruins of the ancient tell where they had sought refuge, we can now assert that Jordan is a privileged region for this art form. The geographical area that most concerns the study of mosaics is that between the River Yarmuk and the Wadi Mujib-Arnon, and from the River Jordan to the steppe.

The best represented period is the Byzantine-Umayyad, which dates from the 5th century to the 7th century AD. However, there are also mosaics from the Roman period. The surviving fragment of the floor mosaic that decorated the *apoditerium* of the baths in the Herodian palace of Machaerus – the traditional site of the imprisonment and execution of John the Baptist – dates to the 1st century BC. The mosaic composition known as the *Mosaic of the Muses and of the Poets* that decorated a room of a patrician palace at Gerasa (Jerash) dates to the 3rd century AD.

The Byzantine-Umayyad period may be divided into two periods with their own technical and stylistic characteristics: the Byzantine period (from the second half of the 5th century to the first half of the 7th century AD) and the Umayyad period (from the second half of the 7th century to the 8th century AD). Within these two periods we may distinguish functionally between the decorative programmes of the holy places, such as churches, monasteries and their annexes, and the programmes which decorated civilian buildings with public or private functions, such as public baths, patrician houses of the Byzantine era and the castles of the Umayyad period.

The decorative schemes of the holy and profane places have a common denominator in that all the surviving mosaics are floor mosaics. There remain only glass *tesserae* and small, insignificant fragments collected during excavations to testify to the existence of wall mosaics that decorated the walls and the apses of churches, such as the Moses Memorial on Mount Nebo, the cathedral at Madaba or the Church of St Stephen at Umm er-Rasas.

The laying of the mosaics is technically uniform. The *tesserae*, usually obtained from local stone, were laid down by the craftsmen on a fairly thick layer of wet lime, which was spread out at the

moment of laying the mosaic over a previously prepared bed. This bed was made up of a homogeneous mass of rounded gravel in an impermeable layer of wet *terra rossa*, the whole being covered by a layer of lime and ash.

The mosaics of the churches are characterised by numerous inscriptions which are a part of the decorative scheme. These inscriptions are of great importance for the dating of the mosaics themselves and for following the development of mosaic art in the area. Here we may read the names of the bishops of the bishoprics, of the clergy and the patrons, formulae of faith and occasionally also the names of the mosaic craftsmen who signed their work. Historically, such inscriptions integrate the scanty historical data of the contemporary literary sources. Thanks to these inscriptions we are able to rewrite, even if only partially, the history of the Christian community of the dioceses into which the whole of Jordan was divided.

In the Byzantine period the modern state of Jordan was divided into four imperial provinces:

1. Provincia Arabia, with Bostra (today in Syria) as its metropolis. The diocesan territory extended south of the present-day Jordanian border, and included the cities of Gerasa-Jerash, Philadelphia-Amman, Esbous (Hesban) and Madaba and the area up to the Wadi Mujib-Arnon.

2. South of the Arnon was the province of Palaestina Tertia with Petra as the capital.

3. The territory between Arabia and the River Jordan, with the cities of Livias, Gadara, Amathus and Bacatha, was under the control of Palaestina Prima with Caesarea Maritima on the Palestinian coast as the capital.

4. Continuing towards the north, the territory of the city of Pella, in the valley of the River Jordan, and of Capitolias, Abila and Gadara on the plateau to the south of the River Yarmuk, was part of Palaestina Secunda with Beth Shan Nysa-Scythopolis on the West Bank as its metropolis.

Mosaics have recently been unearthed in the basilicas at Pella, at Gadara in the north (in the baths of Erakleide and in a church), and in the vicinity of Irbid, the ancient city of Arbela on the border with the territory of Pella and Capitolias (the churches of Yasileh and of Qom), in the village of Shuneh al-Janubiyah in the territory of Livias, and in the village of Zay, in the territory of southern Gadara. The excavation of Deir ʿAbbata near Zoara, south-east of the Dead Sea, is yielding the first mosaic floors of Palaestina Tertia.

The more numerous pieces, better preserved and more representative, come from the territory of Provincia Arabia.

Rihab and Khirbet es-Samra

In the southern territory of the metropolitan city of Bostra, so far we have the decorative schemes of about fifteen churches and chapels in the villages of Rihab and Khirbet es-Samra, whose mosaics were laid towards the end of the 6th century AD and in the first three decades of the 7th century AD. In these mosaics geometric motifs prevail, although some figurative motifs are also included which were systematically damaged during the iconoclastic crisis (the period in the 8th and early 9th centuries AD when a movement condemning religious images and pictures was powerful in Byzantium).

Historically, the epigraphically rich mosaics of the two villages are the best evidence for revising an opinion held among archaeologists and historians, according to which the Persians, who occupied the region from AD 614 to 629, brought mourning and destruction in their wake. At least two churches of the village of Rihab, St Stephen and St Peter, were built and decorated with mosaics in AD 620 and 623 respectively, in the middle of the Persian occupation. Other churches, such as St Menas and St Isaiah at Rihab and that of St George at Khirbet es-Samra, were built in AD 634/5, during the Arab-Islamic occupation of Bostra. The armed struggle between the tribes coming from the Hijaz and the Byzantine Empire was evidently not felt in a dramatic way. The inhabitants of the two villages continued their daily lives as if nothing untoward was happening.

The mosaic craftsmen involved with the decoration of the churches of the two villages probably came from nearby Gerasa, to judge by the Nilotic motif in the Church of St John at Khirbet es-Samra, which repeats the motif of two vignettes of Egyptian cities, Alexandria and Memphis, used in the Church of the Holy Apostles Peter and Paul at Gerasa.

Jerash

Gerasa-Jerash was an important centre of mosaic art in Provincia Arabia during the Byzantine era. Except for the basilica of St Theodorus, which has an *opus sectile* floor, all the other churches were given mosaics. Thus we have decorative schemes that date from the 5th century AD (mosaic in the rear courtyard in the cathedral complex) to the first decade of the 7th century AD (the chapel of Elijah, Mary and Soreg; Plates 134, 135), with peaks in the Justinianic period, in the first half of the 6th century (e.g. the mosaic in the synagogue, the mosaics of the three adjoining

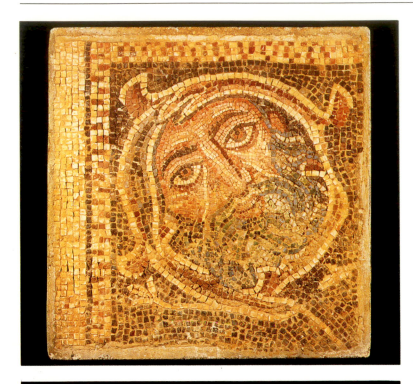

134. Mask (Personification of a River of Paradise?). Jerash, Chapel of Elijah, Mary and Soreg. First decade of the 7th century AD. Height: 71 cm. Jerash Archaeological Museum

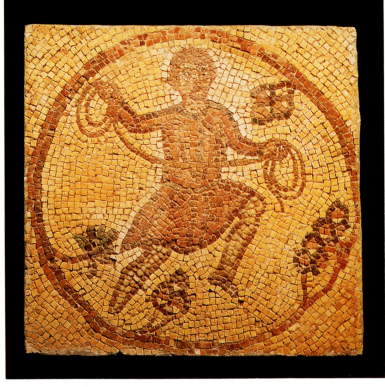

135. Hunter with lasso. Jerash, Chapel of Elijah, Mary and Soreg. First decade of 7th century AD. Height: 70 cm. Jerash Archaeological Museum

churches and in the church of the bishop Isaiah). The only biblical motif is that in the synagogue, in which Noah and his family are pictured leaving the ark after the flood. At the time of excavation all that remained were details of the heads of Shem and Japheth, the dove with the olive branch, and various groups of animals.

The richest and most complex compositions are those which decorated the three adjacent Churches of St George, of the Holy Martyrs Cosmas and Damian and of St John, mosaics which were installed between AD 529 and 533. In the church with a central plan, St John's, the space was divided into three sectors. The area formed by the four columns which supported the roof was enclosed by a border with a perspective meander alternating with the personification of the months. The central field was divided by curving grapevines. A large border ran the length of the internal perimeter of the church. The band was composed of acanthus roundels, particularly brightly coloured, animated with birds, running animals and human figures. The lunette of the four *exedrae* of the church was decorated with a fantastic candlestick made up of four superimposed pyramidal levels. The two irregular spaces between the band and the central field, to the north and to the south, contained an elaborate Nilotic scene depicting views of the cities of the Delta, fish, birds and aquatic flowers. The river bank was populated by persons travelling on or with their donkeys.

In the mosaic of the Church of the Holy Martyrs Cosmas and Damian there were depicted the patron Theodorus with his wife Georgia, and two young benefactors bringing gifts, Callinistos and John the son of Astricius. An inscription inserted in the geometric pattern of the field refers to the financial contribution of the tribune Daghisteus, one of Justinian's generals who participated in the erection and embellishment of the church. In the year AD 565 the propylons that united the eastern quarter of the city with the temple of Artemis were converted into a church. An *exedra*, opportunely adapted to the new purpose, became a deaconry. The circular floor was provided with a mosaic with a splendid composition of interwoven geometric designs, which closes the golden era of mosaics at Gerasa.

Amman

In comparison with Gerasa and other towns of Provincia Arabia, Philadelphia-Amman is poor in Christian monumental buildings. The few mosaics hitherto discovered both in the town and in its territory are of modest technical quality. In the town mosaics have been found in the church and in a chapel on the acropolis. Out of town mosaics have been brought to light in the churches of Jubeiha and of Quweismah, and in the chapels of Jebel el-Akhdar, of Khirbet el-Kursi and of Suwayfiyah.

The best preserved mosaic is that in the chapel of Suwayfiyah, laid in the time of the bishop Thomas in the second half of the 6th century AD. A small tree between two birds decorated the space above the entrance. The nave of the chapel was enclosed by a narrow border of acanthus roundels with animals, birds and leafy masks above the corners. Roundels of grapevine tendrils spanned the internal space of the field, decorated with scenes depicting hunting, grazing animals and harvesting, as well as the transporting of building stone on a camel's back.

Historically the most important mosaic is that in the floor of the smaller church at Quweismah dated to AD 717, in the Umayyad period. The double nave of the church is decorated with two independent geometrical compositions enclosed in a plait. The better preserved motif in the southern nave is composed of an interlacing of lozenges and squares decorated with stylised buildings, flowers and geometrical motifs. A peculiarity of the church is the inscription in Christian Palestinian Aramaic in the vicinity of the step of the presbyterium, which repeats the names of the benefactors in the language spoken by the population, names that could also be read in the long dedicatory inscription in Greek over the entrance.

Hesban

Within the three churches hitherto identified and partially explored on the tell of Hesban-Esbous, the most significant mosaic is the lower one in the presbyterium of the northern church, decorated with Nilotic motifs. In the village of Massuh, 3 km. east of the town, under a mosaic of the second half of the 6th century, there has been found an intact 5th-century mosaic of good workmanship that decorated the primitive church of the village. The border with interlaced crosses, measuring c. 16 m. in length by 2.5 m. in width, decorated the centre of the church, which otherwise was covered uniformly with white *tesserae*. The geometric motif was interrupted in the centre by a medallion with a lamb tied to the branches of a small tree.

Madaba

In this brief survey of the mosaics of Jordan special reference should be made to the town of Madaba. As a result of the high number of mosaics and the quality of those so far discovered both in the town and its diocesan territory, Madaba is an important centre of mosaic artistry in the empire, famous among scholars as the School of Madaba. On the slopes of the acropolis and on the flattish area to the north, on to which the town had extended in the Romano-Byzantine period, mosaics have so far been found in churches, rooms in private houses, and shops.

Among the numerous churches, we should particularly consider, in the southern quarter, the baptistery complex in the courtyard of the cathedral, with the Chapel of St Theodorus dating to AD 562, to the south, and the baptistery chapel built in AD 576, to the north, which covered an earlier baptistery chapel dating to the beginning of the century.

The mosaic of the Chapel of St Theodorus has a rectangular panel enclosed by an acanthus border animated with hunting and pastoral scenes. Four eagles with outstretched wings and with bells around their necks are placed in the corner roundels. The field is covered by an orthogonal composition of *scuta* crosses with the resulting octagons decorated with individual motifs from harvest and pastoral scenes. The four octagons in the corners carry the personifications of the four rivers of Paradise: Gihon, Pishon, Tigris and Euphrates. Two lambs tied to a small tree decorate the area in front of the font in the baptistery chapel. The rest of the *aula* of the chapel was decorated with a continuous series of birds, fish, fruits, trees and baskets inserted in a net of flowers enclosed by a border decorated with scenes of hunting and pastoral activities.

Further south stood the Church of the Apostles, decorated with mosaics in AD 578 by the artist Salamanios, who inserted into the centre of the nave the medallion with the personification of the Sea, superimposed over the geometrical pattern obtained by the systematic repetition of pairs of facing birds (Plate 136). In the medallion, which measures 2.2 m. in diameter, the Sea is represented as a woman emerging half-naked from the waves amid the frolicking of fish and other marine creatures. Like the goddess Thetis of classical mythology, the Sea is depicted as a half-bust with her breasts partly uncovered, loose hair framing the oval face with large eyes, right hand lifted, with bracelets that enhance the wrist and forearm, and holding a raised oar like a standard. The figurative motifs that decorate the acanthus roundels of the border are particularly colourful (Plate 137). In the central roundel on each side the artist has furthermore inserted a child playing with a bird, a motif from the little circus of Hellenistic-Roman tradition. The space above the entrance, facing outward, is occupied by a pair of bulls and rams facing an acanthus bush.

In the northern quarter, along the *cardo* that crosses the residential quarters from east to west, once stood the Church of the Prophet Elijah with a crypt dedicated in AD 596, in front of the Church of the Virgin. The mosaic of this church, built over the area already occupied by the ruins of a *nymphaeum* of Roman date and by a room of the first half of the 6th century AD, was relaid in the Umayyad period, in the time of the bishop Theophanes. Further west stood the Church of the Khadir, its mosaics showing a rich repertoire of hunting scenes.

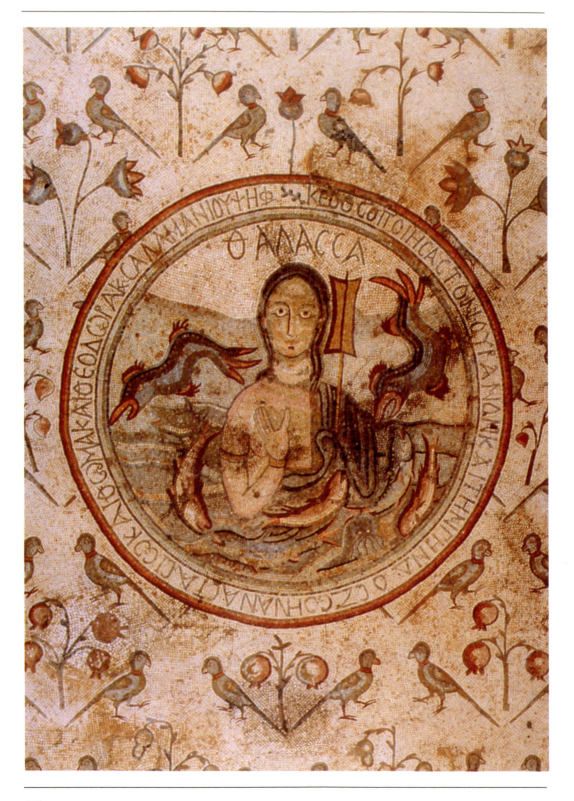

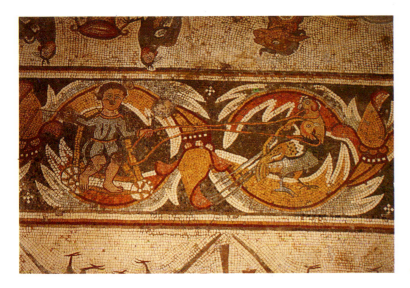

137. Hunting scene. Madaba,
Church of the Apostles. AD 578

To the north was the Church of the Map, which takes its name from the geographical mosaic of the Promised Land, to which Madaba owes its fame among scholars (Plate 138). The mosaic was discovered during the construction of the parochial church of the Greek Orthodox community in 1898. Most probably the map did not extend further than the limits of what remains of the interior of the church, 15.7 m. in length by 5.6 m. in width. The approximately 150 place-names on the map refer to sites in the Middle East from Tyre and Sidon in the north to the Nile Delta in the south and to the Mediterranean Sea in the west, and as far east as the Arabian desert, a territory which in the Bible corresponds to the limits of the land promised to Abraham. In the most extensive fragment the physical characteristics of the Palestinian zone are rendered with a pictorial realism which makes them easily recognisable: from the central axis formed by the course of the River Jordan and by the Dead Sea there extend to the east the mountains of Moab and Edom, and to the west the mountains of Samaria and of Judaea well distinct from the coastal plain that borders on the Mediterranean Sea. The focus of the mosaic is the Jerusalem vignette which, in some ways, is the ideal centre of the composition. The town, seen from a bird's eye view, is represented with partially identifiable walls, gates, streets and principal buildings. The *cardo* is dominated by the Constantinian complex of the Basilica of the Holy Sepulchre. Artistically, the map should be seen in the context of the classicising rebirth of the Justinianic era, securely dated towards the middle of the 6th century AD.

Among the mythological scenes that decorated the rooms of private dwellings, such as the Bacchic procession, Achilles and

136. (OPPOSITE) Medallion with the personification of the Sea. Madaba, Church of the Apostles. AD 578

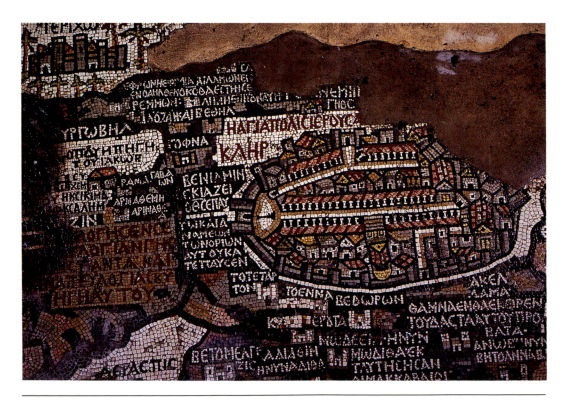

Patroclus with two Erotes crowning a maiden, Heracles strangling the Nemean lion, and the reclining woman of a house of the northern quarter, the decoration of the room of Hippolytus has reached us virtually intact. It was discovered in two stages, in 1905 and in 1982, under the Church of the Virgin along the *cardo* of the town. A broad acanthus border marks out the central area of the mosaic, which is divided into three rectangular panels. Pairs of facing birds decorate the spaces in between the engaged pilasters on the northern and southern walls. In the roundels of the border are depicted hunting and pastoral scenes, with the busts of the personified seasons in the corners. The first panel of the field, to the west, carries floral and faunal motifs, influenced by the Nilotic repertoire. In the central panel are depicted the personages of the Euripidean drama of Hippolytus: the maidens assist Phaedra, ailing from love, while the nurse turns to Hippolytus, accompanied by the administrators and by a servant holding a horse by the reins. In the third panel, Aphrodite, seated on a throne next to Adonis, threatens with her sandal a cupid who is being held out to her by one of the Graces. The scene continues with the other two Graces running after the cupid and the whole is concluded by a peasant woman returning from the fields laden with fruit. In front of the door, in the irregular space between the border of the field and the eastern wall of the room, are two marine monsters facing each other, and the cities of Rome, Madaba and Gregoria (the latter unknown) are depicted as Tychai (Fortunes) seated on thrones with staffs topped by crosses in their right hands. Despite its isolated position, the mosaic fits well stylistically amongst the works of the mosaicists of Madaba in the middle of the 6th century AD, because of its technical quality and figurative wealth.

Mount Nebo

In the diocesan territory the major discoveries are centred around Mount Nebo (Plate 139), in the village of Ma'in and in the town of Kastron Mefaa – Umm er-Rasas. On Mount Nebo we have the mosaics of the Memorial to Moses on the Siyagha peak beginning in the second half of the 4th century AD; the mosaics of the small village churches of Nebo on the peak of Khirbet el-Mukhayyat that date from the second half of the 5th century to the middle of the 6th century AD; and the mosaics of the churches in the valley of 'Ayoun Mousa to the north of the mountain which date to the first half of the 6th century AD.

In the Basilica of Moses, the most significant work is the mosaic that decorates the ancient *diakonikon*-baptistery of the sanctuary, excavated in the summer of 1976 (Plate 140). The mosaic, signed by the craftsmen Soelos, Kaiomos and Elijah, was financed by imperial functionaries and completed in August of AD 531. The

138. (OPPOSITE) Mosaic map of the Holy Land (ABOVE), with detail showing Jerusalem (BELOW). Madaba, Church of the Map. Mid-6th century AD

139. Mount Nebo, the Siyagha peak

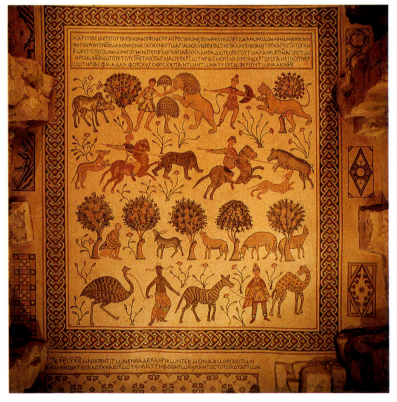

140. Mosaic in the *diakonikon*-baptistery of the Basilica of Moses, Mount Nebo. AD 531

decorative programme of the pavement includes a panel with floral crosses facing the entrance stairway, the central field enclosed in a plait with hunting and pastoral scenes arranged in four registers and a fish-scale motif which surrounds the cruciform baptismal font that occupied the eastern end of the chapel. In the first register of the field a young shepherd is depicted defending a zebu tied to a tree from the attack of a lion. There follows a soldier with a Phrygian cap, armed with a lance and shield, transfixing a lioness that is launching herself at him. In the second panel two hunters are riding horses accompanied by dogs, while transfixing with their lances a bear and a wild boar. In the third panel a shepherd is seated on a stone in the shade of a tree, gazing at a flock of sheep and goats that are grazing the leaves from the trees which highlight the scene. In the fourth scene two further hunting motifs are depicted: a negro is bringing an ostrich tied to a rope and a young man with a cape and Phrygian cap is holding a zebra and a camel.

In the first decade of the 7th century AD, at the time of the bishop Leontius of Madaba, the Chapel of the Virgin on the southern side of the basilica was built and furnished with mosaics. A rectangular panel, with gazelles facing two flowering bushes and with two bulls facing an altar covered by a *ciborium* inside an apsidal building, decorated the area of the presbyterium of the chapel. The citation from Psalm 51:21 ('Then they will offer bulls on your altar'), added above, explained the scene as an illustration of the biblical verse and implied to the viewer that the apsidal building was the temple at Jerusalem with the altar of the sacrifices outside and the altar of the offerings inside. The only well-preserved animal is a gazelle with a bell around its neck, rendered with taste and skill.

In the village of Nebo the two mosaics of the Church of SS Lot and Procopius and of the upper Chapel of the Priest John (Plate 141) were laid by the same team of craftsmen, operating at the time of the bishop John, whom we know was in office in AD 562. The meandering border which encloses the field of the Chapel of the Priest John was decorated with a series of birds alternated with portraits of the patrons (Plate 149). The internal field is subdivided by a *tympanum* which encloses a dedicatory inscription and four series of acanthus roundels with hunting, pastoral and agricultural scenes. At the centre of the composition is depicted the classical theme of the generous and fruitful Earth figured between two young fruit- bearers.

The hunting, pastoral and harvesting scenes are repeated in the roundels formed by grapevines in the central field of the Church of SS Lot and Procopius, which is subdivided into two panels. In the western panel, showing four trees placed at an angle, there are four pairs of animals facing each other. Motifs from the Nilotic repertoire, rendered with particular delicacy, decorate the intercolumnar spaces: aquatic birds rest on the water, in which

141. Woman with a basket.
Detail from the mosaic in the
Chapel of the Priest John,
Khirbet el-Mukhayyat. Time of
the bishop John, AD 562.
Height: 200 cm. Mount Nebo,
Department of Antiquities

multicoloured fish swim intermingled with nymphs; two
web-footed birds face a flower; two marine animals with their tails
tied together face a flower on which a bird is perched; and a river
landscape with a church between a boatman and a fisherman with a
fishing-line.

On the acropolis of the village the Church of St George, built
and provided with mosaics in AD 536 in the time of the bishop
Elijah of Madaba, was excavated in 1935. The mosaic was laid by
the craftsmen Naouma, Kiriacos and Thomas. The field in the
central nave, surrounded by a meandering border alternating with
square panels containing the busts of the Seasons, a large mask and
floral and animal motifs, was decorated with four sets of grapevine
roundels, with agricultural and hunting scenes and the
personification of the generous Earth. The portrait of a patron
added to a palm-tree in between two peacocks was depicted in the
side nave over the entrance of the north doorway.

A mosaic dating to the second half of the 5th century AD, in the
time of the bishop Fidos of Madaba, was brought to light in the

142. (OPPOSITE) Mosaic in the
Church of the Deacon
Thomas at 'Ayoun Mousa,
Mount Nebo. First half of the
6th century AD

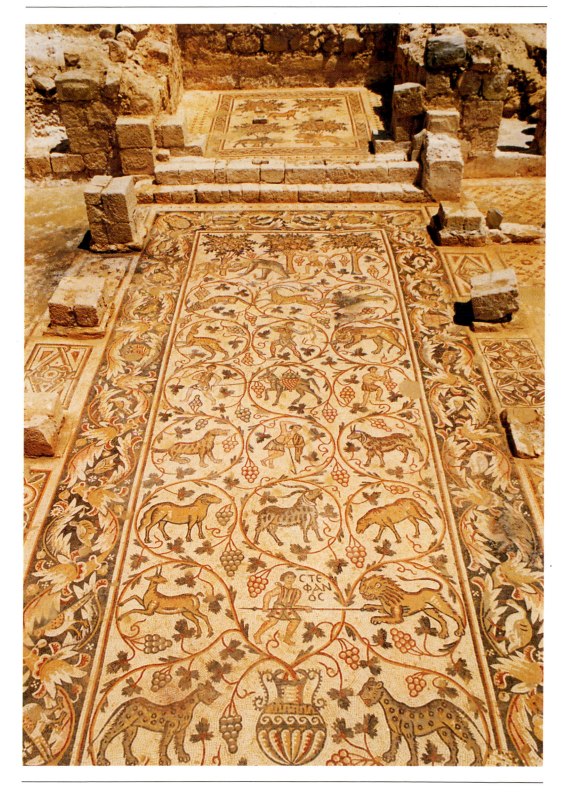

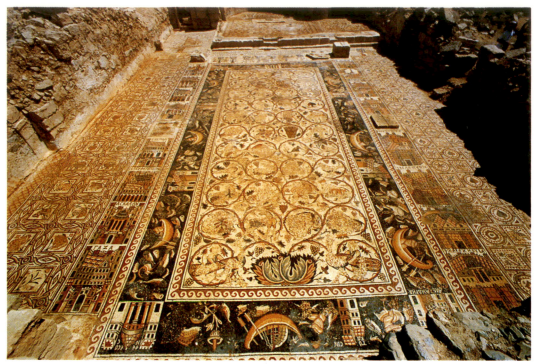

143. The mosaic floor in the Church of St Stephen, Umm er-Rasas – Kastron Mefaa. 7th century AD.

Chapel of the Priest John, once the mosaic above had been removed for restoration. The decorative scheme is, at least in part, similar to the mosaic in the upper chapel with the meandering border band and the grapevine roundels decorated with hunting, pastoral and harvesting scenes. The draughtsmanship of the mosaic is, however, rather rigid and imprecise, typical of the earliest mosaics so far discovered on Mount Nebo.

Another mosaic of excellent quality dating to the first half of the 6th century AD was brought to light in the summer of 1987 in the Church of the Deacon Thomas in the valley of 'Ayoun Mousa (Plate 142). The raised presbyterium is decorated with a double series of trees among which are depicted a lamb and a lion facing a zebu. The central nave is enclosed by a band border of acanthi animated with birds and fruit and with leafy masks in the corners. Two tendrils that emerge from a two-handled vase, situated at the centre of the western side, generate eight superimposed ranges of three circles each, decorated with hunting, harvesting and pastoral scenes. Three trees end the composition to the east, with a man picking pomegranates in the centre. In the southern nave, in the lattice of flowers, there is a medallion with an eagle with outstretched wings accompanied by the Greek letters alpha and omega which give a symbolic, christological character to the motif.

Although it stays within the same figurative context of the Church of SS Lot and Procopius, the mosaic achieves a far superior result in terms of calligraphy and colour, especially in scenes such as that of two goats of the flock, the greyhound attacking the leg of a deer and the fox eating grapes from the overturned basket.

Ma'in and Umm er-Rasas – Kastron Mefaa

Two splendid mosaics of the Umayyad era decorated the church on the acropolis of Ma'in and the Church of St Stephen at Umm er-Rasas – Kastron Mefaa, excavated in 1986. In both mosaics the leading motifs of the decorative scheme are vignettes of towns. In the church of Ma'in, at the time of excavation, there remained only eleven vignettes of regional towns to the east and west of the River Jordan. In the mosaic of the Church of St Stephen, which has come down to us intact (Plates 143–7), we have twenty-eight vignettes of towns that accompany the elaborate decorative programme, rich in inscriptions, portraits of the patrons, and in hunting, pastoral and harvesting scenes. Sixteen vignettes decorate the intercolumnar spaces with two continual registers of towns in Palestine and Transjordan, beginning with the Holy City of Jerusalem and with the vignette of Kastron Mefaa, to which should be added two vignettes in the lateral naves and ten vignettes of towns in the Egyptian Delta beginning with the city of Alexandria.

Together with the mosaics of the Church of the Virgin at Madaba, and the mosaics at Quweismah and at Shunagh, these mosaics are a precious historical testimonial to the survival of the Christian communities in the Umayyad period and for the continuity of mosaic art in the area. The mosaics that decorate the mosques and the Umayyad palaces of Qasr al-Hallabat (Plate 148), of Qasr Amra and Qasr Hisham at Jericho, should be seen from this historical perspective as the work of the same local workshops of mosaic artists and craftsmen that were active in Jordan from the 5th to the 7th centuries AD.

The Character of Jordanian Mosaics

The mosaics that we have considered come from a geographically vast and administratively diversified territory. However, the mosaics show certain common characteristics when compared with contemporary mosaics of neighbouring areas. These characteristics stand out particularly in the mosaics of the Madaba region, where the art of the mosaic in Jordan reached its peak.

In terms of formal composition the mosaicists of Jordan preferred to break up large surfaces by miniaturising larger and more articulated compositions. For this reason the motifs of

144. (OVERLEAF, LEFT) Detail of Transjordanian sites, Church of St Stephen, Umm er-Rasas – Kastron Mefaa. 7th century AD.

145. (OVERLEAF, RIGHT) Detail of Palestinian sites, Church of St Stephen, Umm er-Rasas – Kastron Mefaa. 7th century AD.

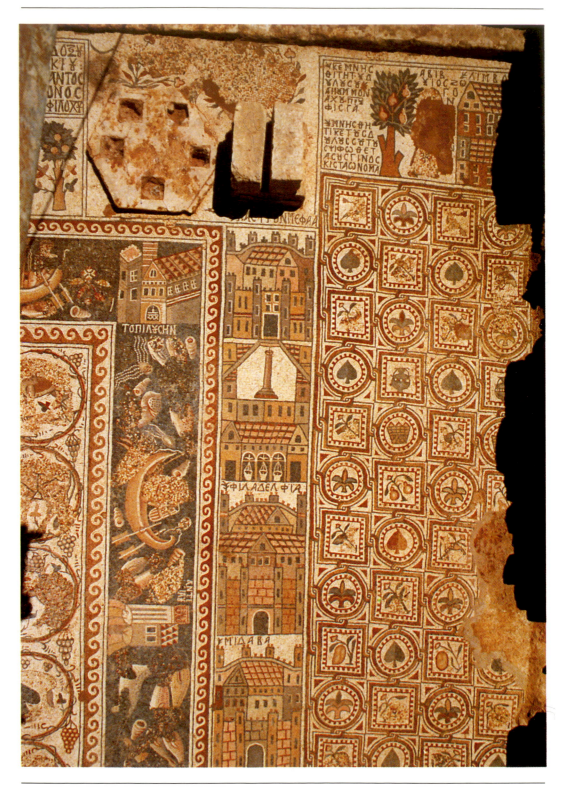

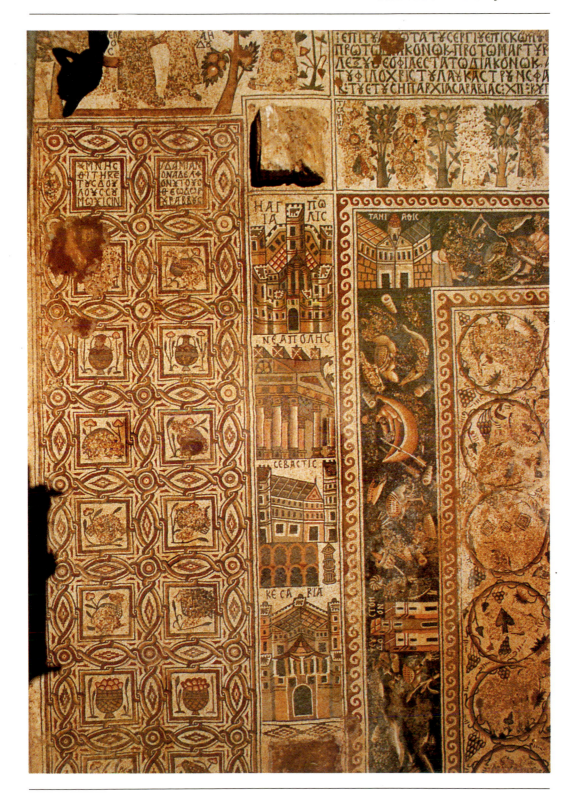

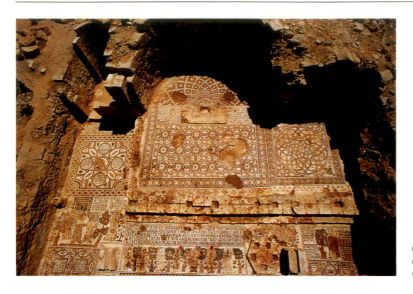

146. The presbytery of the Church of St Stephen, Umm er-Rasas – Kastron Mefaa. 7th century AD.

individual scenes are rendered independently in roundels of acanthus or grapevine tendrils.

Technically and stylistically, a characteristic of 6th-century AD mosaics is the frontal depiction of figures, with fragments of *tesserae* used for the flesh tones, almost as in painting. This technical characteristic is missing in the more ancient mosaics, as in the figures of the lower Chapel of the Priest John at Nebo and of the lower mosaic of the church of Kaianos in the valley of ʿAyoun Mousa.

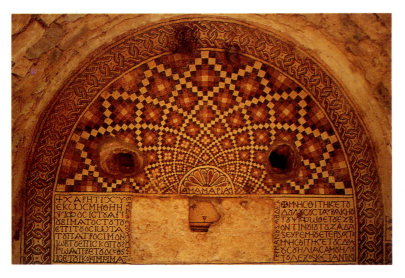

147. One of two dedicatory inscriptions of the Church of St Stephen at Umm er-Rasas, near the altar. Dated to AD 756, it identifies the mosaicist, Staurachios of Hesban, the first mosaicist in the region whose place of origin is known

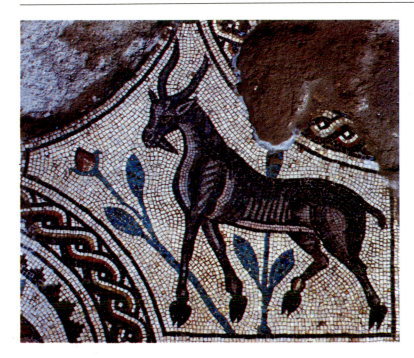

148. Gazelle on a mosaic
floor at the Umayyad palace
of Qasr el-Hallabat

In terms of content, Jordanian mosaics are characterised by
representations of buildings, as at Khirbet es-Samra in the north, in
the churches at Gerasa, Zay and Quweismah, but above all in the
mosaics of Madaba, Nebo, Ma'in and Umm er-Rasas – Kastron
Mefaa. Hitherto unsurpassed in this kind of representation remains
the map at Madaba.

The mythological scenes in the secular buildings, contemporary
with the classical personifications that decorated the mosaics of the
holy buildings, such as the Sea, the Earth, the Seasons, the Tychai
of the cities, the Rivers of Paradise and the leafy masks, testify to
the rebirth of a classicising taste that reached its greatest popularity
in the Justinianic period. These are classical themes which lie at the
very origin of the art of the mosaic in the Hellenistic-Roman
period. The other, more widespread, figurative themes of hunting,
fishing and pastoralism also look back to this period for models.

Taking into account the rich repertoire of contemporary mosaics
laid in the Mediterranean area, we must recognise that the mosaic
artists of Jordan were inspired by topical pattern drawings in their
choice of compositions. These drawings reached them in
handbooks compiled in the cultural centres of the empire, where
they had developed and taken root, in a long and slow evolution.
The originals of the Hellenistic-Roman period came back into
vogue because of the current classicising tastes. To these tastes
belong the pastoral, agricultural and hunting scenes, the Nilotic

motifs, as well as the syntactic compositions which were used as borders to frame the figurative motifs. Thus the rich repertoire concerning hunting goes back to the *venationes* scenes that refer back to the classical representations of the capture and transport of wild beasts for the amphitheatre. The scenes with a marine topic, with men in boats, fishermen with rods, fish, birds and aquatic flowers, go back to the Nilotic compositions of the classical period. The most complete mosaic of this kind is the Nilotic border in St Stephen's at Umm er-Rasas. On a background containing a marine-river landscape with towns, flora and fauna of the Nile Delta there are depicted sailing-boats with naked cupids on board with conical headgear, rowing, pulling up ropes, angling, or standing beside the boat, holding a captured web-footed bird by the neck.

To the same erudite cultural and literary context of the period belong the rich repertoires of animals, birds and plants which are the motif most commonly used by Jordanian mosaicists (Plate 149). By examining them one may obtain a long list of animals, exotic beasts from Africa and Asia, including elephants, crocodiles, different kinds of fish, sea-urchins, sea shells and squid, as well as purely imaginary sea monsters, birds of every kind, among which is included the mythical phoenix with a radiate head, and a rich variety of flowers and plants with their fruits. The whole constitutes an encyclopaedia of natural history revisited and transcribed by the mosaicists.

The mosaic of St Stephen's at Umm er-Rasas – Kastron Mefaa, the last of the dated mosaics in Jordan, fortunately complete despite iconoclastic damage, testifies to the persistence of gradually developed themes in Jordanian mosaics at the end of the Umayyad period. In the church at Ma'in and in the Church of St Stephen at Umm er-Rasas there are present simultaneously geometric non-figurative border patterns, a geometric composition with figurative motifs and the scheme with roundels of acanthus leaves or grapevines decorated with traditional scenes, besides the panels with the portraits of the most prominent patrons. The same is true of contemporary mosaics and frescoes in the Umayyad palaces where, next to the virtuosity of non-figurative geometrical patterns, we find figurative scenes of a lively expressive naturalism and precise mythological references. These are views which should not be seen simply as memories from the past, but as the continuation of an uninterrupted tradition among the mosaicists operating in the area.

Of the Jordanian mosaicists the following names are worth noting:

Soelos, Kaiomos and Elijah, who 'decorated with mosaics and beautified' in AD 531 the *diakonikon* of the Memorial of Moses on Nebo

149. (OPPOSITE) Mosaic fragments of birds from the Chapel of the Priest John, Khirbet el-Mukhayyat, AD 562. Mount Nebo, Department of Antiquities

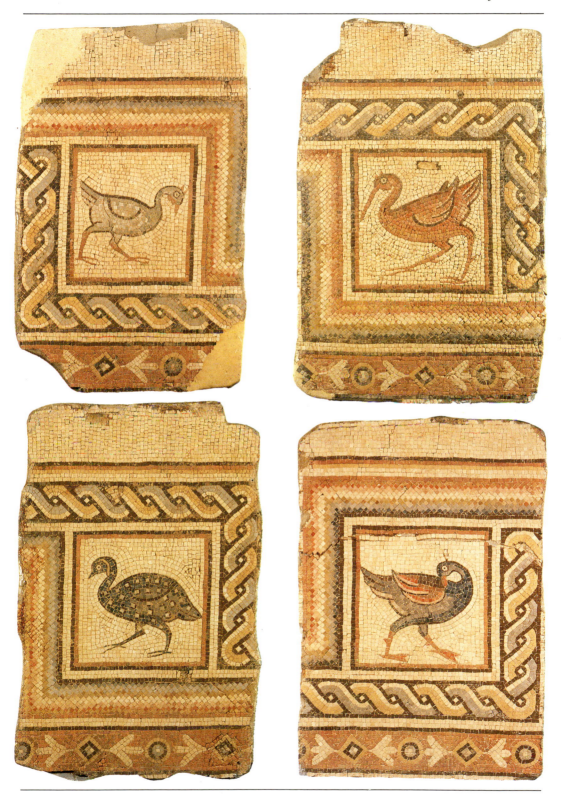

Naouma, Kiriakos and Thomas, who in AD 536 decorated the Church of St George in the village of Nebo

Salamanios, who in AD 578 laid mosaics in the Church of the Apostles at Madaba

Silanos, who laid the mosaic in the upper church of Quweismah

Anastasius, son of Domitian, who laid the mosaic in a chapel at Khirbet es-Samra

Staurachios of Esbous, son of Zada, together with his colleague Euremios, who in AD 756 laid the mosaic in the presbyterium of the Church of St Stephen at Umm er-Rasas – Kastron Mefaa.

Finally, we must remember that various mosaics of Jordanian churches show marked traces of iconoclasticism, with individual characteristics which distinguish this local movement from the theological battle for or against the sacred icons of the Byzantine Empire. In different mosaics the human and animal figures have been voluntarily disfigured. When, how, and on whose orders? These are questions for which we do not yet have satisfactory answers. The Christian historians of the area, who wrote in Syriac, placed the blame on an order of the Caliph Yazid II (AD 720–4), 'who ordered the destruction in his empire of all the images and figures, be they of bronze, wood or of stone, or painted in colours . . .' On the whole these traces of aversion to images in the mosaics of the churches of Jordan testify to a period of crisis which the Christian community in Jordan underwent during the Umayyad or Abbasid periods, after a time of relative peace and tolerance by the Muslim authorities.

Further reading

C.H. Kraeling, *Gerasa: City of the Decapolis*. New Haven 1938.

M. Piccirillo, *Chiese e Mosaici della Giordania Settentrionale*. Jerusalem 1981.

M. Piccirillo, *I Mosaici di Giordania*. Rome 1986.

M. Piccirillo, *Chiese e Mosaici di Madaba*. Jerusalem 1989.

M. Piccirillo, *Mount Nebo*. Amman 1989.

S. Saller, *The Memorial of Moses on Mount Nebo, I, II*. Jerusalem 1941.

S. Saller and B. Bagatti, *The Town of Nebo (Khirbet el-Mekhayyat)*. Jerusalem 1949.

Writing in Jordan: From Cuneiform to Arabic

The Early Bronze Age and the First Writing Systems

The gathering of thousands of people in the urban centres of Babylonia and Egypt during the 4th millennium BC led to the growth of more complex and far-reaching administrative controls than had been necessary in earlier Neolithic centres like Jericho. Almost certainly it was the need to account for taxes and offerings that brought about the invention of writing in Babylonia and the adoption of the idea in Egypt shortly before 3000 BC. Both the Babylonian cuneiform system and the Egyptian hieroglyphs were complicated, demanding a long period of training, and so their use was restricted to the professional scribes and some other officials. The scripts themselves, however, were remarkably flexible and could be used for recording information and ideas of any sort. The Babylonian writing apparently created for the Sumerian language was adapted in due course by other people for their own tongues – East Semitic Babylonian and Assyrian, the West Semitic dialect of Ugarit, Elamite in Iran, Hurrian in northern Mesopotamia, and the various languages of the Hittite Empire in Anatolia. The script was commonly impressed with a reed stylus on soft clay tablets which were then dried in the sun (occasionally tablets were baked in an oven). From at least 2000 BC cuneiform was also written on wooden boards covered with wax, especially for records of only passing value. At all periods the script was engraved on stone and metal to mark ownership or to produce a lasting monument. Egyptian writing was used in the same way, but instead of clay or waxed tablets, papyrus was the normal writing material, a form of paper made from a reed growing in the River Nile. Where papyrus was not available, or when it was too costly for the purpose, flakes of stone, pieces of broken pottery and wooden boards were used

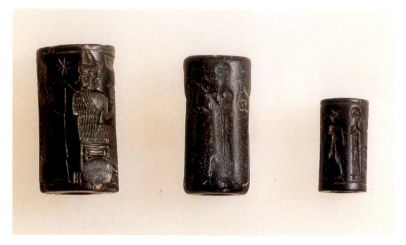

150. Haematite cylinder seals from Amman, Jericho and Jerash(?). The design was engraved around the circumference so that it appeared in relief when the stone was rolled across soft clay. The first two are Babylonian workmanship, the third is Syrian. Middle Bronze Age II, c. 1800 BC. Height: 2.3, 1.6, 2.3 cm. Amman Archaeological Museum

instead. The writing was done with a reed pen and black ink. Not long after the birth of the hieroglyphic script, scribes developed a cursive form for daily affairs, which is now known as hieratic.

Inscriptions on stone, metal, clay and potsherds can survive burial in various conditions, papyrus scrolls and wooden tablets only in exceptionally dry or waterlogged conditions (such as the Egyptian desert, the caves near the Dead Sea, or the bottom of a well). Consequently much ancient writing has disappeared. Egyptian administrative records will never be recovered on the scale of the thousands of documents from Babylonia and Assyria because the cities where they may have been buried lie close to the Nile. In the same way, records on papyrus are unlikely to be found in the ruined cities of Jordan, because the soil is damp. As will be shown, there is evidence that papyrus was used there.

Babylonia's city culture was influential along the length of the River Euphrates in the late Uruk period (c. 3500–3000 BC), carrying its innovations, including writing and the cylinder seal, into Syria, whence they were probably exported through ports like Byblos to Egypt. Inscribed stone vases from the earliest dynasties of Egypt unearthed in Byblos show this link. Babylonian cultural influences in Syria several centuries later are strikingly attested by the discoveries in the Early Bronze Age III city of Ebla (Tell Mardikh). Thousands of cuneiform tablets reveal that the scribes there were trained in a long-established Babylonian tradition. Two hieroglyphic inscriptions on stone vessels raise the possibility that other scribes were competent in Egyptian, although these texts may have reached Ebla through various hands as valuable curiosities. The Ebla tablets imply that scribes were writing cuneiform in other cities of northern Syria in the 3rd millennium BC but there is no evidence suggesting knowledge of that script had

151. Two scarabs from Tomb 62, Pella. The first shows two figures, one seated. The second has a group of Egyptian hieroglyphs, with no particular meaning. Middle Bronze Age–Late Bronze Age, second half of 16th century BC

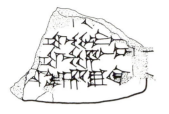

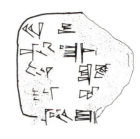

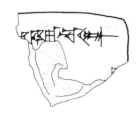

152. Drawings of fragments of two clay tablets inscribed in Babylonian cuneiform. Pella, 15th century BC

reached Jordan or Palestine then. Although the route from Mesopotamia to Egypt bypassed that area, some Babylonian influence did trickle into Jordan in the form of seal impressions on pottery. Egyptian influences may have penetrated from the south-west of Palestine across the Negev in connection with the copper-mines in the Rift Valley. Future explorations can be expected to shed light on these matters.

Writing in Jordan during the Middle and Late Bronze Ages

When city life resumed in the Levant in the Middle Bronze Age, Babylonian influence was felt strongly from the north and Egyptian from the south-west. Cuneiform texts from Mari on the mid-Euphrates record contact between its rulers and Hazor in Galilee about 1800 BC. Such direct contact with towns in Jordan at this time is not known, but cylinder seals of Babylonian design have been found there which could have been used for sealing clay tablets as well as containers, jars or boxes (Plate 150). Cylinder seals also had value as amulets and their strange figures could have brought them to Jordan in that role. Egyptian scarabs (Plate 151) had magical value, too, both through their shape – the scarab beetle, symbol of the rising sun and new life – and through the designs engraved on them, either pictures or emblems of gods, or hieroglyphs giving the names of gods or kings, or magic formulae. Both cylinder seals and scarabs were placed in tombs.

Egyptian military activity in Canaan spilt across into Jordan from time to time. Seti I dealt with rebel rulers south of Galilee,

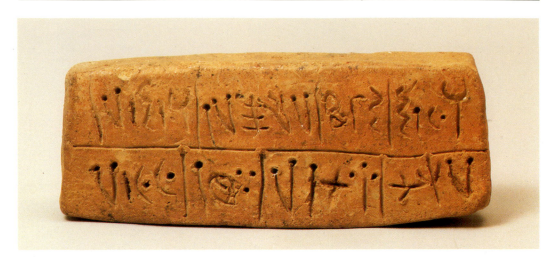

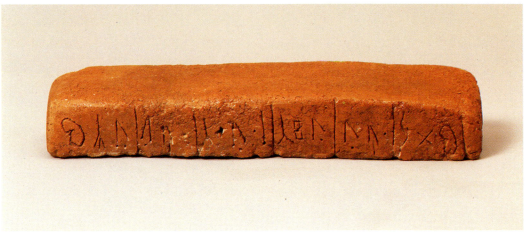

153. Two clay tablets excavated at Tell Deir Alla in the Jordan Valley bear inscriptions in writing which has not yet been deciphered. They were probably written soon after 1200 BC and may be a local attempt to produce an alphabetic script like the one used in Canaan. Length: 15.5, 12.5 cm. Amman Archaeological Museum

154. (OPPOSITE) The Moabite Stone, recording the achievements of Mesha, king of Moab c. 853–830 BC, was set up in Dhiban. The black basalt stela, 1.15 m. high, bears thirty-four lines of writing in the 'Phoenician' alphabet. Louvre, AO 2142–5060-5066

capturing Beth Shan in his first year (*c.* 1294 BC) and dealing with Pella two or three years later. He celebrated his power on a stela set up at Tell es-Shihab, north-west of Ramtha, and on others at Beth Shan. His son Ramesses II faced unrest in southern Canaan and Jordan. In a vigorous attack Egyptian forces subdued Moab and Edom, taking Dhiban (*c.* 1272 BC). Commemorative carvings on stelae or rocks may have been left in this area at the pharaoh's orders, as one was left cut in the rocks at Sheikh Sa'id in the Hauran. Such monuments displayed Egyptian writing to local people who saw them.

To the Late Bronze Age belong the two fragments of Babylonian cuneiform tablets found at Pella (Plate 152). They join slightly larger numbers found on sites west of the Jordan. Pella is mentioned in one of the famous El-Amarna letters (No. 256),

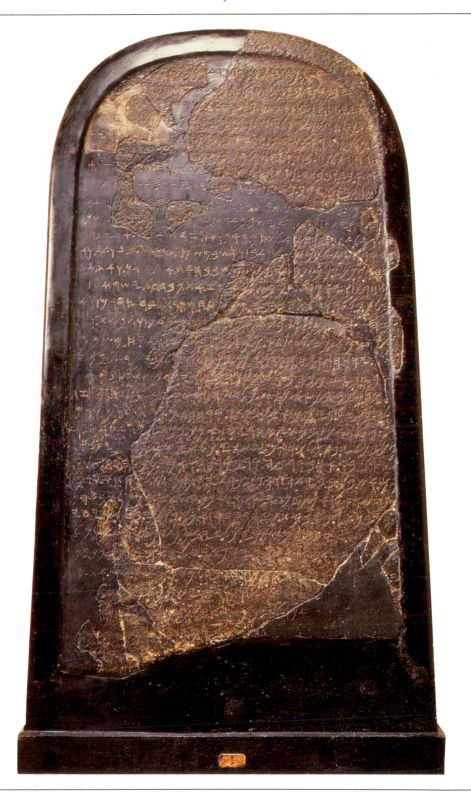

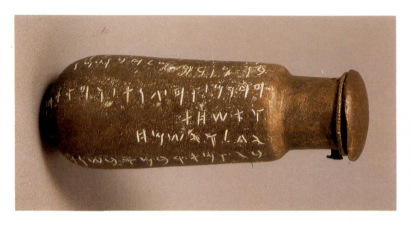

155. Lying in rubble of the Mamluk period at Tell Sirân archaeologists discovered this bronze bottle 10.5 cm. long engraved with an account of the works done by Amminadab, king of the Ammonites. 7th century BC. Amman Archaeological Museum

cuneiform tablets written about 1350 BC, this one perhaps sent from Pella. One other place in Jordan occurs in two of the letters: Ashtartu, biblical Ashtaroth, now Tell 'Astara (Nos. 197, 256). Clearly, more writing on clay tablets was done there than the surviving examples show.

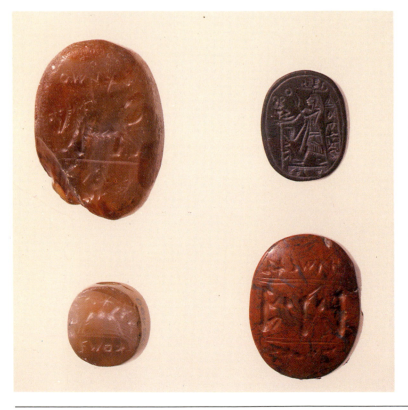

156. Iron Age seals found accidentally have entered many collections without record of their provenances. Consequently it is not always possible to state with assurance which ancient kingdom each came from. Of these four in the British Museum, the first, cut in jasper, with a fine roaring lion and a scarab beetle, belonged to a man named Asaniel (*l'sn'l*) who may have been an Ammonite or an Israelite. The second seal is a jasper scarab bearing an Egyptian-style figure with the name Shema (*lšmʿ*) inserted along the sceptre. Although often considered Hebrew, this seal could be Moabite. The seal of Yesha (*lyšʿ*), the third, is Ammonite work. Elsagab daughter of Elshama (*l'lsgb bt 'lšmʿ*) owned the fourth seal, of red jasper, which is Ammonite in style with two monkeys flanking a plant between the writing

The 2nd millennium BC was a time of experiment as scribes in the Levant tried to find ways to record their own local dialects. The Babylonian script was quite versatile but it could not register all the sounds of West Semitic, and it could only be learnt through years of study. Egyptian, too, was tedious to learn and not easy to use for writing other languages. Excavations at Byblos in Lebanon have recovered a few inscriptions on stone and metal using about 110 different signs. Although no satisfactory decipherment has been made, it is likely these signs are a syllabary (one sign for *ab*, others for *ba*, *ib*, *bi*, etc.). This is a step forward from the older systems which mixed signs for words and signs with syllabic values, and so had hundreds of signs. (The 'Linear B' script of Crete was moving in the same direction, but retained some word signs.) The age of the Byblos script is uncertain; it probably arose before 1500 BC.

In circumstances which are still obscure the next major step in the history of writing was taken sometime before 1500 BC and somewhere in the Levant. A well-instructed scribe analysed his language and created one sign for each distinct sound. He used pictures chosen on the acrophonic principle, so that a head (*ra'sh*) stood for *r*. In this way he created a simple set of about thirty signs that could stand for a consonant followed by any vowel (*b(a)*, *b(i)*, *b(u)*, etc.) which was a sort of alphabet. No examples of the early stages of this script have been found in Jordan yet, although they are known from graffiti on stone in western Sinai (Serabit el-Khadem) and on pottery and metal from Palestinian sites such as Gezer and Lachish. Again, this script was almost certainly written with ink on papyrus in the Egyptian style for most purposes, and the papyri do not survive. Scribes trained in Babylonian customs invented an imitation 'alphabet' of cuneiform signs for writing on clay tablets. This script is best known from the archives of Ugarit on the Syrian coast, flourishing in the 14th and 13th centuries BC, where it was used for writing as wide a variety of documents and literature as were the Babylonian and Egyptian scripts. A few examples of a cuneiform alphabet have been found in Canaanite towns, and one is significant here. A small tablet from Beth Shemesh appears to carry the signs in the order of the South Semitic alphabet known from later in the 1st millennium BC in the eastern desert and in Arabia.

Jordan makes two unique contributions to this subject. The first is the stone stela found at Balu'a, north of Kerak, in 1930 (Plate 33). Above the carving are traces of four lines of writing. They are so badly worn that they cannot be identified or deciphered; they might be a local form of the alphabet. The Balu'a stela is usually dated about 1200 BC.

The second contribution is made by the three clay tablets excavated in a Late Bronze Age level at Tell Deir Alla (Plate 153). The signs deeply incised in the clay with a pointed stylus have not

157. This brown sardonyx seal has typically Moabite features in the roughly-cut, winged solar disc and the shapes of letters *k* and *m*. The owner's name, Chemosh-yehay (*lkmšyhy*), is proof. Height: 2.53 cm. Bibliothèque Nationale, Paris

158. The seal of Elisha son of Gargur (*l'lyš' bn grgr*), although found in the Kerak area, Moabite country, has Ammonite features in letters and the arrangement of the design (cf. Plate 156, No. 4). Black steatite; height: 1.89 cm. Musée Bible et Terre Sainte, Paris

been identified. Vertical lines divide them into groups, which may imply each group is a word and the signs simple syllables or even alphabetic, but need not. Some of the signs resemble those in the Late Bronze Age alphabet of Canaan, while others do not. Twelve tablets were found altogether, the others having only dots on them. The discovery of the group suggests they were made at the site.

Writing in Jordan in the Iron Age

The upheavals at the end of the Late Bronze Age broke the long-standing traditions of Babylonian and Egyptian writing in the Levant. In the national kingdoms which arose – those of Aram in Syria, Israel and Ammon, Edom, Moab, and in the Phoenician cities – the Canaanite (or 'Phoenician') alphabet became the normal writing system for all purposes. The way in which the amount of inscribed material from the Iron Age outweighs all from the previous millennia in variety and quantity testifies, in part, to the simplicity of the alphabet. The twenty-two letters were easy for anyone to learn who wished, and so the scribes lost the monopoly they had held for so long.

159. A spirited charging antelope decorates the seal of 'Tamakel, son of Miqnemelek' (*ltmk'[l] bn mqnmlk*), also of Ammonite type. Reddish agate; height: 2.04 cm. Bibliothèque Nationale, Paris

Kings had monuments inscribed in this alphabet in their local dialects, and notable examples come from the kingdoms of Jordan. Most famous is the stela of Mesha, king of Moab, found at Dhiban in 1868 (Plate 154). The black basalt stone once stood in the high-place of the national god, Chemosh, in Qarhoh in Dhiban. Local people broke the stone soon after its discovery and many pieces were lost. Happily, a squeeze made earlier enabled the missing parts to be restored in plaster. The writing is engraved clearly in well-formed letters, each word separated from the next by a point. At this date, about 830 BC, the script does not differ from the letters used to write Hebrew, but the language has a few features which distinguish it as Moabite. The text recounts Mesha's success in gaining independence for his land from Israel, and his conquest of towns occupied by the Israelite tribe of Gad in the area of Madaba. Mesha asserts that Chemosh was angry with his land and so allowed Omri of Israel and his son(s) to dominate Moab, then Chemosh saved Mesha from his enemies and gave him his victory. Among the booty were objects sacred to Yahweh of Israel, this stela providing the earliest occurrence of that divine name outside the Bible. This Moabite stone remains one of the most important ancient West Semitic inscriptions, both for the history of script and language and for the history of Moab and Israel. Relating it to Israelite history is complicated because phrases in the stela are ambiguous. Mesha speaks of Omri and his oppressing Moab and occupying Madaba for forty years, Omri's reign and half his son's reign, whereas the Hebrew record gives only twenty-nine or thirty years to the two together (1 Kings 16:23, 29). The forty may be a

160. The winged solar disc, stars and letter-forms all indicate that the seal of Yesha (*lyš'*), carved in milky quartz, was made in Moab. Height: 1.7 cm. Ashmolean Museum, Oxford

round number, or the 'son' of Omri may be a 'grandson'. The time of Mesha's victory celebrated in the stela may follow the decline of Israel under the attacks of Hazael of Damascus (2 Kings 10:32, 33). There is no reason to expect the monument to report every victory of Moab over Israel, rather it may record details of the king's latest triumphs at the moment of its composition.

In 1958 part of another Moabite inscription on stone was found at Kerak. This was apparently a sculpture of a human figure, probably a king, with three incomplete lines of clear letters mentioning a king of Moab, Chemosh-yat, possibly named as father of Mesha, and his piety.

Edom has yet to yield inscribed stone monuments erected by her kings.

Ammon, however, offers a variety of commemorative inscriptions. Part of a large stone slab was found about 1961 on the Citadel at Amman with some letters of eight lines of writing. The name of Milkom, national god of Ammon, is apparently the first word preserved, but the rest of the text is obscure, although some of it may be addressed to the god, and some a curse. The style of the script suggests a date shortly before 800 BC and was evidently learnt in an Aramaean-influenced school.

A second stone fragment from Amman, found in the Roman theatre, bears parts of two lines of writing including the words *bn* '*mn[n]* ('Ammonite(s)'). Judging by the shapes of the letters, this piece is to be dated about 600 BC.

One of the several statues found at Amman (see Plate 38) has the name of the man portrayed which, despite damage, F. Zayadine has plausibly identified as a grandson of Sanipu, king of Ammon, mentioned by the Assyrian king Tiglathpileser III, about 730 BC.

These three may be royal inscriptions of Ammon, one text is certainly royal, and that is unique and peculiar, engraved on a bronze bottle excavated at Tell Sirân near Amman (Plate 155). The bottle, 10.5 cm. long, was sealed with a bronze cap riveted in place. When the cap was removed, the bottle was found to contain a few grains of wheat and barley and seeds of weeds. These may be samples of the plants grown in the gardens which the inscription celebrates, or they may come from a later use of the bottle, which was not found in its original position. The writing was done for Amminadab, son of Hissal-el, son of Amminadab, each titled 'king of the Ammonites'. An Amminadab of Ammon is listed by Ashurbanipal of Assyria among kings who paid tribute at the start of his reign, about 667 BC. It is believed he is the grandfather of the Amminadab for whom the bottle was made and so a date in the middle of the 7th century BC or slightly later is likely.

Small stones, some prettily coloured, were polished and engraved as seals (Plate 156). Dozens have been found in Jordan. Where their find-place is known, it is usually a tomb, and it is

161. An Ammonite lady, 'Abihay, daughter of Yenahem' (*l'byhy bt ynhm*), owned this seal, the writing enclosing a winged solar disc. Haematite; diameter: 1.5 cm. Bibliothèque Nationale, Paris

162. A tomb at Umm Udhaina, west of Amman, yielded this fine agate seal together with the metal ring in which it hung. Although found in Ammonite territory, features of the design and script suggest a Moabite engraver made it for 'Palti, son of Maish, the herald' (*lplty bn m'š hmzkr*). Height: 2.2 cm. Amman Archaeological Museum

probable that most were originally buried with their owners. Of interest here are the considerable number with the names of their owners cut on them, coming from the late 8th to the 6th centuries BC. The names give valuable clues to the origins of the seals as they are often composed with a divine name (Plate 157). Thus Chemosh-nathan ('Chemosh has given') is classed as Moabite because Chemosh was Moab's god, Milkom-ʿoz ('Milkom is (my) strength') as Ammonite, and Qaus-gabr ('Qaus is mighty') as Edomite. Examination of the letters reveals differences which fall along the same lines. In the case of the Ammonite seals, which are the most numerous, certain distinct letter shapes also occur, for example, on the Tell Sirân bottle, notably the square ʿayin and the kaph with a triangular, axe-like, head (Plate 158). When name-types and letter-shapes are combined they are seen to accompany particular styles of design or motif (Plate 159). Ammonite engravers, or one workshop, favoured an animal or a group of symbols at the centre of the seal with the names above and below; Moabite seals may carry a crescent moon and star (Plate 160). A noticeable proportion of these seals have only the name of the owner and the father's or master's name, a common feature of Hebrew seals. The skill of the engravers in designs and lettering varied, from quite skilled to clumsy.

The inscribed seals contribute valuable information by supplying examples of Ammonite, Edomite and Moabite personal names, revealing the presence of an Arab element in the Ammonite kingdom, for example. A few seals belonged to women, described as 'daughter' or 'servant' of someone (Plates 156, 161). Women's names are not always distinguishable from men's names, so seals carrying a single name may remain indeterminate. In place of a parent's name occasionally a title is given. A tomb at Amman yielded the simple seal of Adoni-nur, servant of Amminadab, who was probably the king of Ammon mentioned by Ashurbanipal. A fine Moabite seal, also found in a tomb near Amman, adds its owner's occupation, 'the remembrancer' or, perhaps, 'the herald' (mzkr) (Plate 162).

One unusual seal was first cut in Babylonia or Assyria, then a man's figure was added on one side somewhere in the Levant and an Ammonite inscription on the other side (Plate 163). This shows it belonged to a man with an Assyrian name, Mannu-ki-Ninurta, who had Ammonite ties, for he is described as 'blessed by Milkom'. Foreign connections are seen in another seal dedicated to the goddess of Sidon by an Abinadab or his son, with typical Ammonite script. A tiny Moabite seal, belonging to Chemosh-nathan, was found at Ur in Babylonia; its owner may have been a merchant or an exile there (Plate 164).

Seals could be amulets, as in earlier times, but were principally for guaranteeing security and marking ownership. They were

163. A simple Babylonian stamp-seal, with a man fighting a winged dragon drilled on its base, was turned into an important Ammonite seal by the addition of a figure with hands raised in blessing and the statement 'Seal of Mannu-ki-Ninurta blessed by [or blesser for] Milkom' (htm mng'nrt brk lmlkm). The owner may have been an Ammonite held as a young hostage in Assyria and given an Assyrian name there. Grey chalcedony; height: 2.55 cm. Bibliothèque Nationale, Paris

pressed on to small lumps of clay to seal papyrus documents. A few of these *bullae* survive from Jordanian sites (e.g. Tell es-Saʿidiyeh), with the imprints of the long decomposed papyrus sheets on their backs. The most important specimen was excavated at Umm el-Biyara in Petra (Plate 165). There is hardly any doubt that the inscription above and below the winged sphinx gave the name and title of 'Qaus-gabr, king of Edom', a ruler mentioned by the Assyrian kings Esarhaddon and Ashurbanipal before and after 670 BC. This is the only example of a West Semitic king's seal from the Iron Age. Seals were also impressed on pottery jars, perhaps to mark a standard size or the authority under which they were made. The site at the head of the Gulf of Aqaba, Tell el-Kheleifeh, produced several examples stamped with the seal of an Edomite official, 'Qaus-ʿanal, servant of the king'.

The spread of seals like this last, engraved with writing alone, implies a number of people able to read enough to recognise names, and this indication is supported by various pottery vessels from sites in all three kingdoms scratched or inscribed in ink with their owners' names. Inscribed potsherds sometimes attest the presence of foreigners, unless the pots were imported. There are, for example, Phoenician letters on a sherd from Tell es-Saʿidiyeh and South Arabian ones on sherds from Tell el-Kheleifeh. Letters of the alphabet served as marks to direct craftsmen assembling objects

164. A Moabite named Chemosh-nathan (*kmšntn*) left his tiny lapis lazuli seal at Ur in southern Babylonia, where he was, presumably, a visitor or an exile in about 600 BC. Diameter: 1 cm. British Museum

165. Dating the occupation of buildings uncovered on top of Umm el-Biyara in Petra was helped by the discovery among the broken pottery of a clay bulla bearing the name of 'Qaus-gabr, king of Edom' (*lqwš g[br] mlk ʾ[dm]*), who is mentioned in Assyrian texts of about 670 BC. Burnt clay; 1.9 × 1.6 cm.

made in several pieces and can be found on the backs of the eyes inlaid in the stone heads from Amman (see Plate 45).

Papyrus and leather were expensive writing materials for everyday notes of momentary value, so people continued to write in ink on potsherds, following Egyptian custom (Plate 166). Several sites have yielded examples from the 7th and 6th centuries BC, mostly lists of names of recipients or payers of goods, perhaps taxes (for instance, Ammonite: Tell Mazar, Hesban(?); Edomite: Tell el-Kheleifeh, Umm el-Biyara; Moabite: Dhiban).

The oldest papyrus books surviving in a West Semitic language are Aramaic scrolls from Elephantine by Aswan in Egypt. They date from the 5th century BC. However, the remarkable discovery of inscribed plaster fallen from a wall at Tell Deir Alla gives a picture of a column of a scroll in the 8th century BC, the time of the Hebrew prophets Amos, Hosea and Isaiah (Plate 167). The text is written in black and red ink in Aramaic letters, but in a local dialect, the red ink used for opening words of certain sections and the top and left-hand margins, an Egyptian practice (Plate 168). Writing on a wall in the careful, professional way this was done suggests that the room had a special purpose, but nothing was found to make that clear. The fragmentary text tells of the prophet Balaam, son of Beor, and oracles that he received from the gods at night, warning of coming disaster. Apart from the prophet's name, there is no connection with the biblical narrative about Balaam (Numbers 22–4). Even in its damaged state this is a unique and valuable

166. People sometimes scratched or wrote their names on pots and pans, or used pieces of pottery as scrap paper. This potsherd from Buseirah has the end of an inscription in black ink: *hkrkb*, at present not easily explained. *c.* 700 BC

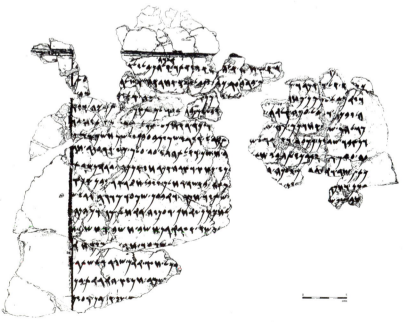

167. Excavators at Tell Deir Alla were surprised to see that the plaster which had fallen from a wall bore lines of writing in black and red ink. Although fragmentary, enough of the text survives to show that it was a story about the prophet Balaam, who is also known from the Bible. This facsimile represents the largest section and imitates a column from a scroll of the 8th century BC

witness to the existence of written literature and particular religious beliefs in Iron Age Jordan.

Under Persian rule (*c.* 539–331 BC) Aramaic became the common language and script for most purposes. Aramaic ostraca and graffiti have been recovered from a few places in Jordan, e.g. Tell Mazar and Umm Udhaina (see Plate 114). Yet the cuneiform tradition had not died in Mesopotamia and one stray clay tablet was a surprise find at Tawilan (Plate 169). It was written in Harran, far to the north, to record a contract between two Aramaeans and an Edomite, Qaus-shama, in the first year of Darius, most likely Darius I, *c.* 520 BC. Presumably Qaus-shama carried it with other business documents to Tawilan, which may have been his home, where it was lost.

168. A detail from the opening lines of the Balaam text. Introductory words were written in red ink. In the first line the copyist missed out one word (*'lwh*) because it was like the next one (*'lhn*) and inserted it above the line. The average height of each letter is approximately 0.8 cm.

Writing in Jordan from Alexander to the Rise of Islam

This period of one thousand years saw one group of scripts flourishing in the desert regions, foreign alphabets introduced in urban areas, and an adaptation of the Aramaic alphabet current in both developing into the major writing system which eclipsed all others in the country.

Already before the fall of the Persian Empire, Arab tribesmen pasturing their flocks in the desert regions were scratching their names on rocks and boulders, sometimes with pictures, a habit continuing to the present time. Those writers used letters drawn from the South Semitic alphabet, for which there is a little evidence in earlier periods (pp. 139, 143), and developed in several forms, known by the Arab dialects which they wrote as Thamudic and Safaitic. Naturally, these herdsmen recognised no national frontiers, so their writings are spread widely across Jordan, Iraq, Syria and Saudi Arabia, often clustering around water sources and sacred places, but also occurring on stones strewn across the desert (Plate 170). The commonest texts simply give a name 'By Salim', or add the father's name. Some give a longer genealogy, covering up to fifteen generations. Others are brief prayers for blessing from a god or goddess, or curses on enemies, commemorations of the dead, or expressions of the writer's affection for a friend. More rarely there are remarks on events, mostly banal, and scurrilous graffiti. They are difficult to date closely, although the majority belong to the early centuries of the Christian era. The extraordinary fact about the authors of these inscriptions, which can be counted in thousands, is that they have left no other documents; inscribed seals, pottery, or metal objects are unknown, nor are there any formal monuments on stone. Much of their writing seems to have been done merely to pass the time as they guarded their flocks.

169. The clay tablet from Tawilan was the first to be recovered from a site in Jordan. It was written in Harran (southern Turkey), probably in 520 BC. Length: 16 cm. Petra Archaeological Museum

Knowledge of letters was, presumably, passed from one to another as little more than a hobby. Future discoveries may alter this impression.

Alexander the Great's campaigns spread Greek across the Near East as the language of government and commerce, and so the Greek alphabet, derived from the same Canaanite ancestor as the Aramaic, became a familiar sight through the legends on coins of the Ptolemies of Egypt and the Seleucid kings of Syria which circulated in Jordan. Greek monuments of all sorts were set up in the cities (for example, at Amman and Jerash) and important people had tombstones inscribed in Greek (see Plate 63). A glimpse of the administration of Jordan as a part of the Ptolemaic realm comes from the archives of the official Zenon, papyri found in Egypt which report his visit to the area in 259/8 BC and include letters sent to him from there after his return to Egypt. Use of Greek continued as the language of the towns under Roman rule as shown by coins issued for the emperors in the cities of the Decapolis (such as Gadara-Umm Qais, Gerasa-Jerash and Philadelphia-Amman) and in the conquered Nabataean kingdom at Petra. Numerous formal inscriptions from temples, public buildings and tombs illustrate the extent Greek had entered society, and how it had become the common language for people of varied origins, even to its appearing on rocks in the eastern desert beside Safaitic texts. It is also found on pottery and other objects. Its role continued under the early Byzantine Empire, when it was also the major language of Christianity in Jordan. Dedications in stone and mosaic, other religious captions in churches, gravestones and ownership marks abound from the 5th and 6th centuries. After the rise of Islam Greek rapidly became restricted to church circles.

170. Herdsmen in the steppe delighted in scratching short notices on rocks and stones. This is a Thamudic ABC, the only one ever found for this script, probably dating from the Roman period. It follows the Aramaic letter-order, with some exceptions, and with extra letters which long foreshadow the traditional letter-order of the Arabic script. Khirbet es-Samra; height: 14 cm. Samra, Department of Antiquities

While Greek held the major place under the Romans, official monuments were inscribed in Latin. Imperial dedications, military notices, milestones and funerary notices survive in cities and in the countryside. They attest the presence of the legions in the frontier-posts and garrisons, squadrons drawn from other parts of the empire, some speaking Latin as their native tongue. While jars of Italian wine and other luxuries may have arrived from the west with Latin labels, few outside the army and senior officials are likely to have spoken the language. The most famous monument in Jordan with a Latin inscription is the rock-cut tomb of Sextus Florentinus, legate in Arabia, who died about AD 140 and was buried in Petra.

Until the conquest by Trajan in AD 106, southern Jordan and areas further north had been under the control of the Nabataeans. Although they were an Arab people, they used the Aramaic script and a dialect of Aramaic. The oldest surviving text showing distinctive Nabataean features comes from Petra and is dated *c.* 90

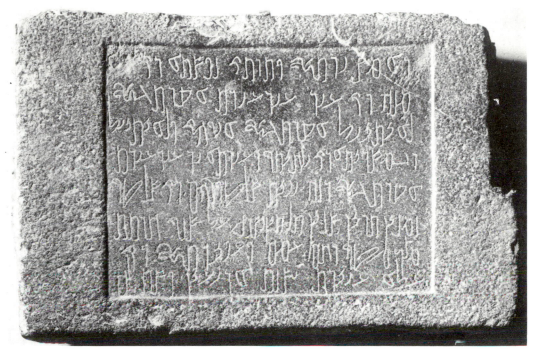

171. The classical Nabataean script is beautifully displayed by this monument which 'Abd-'obodat governor of Madaba made for the tomb of his father and for his son, in the forty-sixth year of 'Aretas, king of the Nabataeans, who loves his people' (i.e. AD 37). Basalt; 54 × 90 cm. Louvre, AO 4454

BC. The features develop and continue to the end of the kingdom and after. Nabataean kings struck coins in silver and bronze with their names and titles at first in Greek (Aretas III, *c.* 80 BC, for use in Damascus) but soon in Nabataean alone (Obodas II, *c.* 62–60 BC, and all later kings). The script was used for every sort of document. There are funerary monuments such as that from Madaba (Plate 171), building inscriptions, religious dedications (Plate 172), and thousands of graffiti on rocks left by travellers and herdsmen, similar to the South Arabic ones mentioned above. They are found especially in southern Jordan, northern Saudi Arabia and in Sinai. Town sites such as Petra, the capital, undoubtedly housed archives of administrative and diplomatic documents on papyrus which have all perished. Clay sealings from Mampsis (Kurnub) in the northern Negev attest an archive there. Only from caves west of the Dead Sea have a few examples of Nabataean legal deeds in cursive writing on papyrus survived. They can be dated between AD 70 and 135. Like other people, the Nabataeans also scribbled notes on pottery and other surfaces, and examples are known from Petra and other sites, including Masada. The Roman conquest hardly affected the currency of the Nabataean script, except that it no longer appeared on coins. Many gravestones and other records continued to be inscribed with it by Nabataeans and other Arabic-speaking tribes, both in the Petra region and further north in the

172. Two objects of gold and silver dedicated with prayers for the long life of the Nabataean king, Malichus, and his wife, Shaqilat, are recorded on this broken plaque from the main temple (Qasr el-Bint) in Petra. AD 40–70. 11.5 × 20 cm. Amman Archaeological Museum

Hauran. Plentiful examples from Umm el-Jimal show it co-existing with Greek.

It is from the latter, northern district that evidence comes of a change beginning. The tomb-stone of 'Imru'l-Qais from Nemara, 80 km. north-east of Bostra, is especially significant. This king, who ruled a large Arab kingdom reaching into Iraq and far into Arabia, died in AD 328/9 and his epitaph is in Arabic, but written in Nabataean letters. Examples of early Arabic texts like this one are rare, yet there seems little reason to doubt that it was from the Nabataean that the Arabic script developed. If papyrus or parchment documents from the 5th and 6th centuries AD are ever found, they may shed light on the process. It is visible in a Christian Arabic inscription from Harran in the Leja dated AD 568, and in two others from Syria, which have letters beginning to look like the early Kufic Arabic script.

173. Christian tombstone from Khirbet es-Samra bearing the name 'Ubeidu in the *estrangela* Syriac script. Probably *c.* AD 600. Height: 51 cm. Samra, Department of Antiquities

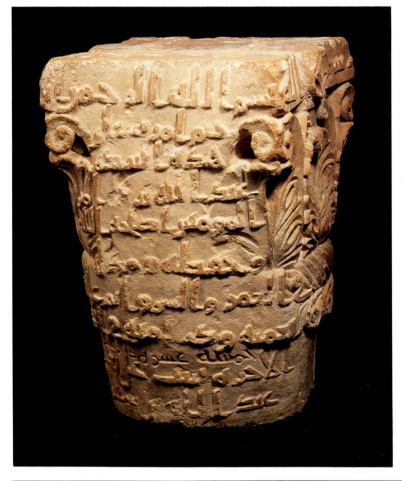

174. The Umayyad caliph, Yazid, had a cistern made for the palace at Muwaqqar in AD 723 with a central pillar marked to show the depth of the water. The builder was 'Abd-'Allah, son of Sulaym, who had this record carved in Kufic letters on the capital of the pillar, dated AH 104. Limestone; height: 60 cm. Amman Archaeological Museum

At the same time, another alphabet derived from Aramaic, the Syriac, which had grown up around Edessa (Urfa), spread to Jordan. This was the *estrangela* form of Syriac script used mainly by Christians for writing the dialect called Christian Palestinian Aramaic. Some of the tombstones from Khirbet es-Samra bear epitaphs in this writing (Plate 173).

The Arabic Script

Adopting the Nabataean alphabet for writing Arabic forced scribes to make an important innovation. As there were insufficient signs for the consonants of Arabic, a dot was added to each of six letters to make the extra signs (so *d* with dot serves for *dh*). This practice began in Nabataean where some letters had taken identical forms in the cursive script. However, it is not found in all early Arabic texts.

Just as Greek and Nabataean were used for all purposes, so was the Arabic alphabet. There are official monumental building inscriptions, such as the record of the making of a cistern at the command of the Caliph Yazid in AD 723 (AH 104) (Plate 174), and there are also the Umayyad coins, at first with Byzantine designs, and soon with inscriptions alone. At a more mundane level there are graffiti in ink or scratched on brick (as at Qasr al-Mashatta) and the series of lamps made in moulds imitating a late Christian Greek type, but with Kufic mottoes such as 'In the name of God, the merciful, the compassionate' (Plate 175). Beyond that point the Arabic script became the major vehicle of communication and literacy in Jordan that it remains today.

175. Pottery lamps from Jerash carry Arabic texts and sometimes name the maker. 8th century AD. Length: 11.5 cm. Amman Archaeological Museum

Further reading

W. E. Aufrecht, *A Corpus of Ammonite Inscriptions*. Edwin Mellen Press, Lewiston, New York and Lampeter, Dyfed, Wales 1989.

A. Dearman, ed., *Studies in the Mesha Inscription and Moab*. American Schools of Oriental Research, Society of Biblical Literature, Archaeology and Biblical Studies 2, Scholars Press, Atlanta, Georgia 1989.

J. F. Healey, *The Early Alphabet*. British Museum Publications 1990.

K. P. Jackson, *The Ammonite Language of the Iron Age*. Harvard Semitic Monographs 27, Scholars Press, Chico, California 1983.

J. Naveh, *Early History of the Alphabet. An Introduction to West Semitic Epigraphy and Palaeography*, 2nd edition. Brill, Leiden 1987.

Traditional Costume in Jordanian Culture

Jordanian costume is characterised by its elegance, sophistication and originality. Unlike other traditional costumes of the area, Jordanian costume, except for the northern region, is not influenced by any other ethnic attire. If these costumes are to be taken as a representation of Jordanian culture, then they reflect a uniqueness that has been largely ignored, since the Jordanian people have generally been looked upon as yet another part of Bilad esh-Sham (the Arabic term for greater Syria, i.e. Palestine, Transjordan, Syria and Lebanon).

The costumes of the Kawar Jordan collection mainly consist of women's attire from the 1920s until the present. However, these costumes represent an historical segment that encapsulates the styles used prior to those years. Because of this each attire should be looked upon as a socio-cultural and economic indicator of the woman who wore it. For example, it reflects women's roles, status and age, community allegiance, trade in material and thread, wealth or poverty. Yet, the aesthetics of the traditional dress are another question. The limited number of men's costumes in the collection is due to their less symbolic significance in Jordanian culture. Men's clothing is less elaborate and not as varied as women's costumes.

It is significant that so much variation exists in this small geographic area. This variation reflects different styles of living, for example, the agricultural societies of the north and the beduin nomadic and settled communities of the south.

In order to paint a picture of Jordanian traditional costume it is important to start first with the lives of the women who produced these costumes and the social context within which they were produced, mainly during wedding preparations. An investigation follows of the origins and types of textiles used for creating those costumes. Finally, detailed description of the costumes according to each region is provided, before discussing men's costumes.

Traditional Costume in Women's Lives

If one investigates the traditional daily life of a Jordanian woman it is a wonder how such expertise and artistry existed in her attire. Traditionally females were assigned the domestic sphere, which included a heavy responsibility towards the home and children.

The woman was responsible for everything that did not deal with public life. She was responsible for the cooking, drying, pickling or storing of food. With the men of the family she was responsible for planting, weeding and reaping. She was also responsible for the livestock and poultry. Lastly she was responsible for producing all kitchen utensils. This included straw-weaving, pottery-making and weaving the household rugs.

Whatever the Jordanian woman did, she always had a high standard of craftsmanship, taste and colour harmony. She also had special pride in her work and identity with her own village or kin. Her burden of work was heavy, yet time was allocated to embroidery and dress-making. Although important, embroidery was considered part of her leisure time. It was the time used for socialising with related women as they sat and embroidered together, putting their culture's signature on their attire.

The *kisweh*

A great deal of social life in Jordan revolved around the wedding, which included a fair amount of preparations and festivities. An example of these preparations was the bride's *kisweh* or trousseau. For this occasion the bride's and bridegroom's families paid a visit to the main market (*suq*) of the nearest city to buy materials for the bride's trousseau and gifts for the elders in both families. This was an event that few women forgot.

Jamileh Hassan's kisweh, *1945*

Jamileh, aged seventeen, left at five o'clock one summer morning in 1945 with her immediate family and her fiancé's family in Umm Qais for the town of Irbid. Among the numerous textile shops in Irbid they chose Abu Ahmad's shop. After hours of picking and bargaining they bought the following textiles: black cotton *dubeit* fabric, enough for two costumes; blue cotton fabric called *sini* for the wedding-dress; black silk *malas* fabric for another ceremonial dress; one black cotton velvet fabric for another dress; black silk crepe fabric for the headdress; a red brocaded silk scarf (*ʿasbeh*) for on top of the headdress; and a number of coloured silk and cotton threads for embroidery. Besides these items, which were expected to be part of

any bride's clothing, other fabrics were purchased as family gifts.

Abu Ahmad, the owner of the shop they chose, insisted on ordering their lunch and fed them in the courtyard of his shop by the fountain and the lemon tree. Afterwards, they thanked him and due to his fervent inquiries about the wedding, which was a few months ahead, they had to invite him to it. Abu Ahmad accepted happily. Eighteen years later Jamileh found herself in Abu Ahmad's courtyard having lunch by the fountain and lemon tree after buying her daughter's trousseau. Again he was invited to the wedding.

After leaving Abu Ahmad's shop young Jamileh went with her own family and her future in-laws to the jeweller Salim, who was the most famous in Irbid at the time. There they bought the following bridal items: a silver head-band (*'irjeh*); two pairs of *sharkas* bracelets; two amulets; two silver rings; a long chain (*jnad*) that is worn sideways; and a number of colourful beads. Afterwards both families headed back to Umm Qais, where everyone was anxious to see the bride's new possessions.

Starting the following day, all the females of her family – her mother, sisters and aunts – started embroidering and tailoring Jamileh's trousseau. This also included preparing household items like cushions, quilts and rugs. As soon as all this work was finished the wedding date was announced.

The Textiles

In the last century fabrics for women's and men's clothing were not woven in Jordan, but purchased in Syria and Palestine. Fragments of fabrics found in the caves in Fouhais and Khirbet Salem (both in central Jordan) show that costumes in the last century were made of handwoven indigo-dyed linen. This fabric was replaced with handwoven indigo-dyed cotton towards the end of the last century. Around 1920, this was replaced by a mechanised black cotton called *dubeit*, imported from Damascus and Nablus. The *dubeit* fabric was used by beduins and peasants all over Jordan.

One area only in Jordan had a love for coloured textiles, and that was Ma'an. Ma'an was a railway station on the Istanbul–Hijaz line. Thus this city was the meeting place for pilgrims on their way to Mecca from all the surrounding areas. To cover the expense of the trip, Syrian pilgrims brought with them hand-woven silk fabrics to sell in Ma'an. As a result, the Ma'an costume emerged as a colourful combination of Syrian silks and an *ikat*-dyed overcoat.

Other fabrics that were used in Jordan were a black silk crepe called *shambar*, used as a head cover and a silk-brocaded square used as a head-band. A black fabric called *malas* was also used for costumes in different parts of Jordan.

In the 1960s all these natural fabrics were replaced by the new synthetic textiles that flooded the Jordanian markets from both

Europe and Asia. The women found the new fabrics cheaper and more practical.

Jordanian Women's Costume by Region

The traditional costumes in Jordan came mainly under two styles:

1. Costumes of the north. These came in one length and were worn beltless with long, tight sleeves and a low neckline. This was known as *shirsh*. The embroidery came around the neckline, sleeves, the hem, and the sides of the costume.
2. The costumes of central and southern Jordan. These were sometimes in double length. A hand-plaited woollen belt was tied around the waist to form a fold around the waist called *ub*. This *ub* differed in length in different areas. It was longest in Salt, where the fold reached the ankle. All these *ub* dresses had long pointed sleeves. These were not worn for everyday use but for special occasions. Everyday dresses were simpler and shorter. Nowadays some older women can be seen wearing the *ub* dresses, but they are becoming less common.

Northern Jordan

Geographically this area is part of the plains of the Ḥauran. Thus the dress here resembled other dresses from the Ḥauran but with slight differences in the cut. The style of the dress in this area was called *shirsh*. The most elaborate *shirsh* was called *thob shaqhat*, which was usually worn at weddings (Plate 176). It was made of black cotton *dubeit* with a simple one-length cut, with multicoloured embroidery around the neckline and the lower half of the skirt. The vertical shape of the embroidery with the many inserted patterns gave a lace-like effect to the embroidered part of the dress. This was achieved through the use of the 'wave stitch' which the women of northern Jordan called *raqmeh*.

The names of the patterns were taken from the women's daily lives. Some related to their domestic reality like the pattern named 'Four Eggs in a Pan' or that called 'Four Bars of Soap'. The number four might have referred to the geometric shape of the pattern. Others referred to the nature around them, like the 'Palm-Trees' pattern, the 'Ears of Corn', the 'Horse's Step in Springtime' or the 'Olive Branch'.

The costume was worn beltless. The low neckline was covered with the head-scarf that draped elegantly from the woman's neck.

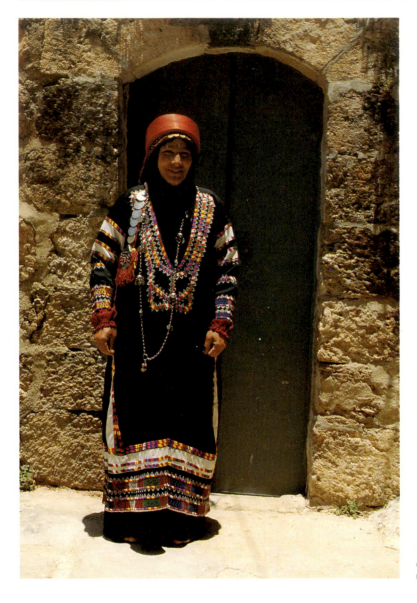

176. Woman's festive dress (*shirsh*) of black cotton. Irbid, northern Jordan

This was crowned by a brocaded red-and-gold coloured turban, called ʿasbeh, that was folded on the head.

Towards the south, in Ajlun and Jerash, patterns and colours changed (Plate 177). However, the cut was similar, although slightly altered as it was narrower.

With social change and modernisation some women have taken up western-style dress. However, other women still wear their traditional costumes, but they are currently machine-made instead of hand-embroidered.

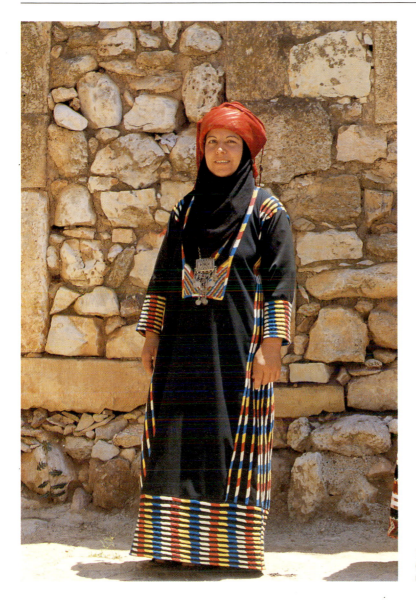

177. Woman's festive dress (*dalaq*) of black cotton. Ajlun, northern Jordan

Kerak

The costume of the region of Kerak in southern Jordan was made of black silk fabric. It was long enough to form a fold that reached the knees. Some cross-stitch embroidery fell around the hem and the neck-line. The dress had pointed sleeves, usually buttoned at the back. The Kerak women were known for their long, braided hair that fell on the front of the dress. The tiny, black tulle scarf they wore was tied to the back and secured on the head with a rope-like silk braid.

On top of the silk costume a felt embroidered jacket was worn. The jacket was either blue or black, and filled with black couching in the neck area, sleeves and hem-line.

Currently, middle-aged ladies have modified their traditional dress. It is now in the form of a black velvet dress that is decorated in the front, around the neck and hem-line. The sleeves are winged and small and, like the traditional dress, tied to the back. In order to avoid exposing the arms women wear coloured blouses beneath their costumes.

Ma'an

Ma'an's strategic location by the main rail road was reflected in women's colourful and elaborate costumes. Early in this century Ma'an had three main styles of dressing. The first, *thob hirimzi*, was made of connected red and green silk bands (Plate 178). Each band was around 20 cm. wide. A second dress style was called *thob kamekh* (Plate 179). It was made of striped silk fabric with *ikat*-dyed fabric on the sides. Last was the *thob atlas*, which was also of red and green stripes, but cotton sateen rather than silk.

These three styles had long, pointed sleeves, with one sleeve long enough to form a head-cover. The shape was uniformly long and widely cut. They were gathered at the waist with a hand-woven belt.

The married women of Ma'an wore a silk band on the head covered with silver and gold coins. This head-band was worn over an embroidered skull-cap. In public the women would only be seen with an *ikat*-dyed overcoat that was draped from the head.

The Ma'ani dress had simple embroidery just around the neck. However, embroidery did consume a large part of the Ma'ani women's time since they embroidered multicoloured elaborate cushions with geometric designs. These were proudly displayed all around their homes.

Salt

The voluminous double-length costume was made of black *dubeit* fabric (Plate 180). It was more than 3 m. long and 2 m. wide. The extensive size of the Salti dress was of significance. However, no explanation can be found for all the extra material that the Salti women used. Added to the dress was a blue cotton fabric. This band-like material formed a hem-line and was also added to the sleeves in vertical lines.

Wearing the Salt dress must have been a special skill of the Salti women. A woven belt called *shweihiye* was pulled around the waist, and the woman would start pulling the dress upwards until the end touched her feet. By then the folded layer would have fallen

178. (OPPOSITE) Woman's dress (*thob hirimzi*) of red and green striped silk. Ma'an

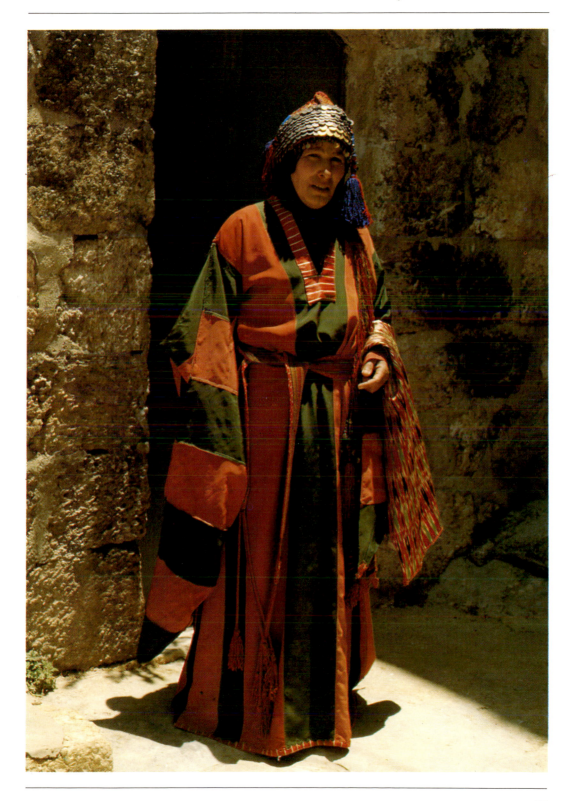

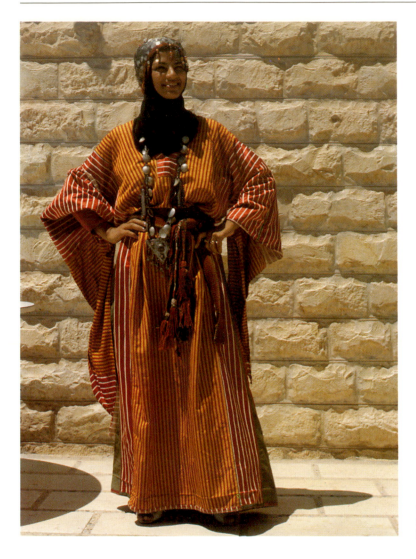

179. Woman's dress (*thob kamekh*) of striped silk fabric. Ma'an

at the knees. This extra layer was usually used as a pocket to store personal items.

One of the large sleeves went over the woman's head exposing the blue-embroidered lines (Plate 181). To hold the sleeve in place the women wore a red and golden head-band (ʿ*asbeh*). The second sleeve was pulled to the back, but sometimes it was used as a pouch to carry things inside.

Jordan Valley (Ghor)

In the northern area of the Jordan Valley the costumes resembled the Hauran area in cut and embroidery (Plates 182, 183). But they

were smaller in cut and the colours used in the embroidery were often limited to two: white and black.

The southern area of the Jordan Valley had a different style. The Idwan tribe and other tribes inhabiting the area wore a costume that was only slightly shorter than the Salt costume. It was also similar to the costumes worn in Jericho on the West Bank of the Jordan. They had multicoloured vertical lines of embroidery on black silk fabric.

For everyday wear women in both the northern and southern areas of the valley tied a coloured scarf towards the back of the head. On formal occasions each covered her head with a black scarf with a silk brocaded band on top.

Men's Costumes

Men's wear in Jordan was not regionally distinct like the women's. Men's clothing reflected their wealth through the quality of the materials used. It also reflected men's background – whether urban, rural or nomadic. In general, a man's costume consisted of a long, open, robe-like garment called *qumbaz* or *kiber*. This was worn over a long cotton under-shirt and pants. *Qumbaz* fabrics came in a great variety of hand-woven cotton satin from Syria, known as *saya* or *dima* fabric, which was usually colourfully striped. In towns and cities more expensive *qumbaz* fabric was available, such as *rozah* and *ghabani* silks. When men went out of the house they would wear a cloak called *ʿabayeh* on top of the *qumbaz*. This *ʿabayeh* was often of hand-woven wool, silk or linen.

The headdress of both beduin and peasant men consisted of a scarf, or *hattah*, that was worn on the head in a triangular shape. This was bound on the head with a two-layer woven band. As for the city men, they wore a *fez* or *tarbush* made of felt. Prior to the First World War men in villages wore a small, rounded felt hat with a turban around it, known as *laffeh*.

One important item of a man's wear was the belt, because it distinguished his class and wealth. The hand-woven, woollen cashmere belts, imported from Iran and Turkey, were popular in the cities and restricted to the chiefs in the villages. Simpler finger-woven belts were used by the rest of the villagers. As for the tribal populations, they wore leather belts that had different pockets for daily use, particularly for holding their weapons.

Costume and Jordanian Culture Today

Today, many Jordanian men and women still wear traditional dress. Their attire, of course, differs from that of the past. It is

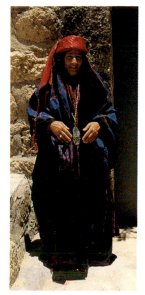

180. Woman's dress of black cotton (*dubeit*), with bands of indigo-dyed cotton. Salt

181. Sleeve detail of woman's dress from Salt, showing bands of indigo-dyed cotton

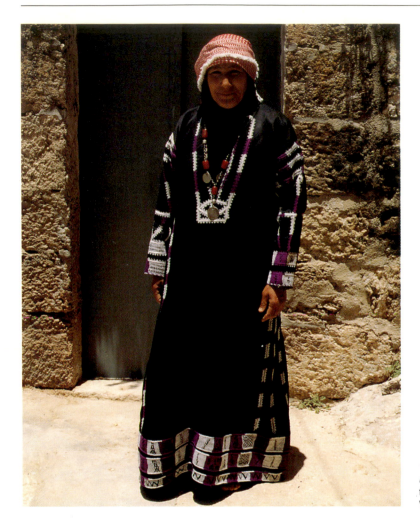

182. Woman's dress (*shirsh* or *dalaq*) of black synthetic fabric (Trevira). North Jordan Valley

simpler and more practical. Also the regional variations of the dress are not as distinct as before. The reason for this is not due to a decrease in the importance of the dress; rather, women who wear traditional modified costumes today are representing Jordanian national dress more than a regional form of costume. What is currently seen in downtown Amman, for example, are women asserting their identity as Arabs and as Jordanians. The Jordanian traditional dress has survived and is alive as part of the modern national identity.

The change that has occurred in Jordanian dress is mostly due to the social and economic changes that Jordan has undergone. Women especially have experienced these changes. Now, young women do not embroider and prepare their *kisweh*. This, however, does not mean that embroidery is vanishing. On the contrary, due to the large demand for traditional clothing, together with the

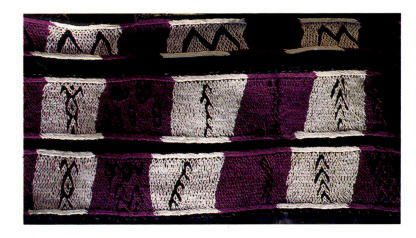

183. Detail of hem from woman's dress. North Jordan Valley

special skills of Jordanian women, both charitable organisations and the private sector have taken to large-scale production of traditional costume. This sector has developed as one of the country's largest employers of women.

It is true that many of the new dresses are not hand-embroidered and many others are machine-embroidered on imported synthetic materials. However, many others have been skilfully modernised and developed, making them not only practical and cheap for the women who wear them, but also an indispensable attraction to the booming tourist industry. Thus Jordanian traditional costume has not simply survived – it has also been revived.

This chapter has concentrated on women's costumes and described the role of costume in their lives and in turn the significance of costume in Jordanian culture. The survival of Jordanian costume can be also attributed to the women. They have adapted their clothes to the changing times and yet have kept their distinctive Jordanian identity.

Further reading

W. Kawar, *Costumes Dyed by the Sun: Palestinian Arab National Costumes.* Tokyo 1982.

G. Völger, K. von Welck and K. Hackstein, eds., *Pracht und Geheimnis: Kleidung und Schmuck aus Palästina und Jordanien.* Rautenstrauch-Joest-Museum, Cologne 1987.

S. Weir, *Palestinian Costume.* British Museum Publications 1989.

S. Weir and S. Shahid, *Palestinian Embroidery.* British Museum Publications 1988.

Folk Jewellery in Jordan

Jordanian Folk Jewellery and its Functions

Folk jewellery in Jordan is part of the corpus of Islamic jewellery, the distinctive features of which emerged gradually as a synthesis of Arabic and ancient eastern and western cultural elements. Particular to Islamic jewellery, throughout all regionally or socially defined variations, is the ornamental use of geometric and floral designs and the abundant use of semi-precious stones.

Much like traditional costume, Jordanian folk jewellery vividly expresses the way people in this region conceive of personal adornment, of attracting attention and of symbols of social prestige. But jewellery serves other functions as well. As it is a woman's strictly personal property which is given to her upon marriage and to which she adds later, she may sell jewellery as she pleases. In fact it represents her economic reserves in times of need. This portable bank account therefore is often composed of rather heavy jewellery and may include many similar items. Jewellery's economic importance also explains the sometimes lavish use of silver coins attached to traditional costumes and jewellery. Yet jewellery is not hoarded: women wear most of the jewellery they own even during work.

Another important function of jewellery is related to its amuletic nature, in that much of the traditional jewellery, its material or certain of its components, are thought to protect the person who wears it from misfortune and to bring her luck. Amuletic properties are attributed to certain materials, shapes, colours or inscriptions.

Among the metals it is silver and iron which in Jordan, as in most parts of the Arab world, are considered to be of greatest amuletic value. Among the semi-precious stones red agate and carnelian are particularly common in Jordanian jewellery. They are valued for their affection-attracting and healing influences. These are also attributed to amber, another prominent material in the local

184. Bracelet, wound from thick silver wires. Jordan, first half of 20th century

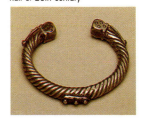

jewellery. Due to colour symbolism other materials of red colour are considered to exert the same influences. Certain shapes, such as the triangle, the eye, the hand, the crescent and the star, and representations of animals such as the lizard or the toad, also fall into the realm of amuletic jewellery.

Often, these various functional aspects of jewellery overlap, in other cases one aspect outweighs the others. But in almost all instances, pieces of jewellery contain something which is thought to counteract the effects of the 'evil eye'. This partly relates to the ambiguous nature of jewellery: meant as a means to embellish, to attract attention, it is in itself a source for envy, considered to be one of the main causes for the 'evil eye' which is thought to cause all kinds of physical, psychical and social damage.

The Character of Jordanian Folk Jewellery

On the stylistic level the jewellery worn in Jordan displays many influences from the neighbouring regions of Bilad esh-Sham, from Saudi Arabia, Egypt and Yemen. This partly relates to the migrations of silversmiths, partly to tribal migrations, but also to the fact that jewellery, much like other commodities, was often purchased in one of the urban centres of Palestine and Syria, and the Hijaz. Jewellery styles were subject to change, and it is difficult to make out regionally defined jewellery styles. The jewellery of Bilad esh-Sham in many ways forms an entity. There is, however, jewellery which is more common in particular regions or population groups, and such preferences may display continuity over longer periods of time.

Most pieces in Jordanian jewellery collections, unless from an archaeological context, do not antedate the early 20th century. They were made at a time when major socio-economic and political changes had already exerted their impact upon the jewellery of the region. Increasing urbanisation had brought an influx of craftsmen from various parts of the Ottoman Empire, among them silversmiths from Yemen, the Hijaz, Armenia and the Caucasus, who all brought with them their local techniques and styles. These, in adaptation to local tastes and due to interaction among the craftsmen, amalgamated into what came to be the common fund of the 20th-century Jordanian silversmithing craft. Embedded in this repertoire are local jewellery traditions dating back to much earlier periods. Being replaced for economic reasons by mass-produced gold jewellery since the 1940s, the art of silversmithing practically came to an end during the early 1960s.

In order to grasp those features which are peculiar to Jordanian jewellery, one ought to gain an understanding of the local jewellery

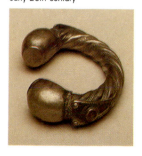

185. Twisted silver bracelet with bulbous finials. Jordan, early 20th century

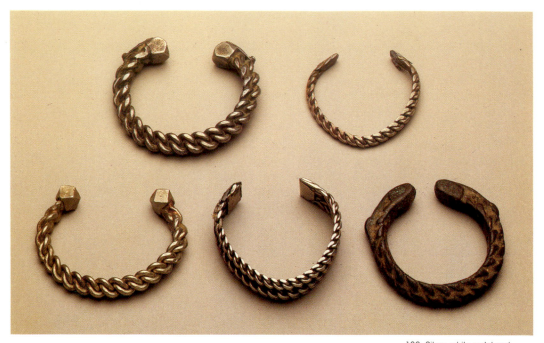

186. Silver, white metal and bronze plaited bracelets. Jordan, late 19th century (the bronze bracelet) and first half of 20th century

from periods prior to the developments of the early 20th century. Information on this issue is scarce, but some is provided in ethnographic literature from the turn of the century. Most useful are the description and illustration of jewellery from Kerak and Madaba from the turn of the century (Musil 1908, pp. 170 ff., Figs. 38–40). Archaeological evidence of Jordanian jewellery from the Ottoman period is scarce, as there has been little investigation of

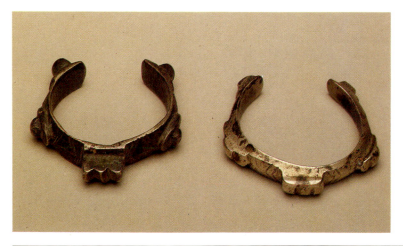

187. Cast-silver bracelets. Jordan, first half of 20th century

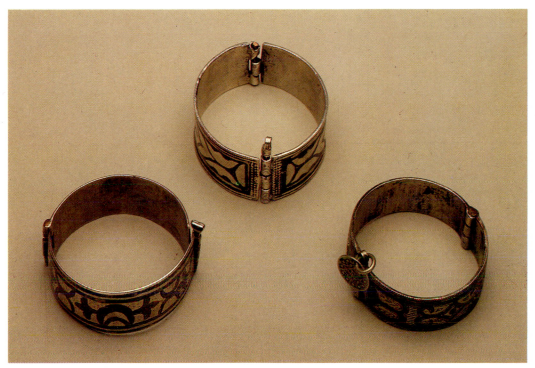

188. Niello-decorated silver bracelets. Jordan, 1930s and 1940s

the sites of the period. Archaeologically retrieved jewellery in Jordan is mostly from pre-Islamic tomb contexts. Islam rejects the practice of grave goods. Yet, for female burials, local traditions appear to have been so deep-rooted that women in many instances continued to be buried with their jewellery well into the 20th century. This practice is evidenced by both ethnographic and archaeological sources. Recently, a significant jewellery assemblage was excavated from Abu an-Naml, a presumably 18th-century cemetery in Jordan, and in the future this will shed more light upon late Ottoman Jordanian jewellery.

For the time being it might be suggested that the jewellery of this period was dominated by heavy, sand-cast and wound metal bracelets and glass bracelets. Rings were cast from silver or bronze in one piece, with a lozenge-shaped bezel bearing an inscription or an engraved geometrical design, or with large semi-precious gemstones or glass imitations in simple fittings. Necklaces, as far as attested ethnographically, consisted of chains with multiple pendants, whereas archaeological evidence points to a preference for necklaces composed of beads from various materials, colours, shapes and sizes, many of which presumably had a magical connotation. Attested both archaeologically and ethnographically are headdresses heavily decorated with beads and coins sewn on to

189. Niello-decorated ring from silver sheet with a fish as central motif. Jordan, 1940s

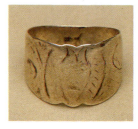

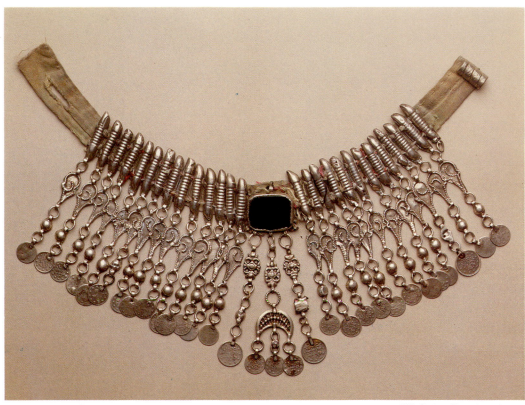

190. Choker. Silver elements on textile ribbon with a mounted green agate as central piece. Kerak, early 20th century

long bands of fabric. Many of the metal bracelets, rings and bead types are easily traced back to Ayyubid-Mamluk, Fatimid and earlier jewellery. A significant part of this jewellery inventory continued to be made and worn through the first half of the 20th century, such as certain silver and bronze bracelets, chains and necklaces of stone, glass, amber and other beads. Other types of jewellery, such as the glass bracelets, the above-mentioned ring types, upper-arm bracelets with long chain pendants and most of the multiple pendant necklaces, fell out of use, and were replaced by new forms.

Typology of the Jewellery Worn in Jordan

The techniques used by Jordanian silversmiths in the 20th century included casting into two-part moulds filled with sand, hammering, repoussé, granulation, filigree and niello. Whereas granulation was a speciality of Yemeni and Hijazi silversmiths niello is said to have been introduced to the country by silversmiths

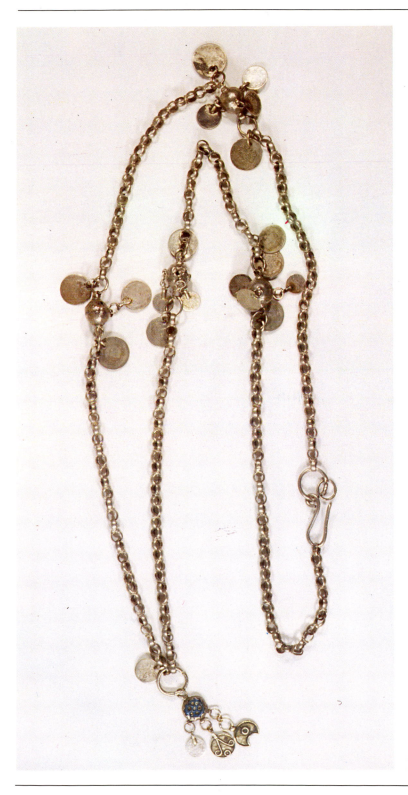

191. Silver shoulder chain.
Jordan, first half of 20th
century

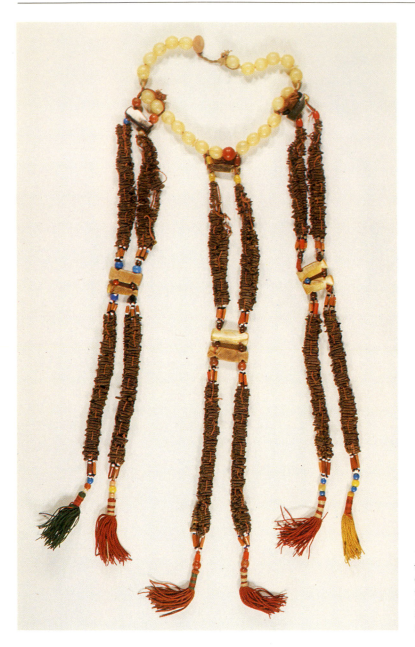

192. Clove necklace. Choker from plastic beads with attached strings of cloves, coral cylinders, glass and mother-of-pearl beads. Southern Jordan, mid-20th century

from Armenia and the Caucasus. With regard to the archaeological evidence of niello-decorated jewellery from late 10th- and 11th-century AD Syria, Egypt and Palestine, it appears more appropriate to talk of a reintroduction.

Jewellery types worn all over Jordan during the 20th century are bracelets, finger-rings, anklets, necklaces, chains and chokers,

amulets and amulet containers. Less common are silver earrings, whereas small nose-rings are worn by many beduin women.

Bracelets were traditionally worn in pairs, with one on either arm. Several types of open silver or bronze bracelets are characteristic of Jordan and worn all over the country. One of these is called *eswara mabroume* and consists of thick silver wires which are either wound around a central wire core, or are twisted with each other, and have a thinner twisted wire wrapped around them. Bracelets of the first variety often have polyhedral finials with punched design, flanked by palmette-shaped elements which in turn are decorated with twisted wire and filigree and granulation (Plate 184). Bracelets of the second variety often have large and bulbous finials, flanked by palmette-shaped elements (Plate 185).

Another bracelet type composed of metal wires is the *eswara majdoule*, which is plaited from thick wires. The ends of the plait are either covered by metal sheet or by polyhedral finials, often flanked by palmette-shaped elements, the latter sometimes replacing the polyhedral finials (Plate 186). Twisted and plaited silver bracelets of similar types figured among the jewellery of the turn-of-the-century Kerak-Madaba region. Twisted bracelets with polyhedral and palmette-shaped finials apparently go back to a type of bracelet which was already common in 11th- and 12th-century AD Egypt, Syria and Iran. In the Jordanian jewellery inventory polyhedral finials with punched circular design also figure as finials of plain open silver bracelets.

Another common type of bracelet is the *eswara mkobaje*, which is cast in one piece. It is decorated with five protrusions: the central one of a three-pointed shape, those flanking it resembling the shape of an eye, and the finials in the shape of a knob upon a rectangular base (Plate 187). The space between the protrusions is engraved with geometric designs. This very heavy bracelet of mostly low grade silver or bronze was made and worn all over Jordan until around the 1940s, and since at least the late 19th century.

Other bracelets worn all over Jordan were designated as *asawir sharkas* or *asawir mhabbar* (i.e. Circassian or inked bracelets). They were made of silver sheet, in two parts with hinged opening and pin fastening. They have engraved and punched decor including floral and geometric designs which are filled with niello (Plate 188). Most of these bracelets date to the 1930s and 1940s. They were still made by silversmiths in Irbid as late as the early 1960s. The beduins often bought them from itinerant Gypsy silversmiths who produced these bracelets from white metal with a silver-covered outer surface, as the niello can only be applied to real silver.

Rings in Jordan can be worn on four fingers, although the middle and the ring finger are more commonly adorned with rings. The practice of wearing a thumb-ring fastened to a bracelet by a chain had completely gone out of use by the early 20th century. The cast

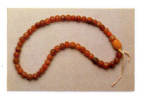

193. Necklace of multi-faceted agate and some glass beads. Jordan, first half of 20th century

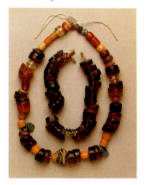

194. Inner necklace made of amber-imitating wedge-shaped plastic beads. Outer necklace composed of amber-imitating plastic beads, genuine amber beads, glass, agate and other stone beads. Northern Jordan, first half of 20th century

and engraved silver rings and the simple rings with large table-cut stones or glass-inlaid bezels also went out of fashion during this period. Instead, smaller stones in high bezels, decorated with filigree and granulation and depicting strong influences from the Arabian peninsula, were produced by the Jordanian craftsmen. In the second quarter of the century until the 1960s rings from silver sheet with niello decor became fashionable (Plate 189). The central motif of these rings was often a fish surrounded by a floral design. These rings were made particularly in Irbid.

Anklets were worn by beduin and peasant women until the 1940s. They were usually open or had a hinged opening with a screw fastening. The anklets made in Jordan were of massive silver and usually cast or hammered. Open anklets often had polyhedral finials. Like the bracelets, the anklets too were worn in pairs, with one on each ankle.

Among the silver necklaces worn in Jordan in the early to mid-20th century two types are of particular importance. Characteristic, especially for the Kerak-Madaba region, is the *kirdan* (Plate 190), a choker which probably replaced the necklace

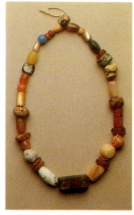

195. Necklace of bone, stone, amber, agate, mother-of-pearl, fossils, faience, glass, wood, and plastic beads, worn by a beduin woman from north Wadi Arabah around the mid-20th century

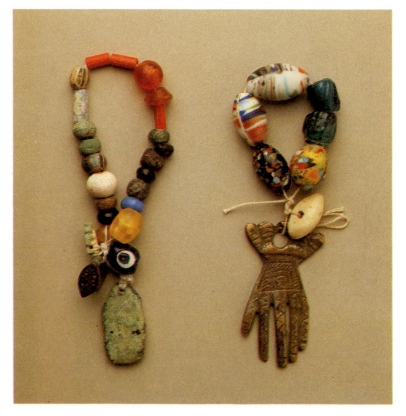

196. Composite bead amulets against the 'evil eye', usually fixed to the cradle of a baby. The string on the left is composed of an iron pendant, a bronze ring, agate, faience, glass and plastic beads. The string on the right is composed of a cast-bronze pendant in the shape of a hand, a bone bead and glass beads. Northern Jordan, mid-20th century

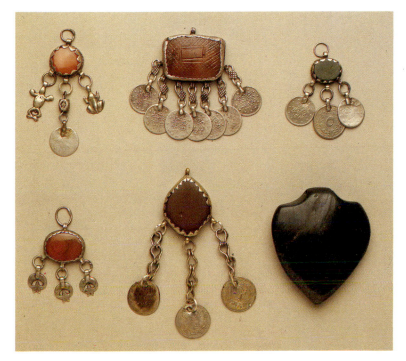

197. Agate amulets: the heart-shaped green agate pendant on the right is thought to protect from the bad effects emanating from menstrual blood. The dark-red agates were presumably worn to attract affection, whereas the light-red agates seem to have been used for matters concerning fertility, a view which is supported by the cast toad-shaped pendants of the piece on the left, as toad amulets are related to birth and growth. Jordan, first half of 20th century

hitherto worn with multiple pendants (like those depicted in Musil 1908, Fig. 39). The choker consists of a textile ribbon onto which are sewn concave 's'-shaped silver elements made in repoussé technique. The central piece stands out as a silver rosette, a mounted glass or gemstone or some other silver element. Attached through perforations in the silver elements of the choker are sand-cast silver ornaments and small Ottoman coins on chains. A peculiarity of Jordanian jewellery was the *jnad*, a long shoulder chain of at least 150 cm. length, worn from the left shoulder under the right arm reaching on to the hip. The chain is of the so-called Jerusalem chain type which, however, was made in Jordan too, and interspersed with hollow silver baubles on to which silver coins are fastened. The chain usually has a central pendant, such as a silver crescent or a blue faience amulet in a silver mounting (Plate 191).

Besides silver necklaces, Jordanian jewellery is rich in necklaces made from beads of other materials, such as stones and semi-precious stones, glass, amber, and coral. Bead necklaces account for some of the most characteristic and oldest types of traditional Jordanian jewellery. A necklace which was popular in particular with beduin women was the *'ugdet grunful*, a necklace strung with cloves and worn by the bride at her wedding and other festive occasions. These necklaces, which served the multiple function of jewellery, perfume and amulet, were not purchased but strung by

198. Fish pendant, made in repoussé technique from two halves, decorated with niello designs and attached Ottoman coins. Jordan, first half of 20th century

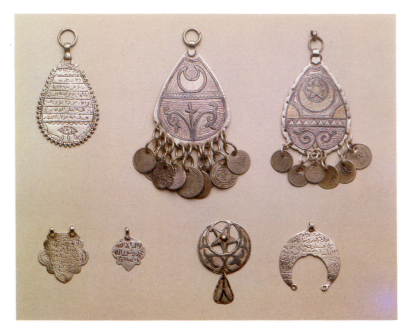

199. *Maske* silver amulets with inscriptions from the Qur'an and niello decoration. The piece on the upper right is partially gilded. Jordan, first half of 20th century

the women. Sometimes the whole necklace was made from cloves with interspersed beads, sometimes the necklace was of glass or plastic beads, and long strings of cloves with coral cylinders, glass beads and mother-of-pearl spacing beads were attached to the former (Plate 192).

Very popular were necklaces of regular strings of multifaceted agate beads (Plate 193) and amber necklaces (Plate 194). In the 20th century real amber was increasingly substituted by plastic wedge-shaped beads, although there are local amber deposits in Jordan, which have probably been exploited for bead-making in the past.

Apart from such uniformly strung necklaces are those composed of beads from different materials, shapes, sizes and colours. They are mostly strung by the person who wears them, and the number of beads often increases with time. Such a bead necklace combines a variety of elements, thought to possess particular apotropaic, affection-attracting or healing properties (Plates 194, 195). Composed according to the particular needs of the person who wears it, such a necklace may be very revealing about the life of its wearer (Mershen 1989). Necklaces of this kind have been worn in the region since prehistoric times. Those recently discovered at Abu an-Naml (cf. above) are very similar in composition to 20th-century bead necklaces. Both combine beads and pendants from glass, agate, carnelian, chert and other stones, amber, coral, faience, bone, cowrie shells and sometimes silver. The colours or a particular design on a bead are thought to have been more

important than the genuineness of a material. A real cowrie may thus have been replaced by a white button, a real coral by a red glass cylinder, without a change in the bead's efficiency.

Many beads are worn to ensure marital luck: brown-white banded agate or glass beads, called 'butter and honey beads' or white and black banded beads, which are supposed to make a wife 'dear' to her husband, belong to this category. Other beads have a more 'medical' function: thus a cylindrical or biconical agate bead of a brownish-red colour is worn against inflammation of the ear or the throat. Opaque white beads are worn to increase the milk of a breast-feeding mother. Certain yellow glass beads are supposed to help against jaundice, whereas light-red agate beads should stop internal bleeding and prevent abortions. Green agate beads or pendants are worn against the damaging effects thought to emanate from menstruating women. A variety of blue glass and faience beads are supposed to protect against the 'evil eye'. Amuletic beads were not only worn as elements of necklaces but also fastened by pins to the inside of clothing or hung upon the cradle of a baby (Plate 196).

A variety of stone plaques in metal fittings were worn as amuletic pendants. Particularly widespread were red agates worn to attract affection, and apotropaic black stone pendants. Often such pendants were engraved in a way which made them resemble written and wrapped-up amulets (Plate 197).

Amulets were also made from silver. A silver amulet which was very popular in the first half of the 20th century had the form of a fish. It was soldered from two repoussé-made halves and was decorated with either niello designs or granulation (Plate 198). Other amuletic pendants included cast or hammered pear-shaped silver plates, designated as *maske*, with one side depicting engraved verses from the Qur'an and one side decorated by floral, crescent or other motifs in niello. Others had only either a Qur'anic inscription or niello decoration. Attached to most *maske* amulets were five or seven chain pendants with coins or cast-silver elements (Plate 199). Silver boxes of rectangular, triangular or cylindrical shape were used as receptacles for written charms. They were decorated with engraved or niello designs, depicting geometrical and floral motifs, or inscriptions mentioning the craftsman, the place of manufacture, or some religious formula. Cast-silver elements or coins on chains were usually attached to such a *hijab* (Plate 200). Besides niello-decorated amulet cases, granulated cases in the Yemeni style were also common in Jordan.

Jordanian folk jewellery is one of the youngest representatives of a cultural heritage which has great antiquity. Information from producers and users of the jewellery on its technical, functional and historical aspects is of relevance for the interpretation of earlier jewellery from the region and may lead to interesting hypotheses concerning stylistic continuity and change.

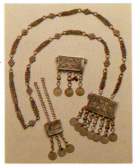

200. Silver amulet containers with inscriptions and designs carried out in niello. The central inscription on the container on the right reads 'Amman', probably the location of the craftsman, whereas the reverse mentions the date of production: 1345 AH, i.e. AD 1926. The chain, to which the container is attached, is particularly common for silversmiths from Kerak. Jordan, 1926

Further reading

N. Brosh, *Islamic Jewellery*. The Israel Museum, Jerusalem 1987.

R. Hasson, *Early Islamic Jewellery*. L.A. Mayer Memorial Institute for Islamic Art, Jerusalem 1987.

M. Jenkins and M. Keene, *Islamic Jewellery in the Metropolitan Museum of Art*. New York 1982.

B. Mershen, 'Amulets and Jewellery from Jordan – A Study on the Function and Meaning of Recent Bead Necklaces'. *Tribus* 38 (1989), 43–58.

B. Mershen, 'The Islamic Cemetery of Abu an-Naml', in T. Weber and A. Hoffman, 'Gadara of the Decapolis – A Preliminary Report on the 1989 Season at Umm Qeis'. *Annual of the Department of Antiquities of Jordan* 34 (1990).

B. Mershen, *Abu an-Naml – An Ottoman Cemetery at Umm Qais*, forthcoming.

A. Musil, *Arabia Petraea III., Ethnologischer Reisebericht*. Vienna 1908.

J.K. Stillman, *Palestinian Costume and Jewellery*. Santa Fe 1979.

S. Weir, *The Bedouin*, 2nd edition. British Museum Publications 1990.

Photographic Acknowledgements

Illustrations are reproduced by kind courtesy of the Ministry of Tourism and Antiquities, Jordan, with the addition of the following, with grateful thanks from the editor:

Ammar Khammash: Plate 1.
Piotr Bienkowski: Plates 3, 13, 15, 121, 165, 166.
J.B. Hennessy: Plate 4.
Jonathan Tubb: Plates 5–8, 113, 120, 127.
K.A. Kitchen: Plate 9.
Trustees of the British Museum: Plates 10, 156, 164.
E. Will/Institut français d'archéologie du Proche-Orient: Plate 11
Alan Walmsley/Pella Excavations: Plates 16 (photo: J. Hargraves), 66 (photo: M. McCord), 75 and 151 (photo: T. Evans), 152.
Gary Rollefson: Plate 27.
Peter Dorrell: Plate 28.
Alison Betts: Plates 29, 103.
Réunion des musées nationaux, Paris: Plates 34, 154, 171.
Fawzi Zayadine: Plates 52, 56.
Cincinnati Art Museum: Plate 55 (gift of subscribers).
H.J. Franken: Plates 67, 68, 76, 80, 84, 85.
Michele Piccirillo: Plates 136, 138, 140, 142–147.
Bibliothèque Nationale, Paris: Plates 157, 159, 161, 163.
Musée Bible et Terre Sainte, Paris: Plate 158.
Ashmolean Museum, Oxford: Plate 160.
G. van der Kooij: Plates 167, 168.
Widad Kawar: Plates 176–183.
Trustees of the National Museums and Galleries on Merseyside: Plates 184–190, 193–200.
Birgit Mershen: Plates 191, 192.

Index